Design and Feminism

Design and Feminism

*Re-Visioning Spaces, Places,
and Everyday Things*

Edited by

Joan Rothschild

With the

assistance of

Alethea Cheng

Etain Fitzpatrick

Maggie Mahboubian

Francine Monaco

Victoria Rosner

Rutgers University Press
New Brunswick, New Jersey, and London

Library of Congress Cataloging-in-Publication Data
Design and feminism : re-visioning spaces, places, and everyday things /
 edited by Joan Rothschild ; with the assistance of Alethea Cheng . . .
 [et al.]
 p. cm.
 Includes bibliographical references and index.
 ISBN 0-8135-2666-3 (cloth : alk. paper). — ISBN 0-8135-2667-1
(pbk. : alk. paper)
 1. Feminism and architecture—United States. I. Rothschild,
Joan. II. Cheng, Alethea.
NA2543.F45D47 1999
720′.82—dc21 98-45275
 CIP

British Cataloging-in-Publication data for this book is available from the
British Library.

Manufactured in the United States of America.

Contents

Both popular culture and the academic aristocracy have in past decades forced us to realize that the world is made of the combination and interaction of many subgroups and their own subtexts and that there is no validity in using absolute viewpoints or in referring to a mainstream. As a matter of fact, those lingering absolutes are often considered signs of fanaticism. Presidents of countries and multinational companies are retroactively acknowledging the sins that have been committed in the name of their own absolute viewpoints, and are apologizing to the communities they have offended and damaged in the past. At this point in the evolution of human thought, feminist critique has lost its initial role of outsider opposition and has at last affirmed itself as a necessary complement to all social studies.

The dismantling of the absolute began in science a long time ago, but only recently has it percolated down to the study of human actions and interactions. Geometry, one of the disciplines that has claimed to describe physical reality, has been among the first to take steps in this direction. The Euclidean models that were in ancient times sufficient to describe the world, even though they were only crudely approximate in their amputation of many of the details that make nature a work of genius, have been challenged throughout the centuries. However, in the 1950s the most recent geometries, such as the one based on Benoit Mandelbrot's fractals, have focused on finding recurrence in what seem complex exceptions, like snowflakes and coastal lines. Physics had already by the 1950s claimed its primary place with Einstein's construct and the quantum theory, while at the same time economics scholars introduced the word "deviance" to describe all the exceptions that influence and mutate the so-called norm. Since then, all disciplines, from philosophy to design, have made attempts to introduce into or impose on their basic dogmas diversification and instant change of perspective.

The 1950s was also a time when the first unconscious feminist overhaul from within the system occurred; the phenomenon was described by producer Jacqueline Donnet in her groundbreaking documentary *Paving the Way*, which aired on PBS in 1996. In the documentary, Donnet explains the pioneering lives of four women

of the 1950s: Ruth Bader Ginsburg, Supreme Court justice; Jeanne Holm, a major general in the U.S. Air Force; Rev. Addie Wyatt, the first African American female labor organizer for the meatpacking union in Chicago; and Patsy Mink, congresswoman from Hawaii. These women were able to organize their lives, which also included families, in such a way as to intrude their unique "marginal" viewpoint into some of the fortresses of mainstream male power and make quantum changes.

Their systemic revolution had characteristics in common with today's feminist activism and attitudes. Today, when the word "mainstream" has become blurred and ambiguous and what was once considered fringe has become the core of reality, feminist criticism is operating from within the system. It has the same necessary function as fractal geometry: that of describing reality in closer, truer, and more revealing detail. Women and other groups—ethnic, economic, religious—have at last acquired cultural power in part because of their having been marginalized in the past. Therefore, it is almost axiomatic that feminist critics do not wish to impose any absolute viewpoint and call instead for all other relative critiques to complete and enrich the picture.

Feminist critics are thus not concerned with reclaiming the whole world and declaring whose time it is but rather are taking the necessary steps to complete and revise history, while helping to focus attention on what used to be considered subtext. In the realm of architecture and design, feminist criticism no longer seeks merely to reevaluate important background women like Charlotte Perriand, Ray Eames, or Lilly Reich. The authors represented in this book, many of them pioneers in their own discrete fields, rather attempt to provide with their passionate and lucid accounts an insight into the real built world of the past and present. They focus on real design and architecture, which are made not only of symbolic monuments and peaks but also of the cities, objects, and buildings that have made everybody's real experience and given form to everybody's material culture.

Paola Antonelli

Acknowledgments

When a project is the result of the support and the collective efforts of so many persons and institutions—many of whom were also involved in the conference that gave rise to the book—it is perhaps not possible to acknowledge the myriad ways each contributed. I can only try.

My first debt is to the Graham Foundation for Advanced Study in the Fine Arts for support to the editor to prepare the book, generously following up its role as major funder of the CUNY "Re-Visioning Design and Technology" conference in 1995. My warm thanks to Emma Espino Macari, vice chancellor for facilities at the City University of New York, who arranged for CUNY's contributions to the conference and has helped to underwrite preparation of the book. The institutional support of the Center for Human Environments (CHE) at the Graduate School and University Center at CUNY has been invaluable. It would not have been possible to produce this book without computer, phone, mailing, fax, photocopying, and countless other office facilities or the innumerable ways the people and atmosphere of the Housing Environment Research Group [HERG] at CHE helped. (What would I have done without Karen Peffley and Heléne Clark to convert those Mac disks to DOS?) My special debt of thanks to Susan Saegert, current director of CHE, who believed in me from the beginning when I brought the conference idea to her. Her continuing encouragement, counsel, and friendship are irreplaceable.

Obviously, there would have been no book without the contributors and their original conference presentations, or their reworking—sometimes completely rewriting—them, sometimes many times over. The quality of your finished work testifies to your efforts. I thank each of you for your patience over what became a very long process and your support of me throughout. To my coauthor of the review essay, it was a pleasure working with you, Victoria, even as we disagreed, and agreed, and learned much from each other in the process.

"With the assistance of" preceding the names listed on the title page does not do justice to the extraordinary role these women played in producing this book. Alethea Cheng, Etain Fitzpatrick, Maggie Mahboubian, and Francine Monaco each participated in

the conference; Francine also served on the planning committee and moderated one of the conference workshops. Forming a publications committee, the four joined with me to produce a book that would reflect the spirit of the conference and carry the work beyond it. These young architects—all working full-time in a profession that does not know the meaning of "nine-to-five"—devoted their "spare time," their evenings and weekends, over an almost two-year period to the project. Selecting and organizing and re-selecting and reorganizing, contacting authors and reworking the manuscripts, engaging in endless discussions about "feminism[s]" and about our concepts of the book, they devoted their energies, enthusiasms, and talents to our project. Their visual orientation was especially valuable, as were their perspectives as part of a new generation entering the design fields. Victoria Rosner joined us a little more than a year into the project. She contributed her considerable editorial skills (as a graduate student in literature) to a number of the essays as well as bringing a fresh eye to what we had accomplished before her arrival. My heartfelt thanks to all of you.

Others contributed valuable comment on various segments of the book. I especially thank Susana Torre, Dolores Hayden, Roberta Feldman, and Susan Saegert for their critiques of an early version of the review essay. Reviewing the entire manuscript for Rutgers, Sherry Ahrentzen provided the kind of thoughtful and incisive critique, plus key suggestions, that proved enormously constructive. It is a better book because of her careful reading, and I thank her for it.

My special thanks to Leslie Mitchner, associate director and editor in chief at Rutgers University Press, for her continued enthusiasm for and faith in the book in its varied stages of development. She has been a pleasure to work with, as has the rest of the staff at Rutgers. Karen Reeds, formerly with the Press, was an early enthusiast of both the conference and the proposed book; I thank her for that support and for initiating the process.

Although this is a collection of writings mostly by others, as editor, as well as a contributing author, I am finally responsible for what appears in these pages. It was a long labor, which had its tedious and frustrating moments but also its pleasures and rewards. I think the outcome was worth it, and I hope the reader will agree.

Joan Rothschild
New York
August 1998

Joan Rothschild

Design and Feminism

Re-visioning is to see again, to re-imagine. But *re-visioning* is also to
revise, to change, to reinterpret, even to subvert accepted mean-
ings. This book started from the question: How well do our de-
signed environments—the places and spaces where we live, work,
and play, the tools we use—meet our needs, both aesthetic and
functional? As the divides of public/private, work/home, city/
suburb, producing/consuming—and their gendering—blur and en-
croach upon each other, new needs are created that demand in-
novative change. Yet the responses of the design community have
been mixed at best. Moreover, most people, even the very privi-
leged, have little control over shaping or changing their environs.
Our streets and parks, our dwellings, our tools are givens. This book
offers feminist critiques of these givens, and ideas, projects, and
programs for change.

But why *feminist*? The impetus for the book was a conference,
"Re-Visioning Design and Technology: Feminist Perspectives,"
held at the City University of New York Graduate Center in the fall
of 1995. What was extraordinary about the gathering was that prac-
titioners, researchers, teachers, and students from architecture, ur-
ban planning, industrial and product design, engineering, graphic
design, and information and communication technologies came to-
gether eagerly and excitedly under the feminist banner. They came
together across their fields, across generations, across theory and
practice. For two days of intensive exchange, feminism emerged
as a positive, creative, energizing force for exploring our designed
environments.

What, then, did the term signify for the participants, and what
does it mean for this book? Perhaps the best way to answer this is
to hear from participants who assisted in preparing this book for
publication. Responding to the question "How is this book femi-
nist?" they answered:

> The book is feminist, not so much because it is *about* women
> (which it is, although not exclusively), or even because it is *by*
> women (although in this case it is), but because it is about the
> critical contributions women can and must make as designers
> and users of created environments. . . .

Introduction:

Re-visioning Design Agendas

Joan Rothschild

The authors in this book have concerns that are everyone's concerns. Designs more sensitive to the needs of women are designs more sensitive to the needs of a diverse population. . . . While some essays specifically address women's concerns, others are much more broad, yet still deeply rooted in a feminism that is constantly alert for who might be left out, how they might be included, and how, in including them, we all benefit. (Alethea Cheng, practicing architect)

The book is feminist because it represents the work of women whose practices and approaches embody feminist thinking. A common thread throughout the essays is the promotion of inclusionary practices which challenge predominant ideologies that separate, divide, and erase identity. . . .

Feminist thinking cuts across disciplines. . . . We must take the threads of feminist practices from all disciplines so that we may re-vision and create a new web. (Etain Fitzpatrick, practicing architect)

The answer to why this book is feminist cannot be found in any one article. It is the collection and the interest in assembling the collection that is feminist. . . . The view is from a collection of perspectives. . . .

The tendency to package information and products in clearly defined containers has resulted in an abstract and reductionist view of the "world." . . . It is important for feminism to be presented as a concept which is central to women as the traditional caretakers and home builders, yet one that does not focus on issues of only women but of the community as a whole. (Francine Monaco, practicing architect)

This book offers essays in design fields contributing to "designed environments": architecture, urban planning, and product, industrial, and graphic design. What does taking the feminist perspectives described mean for the work presented? It means exploring such topics as the New Urbanism, participatory design, housing in the inner city, subverting symbols in the urban landscape, and designing tools and projects that are marketable and sustainable. It means seeking to deal with and overcome a number of divides: the distinctions between the professional designer and nonprofessional user, those within the professions and among them. It means contributors' not accepting marginalized status in their fields and being freed to engage in meaningful critique, to cross disciplinary divides and propose innovative ideas and solutions.

Contributing to the separation of disciplines is the distinction

made between *design* and *technology,* with the professions being classified accordingly. Thus, because of their association with the arts, architecture and graphic design are known as *design* professions, while engineering and computer electronics, associated with the technical, are called *technology* professions. Yet this separation flies in the face of practice. The engineer, too, is a designer, viewing the solution to a design problem as "elegant," the product a work of art; the architect cannot create a building without technical know-how and knowledge of materials. Computer-aided design is a critical tool for both. Industrial design represents the clearest fusion of design and technology, as products—whether vacuum cleaners, streetlights, or stacking chairs—must seamlessly combine function and surface appeal. Yet despite the dictates of practice, design and technology fields remain divided professionally as well as in popular image and usage; their specialized knowledges are often guarded jealously and used to bar entry as well as to shut out users.

The gendering of *design* and *technology* and of their associated professions compounds the issue. Although women and the feminine may be linked to the arts, and men and masculinity to things technical, the gendered hierarchies within these categories and within both the "arts" and "technology" professions give the lie to any such neat divisions. Men remain the sex with prestige and power in each of these areas. Giving the lie on a more positive note is the record of the proven abilities of women who have successfully entered into both arts and technical professions. Feminist perspectives become useful here to expose these splits and paradoxes, and the hierarchies, and to challenge and transcend them.

In this book, we seek to use "design" in its broadest sense—to encompass both the aesthetic and the technical. Whether explicitly or implicitly, the essays reflect the interdependence of design and technology. As they work across these varied divides, the book's contributors transgress established boundaries and create powerful tools for re-visioning our designed-environment agendas.

Reading and Using This Book

The opening review essay places the work that follows in historical perspective so that readers can learn about or enrich their sense of the important and varied work that has gone before. While selected segments of these materials may be known to practitioners and researchers and to an interested public, this feminist work on designed environments on the whole has been largely missing from professional schools and programs. Further, despite its clear links to feminist concepts and practices, this work is largely absent from women's studies teaching as well. The aim of the review essay

and this book, therefore, is to bring these materials to a wider audience—whether those in the various design professions, in the academy, or among the public at large.

The book starts with views on urban and suburban spaces, then moves to housing and neighborhood, next to product designs, and finally to process, that is, approaches to and modes of design. In the first three articles, architect and educator Susana Torre, historian and architect Dolores Hayden, and graphic designer Ellen Lupton are concerned with redefining and reclaiming the urban and suburban landscape. For Hayden, this means recapturing the histories of ordinary working women in places and spaces in Los Angeles, and so developing a mode of urban preservation geared to the lives of people. Critiquing the New Urbanism, Torre finds that examples of the new "urban suburbia" are a replay of gated suburban communities built to exclude others, by class, race, and ethnicity. Noting some positive aspects of the New Urbanism, she points to the concerns and parameters that should mark urban and suburban design. For Lupton, the urban landscape becomes the milieu for subcultures to use graphic design to subvert and appropriate corporate languages and symbols of the street.

For the next group of authors, implicit in existing arrangements for dwellings and neighborhoods are assumptions about "family," home and work, and people's "special needs." Their essays offer varied ways in which the program for dwelling and space operates to influence and change design. Alice Friedman, the art and architectural historian, shows how nontraditional lifestyles of independent women of means earlier in this century produced design requirements—for home workspaces or eliminating the master bedroom, for example—that questioned patriarchal nuclear family norms and subverted traditional housing concepts. Home and work is a central issue for the architect and educator Ghislaine Hermanuz. Her examples of the City College Architectural Center's redesigns for inner-city dwellings emphasize the importance of integrating dwelling places with streets and surrounding neighborhoods and communities, thus addressing the productive needs of women working from the home. For the architect Barbara Knecht, innovative designs for "special needs" housing in New York City provide models that apply beyond such circumscribed groups. It is not a question of *how* to design, she points out, but *what* to design in housing, again extending to neighborhood and community.

Turning to product design, the design historian Cheryl Buckley calls for putting women back into the design picture as both producers and consumers. She aims her critique at the way postmodernist theory, in fastening on *gender,* has emphasized men and masculinity, distorting feminist theory and erasing women from

design history. Taking up Buckley's call in practice, the following chapter features the work of three successful women industrial designers. Nancy Perkins discusses the innovative designs of her great-aunt, one of the first women to graduate from Cornell University's School of Architecture, and her own experiences with appliance design. The city as a venue for imaginative recycling projects is illustrated in Wendy Brawer's work, while alternative technologies that are energy-efficient and attractive are highlighted in the work of Amelia Amon.

Many of the authors are concerned with *process*, which is the special focus of the last three essays—that is, who has input, how designing is taught and carried out. The architect and educator Leslie Weisman, for example, uses feminist pedagogic principles in her architectural design studio to develop ways to break down hierarchies and work collaboratively not only within the classroom but also with clients on an actual project. Roberta Feldman, also an educator and architect, illustrates that participatory design is a positive force as she describes how Chicago public housing residents' attempts to change and improve their living environs brought them increased strength and confidence. Participatory processes are central to the Women's Design Service in London as well; its projects bringing know-how and training to both users and professionals are described by Lynne Walker, architectural historian, and her WDS colleague Sue Cavanagh.

A limitation of the book is its Western and industrialized-world focus. In the Afterword, I ask how the book's feminist approaches might be relevant in very different contexts and cultures. As rural living and work patterns give way to "modernization" and urbanization, often profoundly disrupting the living arrangements for families and communities, will prevailing Western practices that could be further disempowering for women be followed? Discussing varied dimensions of this issue, I call for more efforts to link the thinking and practices of feminist designers across borders and cultures and to connect with individual communities.

The Afterword echoes the intent of this book. The purpose of *Design and Feminism* is to begin a process. Bringing together a variety of feminist perspectives on designed environments—historic, current, and crossing disciplines—the book seeks to open doors and be a useful tool for design practitioners, educators, and a wider public. If it inspires readers to learn more and take a greater role in shaping their designed environments, then the first step will have been taken.

Drawing on their insights and experiences, the contributors to this book look to feminist practices to critique and challenge the received wisdom in their fields. Integral to their approach is the view

that the tools of design need not and should not underwrite and replicate entrenched economic and political patterns that oppress and exclude, patterns and practices that deny access and benefits to those without privilege and resources. Rather, re-visioning means using our collective perspectives for design concepts and practices to serve the wider community.

Feminisms

and Design:

Review Essay

Joan Rothschild and

Victoria Rosner

The literature of feminisms and design came of age with the second wave of feminism and the emergence of women's studies, although there were earlier stirrings.[1] Recovering the history of women in the fields of design, historians, joined by architects, planners, and social scientists, began to ask why women had been excluded in the first place, as both designers and users. As they examined women's experiences in and with designed environments, their work challenged traditional assumptions about the design professions themselves, about the spatial dimensions of women's lives, and about the conceptual frameworks in which these practices were situated. The dichotomies of public/private, city/suburb, work/home were increasingly questioned; women's diverse needs were reassessed in light of changing realities, and new design strategies emerged.

This literature relating to design is vast, having grown almost exponentially over the past three decades. Books, journals and periodicals of the various disciplines, and conference proceedings are among the many sources of this literature. Our review, therefore, will necessarily be selective. It will limit the fields covered to the following aspects of designed environments: architecture, urban planning, product design, and graphic design. Starting with the 1970s, it will highlight key works and trends, and so offer the reader a map to explore further. Most of the sources are from North America and Great Britain.

This review is unique in bringing this literature together across fields, presenting feminist perspectives on designed environments as a multidisciplinary endeavor. The commitment to being multidisciplinary—and ideally interdisciplinary—is central to this book and the conference on which it is based. The materials in this review essay will, we hope, contribute to an ongoing conversation.

Architecture

Feminist work in architecture has encompassed a number of avenues of inquiry. As in other areas of women's studies, research started from the question "Where are the women?" Recovering women's lost history in architecture led to analysis and critique of the profession and to exploring the work and impact of women

architects, including their training and education. Equally important came the examination of how women and their families live, the effects of spatial arrangements, and how well such spaces were meeting women's diverse needs. Such research, in turn, has brought designs and models for change. Theoretical approaches have focused on gender differences in relation to architectual forms and to architectural practice. Recent work, reconceiving difference in light of cultural studies and postmodernist theory, explores how identity is affected by built environments and how the body and sexuality are understood in relation to space and place. Our discussion of the literature in architecture is organized into three areas, which inevitably overlap: women in architecture, spatial arrangements—critique and designs for change, and theories of architecture and gender.

Women in Architecture

A review essay by Dolores Hayden and Gwendolyn Wright in *Signs* in 1976 was the first attempt to pull this literature together.[2] Entitled "Architecture and Urban Planning," the essay reflected the way that, starting from women's traditional association with the home, feminist analysis soon grew to encompass neighborhood, community, and urban and suburban environments. In 1976, Hayden and Wright found only one book on women architects of the past, Doris Cole's *From Tipi to Skyscraper: A History of Women in Architecture,* published in 1973. An "illustrated, journalistic survey of the work of many pioneers" by a practicing architect, Cole's "book encompasses Indian builders, writers on domestic economy, self-trained women, and professionals." Identifying "domestic design as the field where women have made their greatest contributions," Cole argued that the profession should give greater attention to this field. By the mid-1970s, however, Hayden and Wright could cite several articles, conference papers, works in progress, essays, and exhibits about individual women architects, planners, and landscape architects, such as Catharine Beecher, Louise Bethune, Eileen Gray, Julia Morgan, and others; some of this work later found its way into journals and books.

ˑ By the mid-1970s as well, compensatory history had brought searching questions. To what extent, asked Hayden and Wright, has the work of women designers, like that of women artists, been "credited to their male colleagues—husbands, fathers, brothers, partners, employers," citing queries about Brunelleschi's female rival, Christopher Wren's daughter, Margaret Macdonald and her husband Charles Rennie Mackintosh, Marion Mahony and her employer Frank Lloyd Wright.[3] In a theme that would be echoed

Joan Rothschild and
Victoria Rosner

today, an article by Gwendolyn Wright "considers women's marginal participation as an aspect of the hierarchical structuring of the architectural profession." Further, Hayden and Wright noted the importance of looking to women builders who are not formally part of the profession but "self-trained designers and contractors who build for themselves or others."[4]

In 1977, *Women in American Architecture: A Historic and Contemporary Perspective,* edited by architect Susana Torre, carried forward these themes. This handsomely designed and illustrated book grew out of essays documenting a 1976 exhibition organized by the Architectural League of New York through its Archive of Women in Architecture.[5] The first in-depth treatment of women's role in the construction of the built environment, the book explores the myriad ways women's work and approaches intersected with those environments, challenging the categories in the process. The essays on women architects, in documenting and redressing history, reinterpret the roles and impact of such pioneers and more contemporary figures as Judith Paine, Sophia Hayden, Julia Morgan, Elizabeth Coit, and Eleanor Raymond, with examples of their work.

Four years later, in 1981, *Heresies,* the journal of feminist art and politics, offered a provocative series of discussions in a special issue on women and architecture.[6] Produced by a collective of women architects, the articles cover a wide geographical and political swath, addressing issues of spatial design and thought by and for women. The issue, drawing on past and present, includes pieces on Eileen Gray, Lilly Reich, and other European designers of the early modern movement. In 1989, Ellen Perry Berkeley and Matilda McQuaid's *Architecture: A Place for Women* furthered the work of exploring women's historic and contemporary roles in architecture and of critically examining the profession.[7] Several of the articles in the collection take up the important issue of architectural education from past to current practices, including feminist experiments such as the Women's School of Planning and Architecture of the 1970s.[8]

In an article in the *Woman's Art Journal* in 1986 and in her forthcoming book on British women architects, historian Lynne Walker discusses the entry of women into the architectural profession in Britain and addresses the neglect of women in histories of architecture.[9] The catalog for an exhibit she organized in London in the summer of 1997 covers women builders going back to the 1600s.[10] Nonarchitects are included as well, notably feminist patron-builders of the Victorian era who sponsored a kind of social architecture, building schools, colleges, and housing for working-class women and clubs, restaurants, hospitals, and homes for themselves and poorer neighbors.[11]

The gendering of architectural practice, especially as linked to education and training, remains under discussion today, as exclusionary practices continue to marginalize women.[12] Their membership in professional societies, in both Britain and the United States, hovers at about 10 percent, despite the fact that, as Abby Bussel points out, women in the United States make up one-third of undergraduates and graduates in architecture schools and the number of women-owned firms has increased substantially in recent years. Her article "Women in Architecture: Leveling the Playing Field," in *Progressive Architecture* in 1995, charts the glass ceilings, low salaries, and sexual harassment women report experiencing and calls on architectural firms to take countermeasures.[13] From a more theoretical perspective, Francesca Hughes's edited collection, *The Architect: Reconstructing Her Practice,* published in 1996, draws on the individual experiences of a number of currently practicing architects to explore various aspects of architectural culture as they relate to women's limited visibility in architecture.[14] Claire Lorenz attempts in *Women in Architecture,* published in 1990, to render women architects more visible, profiling the careers and projects of over fifty contemporary architects from all over the world.[15]

The experiences of women in architecture in developing and nonindustrialized societies where women are in effect the architects and builders have been largely neglected in the literature until recently. A notable attempt to redress this omission is the collection edited by Hemalata Dandekar, *Shelter, Women, and Development,* published in 1993, which grew out of a conference that brought together first and third world perspectives at the University of Michigan the previous year.[16] In 1995, Labelle Prussin published *African Nomadic Architecture,* and Martha Avery's *Women of Mongolia* appeared the following year.[17]

Spatial Arrangements: Critique and Designs for Change

As architectural practices came under scrutiny, so did designs themselves. Exploring how women experienced the spaces they occupy and use, architects, historians, and social scientists found that inadequacies of built environments reflected patriarchal social beliefs and practices of the white middle-class culture. From housing design to the structuring of neighborhoods, cities, and suburbs, spatial arrangements for women and their families have not only been built on but have also served to reinforce two interrelated, reigning ideologies: (1) women are and should be confined to the home; (2) the private and public are separate spheres. The discussion here will be restricted to housing design, while literature

relating to the environments of city and suburb will be covered below in the section on city living and urban planning.

Hayden and Wright's review essay of 1976 noted an early example of the ways housing designs influence social use in Clare Cooper's *Easter Hill Village.* Assessing the design of domestic space, Torre's *Women in American Architecture,* mentioned above, included articles by Gwendolyn Wright and by Dolores Hayden that questioned and challenged the domestic model and ideal. For example, nineteenth-century reformer and architect Catharine Beecher's redesigns of the home, while altering and improving existing arrangements, still underwrote women's place in the home. Hayden's *The Grand Domestic Revolution,* published in 1981, expanded further on these themes, focusing especially on alternative, often radical designs, such as the kitchenless housing of Charlotte Perkins Gilman.[18]

The early 1980s brought a number of collections that also combined critical analysis with proposals and designs to deal with women's differing spatial and housing requirements. *New Space for Women,* edited by Gerda Wekerle, Rebecca Peterson, and David Morley (1980), was started as a project after the first United Nations Conference on Human Settlements was held in Vancouver, British Columbia, in the mid-seventies. The essays by a varied group of designers and planners, social scientists, and activists provide an overview of the framing of some basic questions about women's roles, attitudes, and expectations—and their determination to change them—related to the nature and effects of human environments. *Building for Women,* edited by Suzanne Keller and appearing the following year, is a symposium that sought to spell out the changing patterns of family life, work roles, and ideologies of gender for land use and for facilites and services; the focus is on housing, community, and urban space.[19] The *Heresies* issue of 1981 on women and architecture noted previously offers a useful set of essays that discuss women's collective efforts to take charge of their spatial destiny, initiating both cooperative and participatory practices. Offering both nineteenth-century and contemporary examples, the essays chart the beginnings of a number of groups and organizations, such as the Women's Development Corporation, that have become ongoing successful enterprises working to meet housing needs, especially of traditionally underserved populations.

The social awareness exhibited in both the critique and designs for change in these collections pointed the direction for continuing research and action. In the seventies, much of the attention centered on white middle-class women and heterosexual family arrangements, as researchers drew for the most part on their own

experiences and milieus, reflecting as well the perceptions and practices of much of the women's movement and women's studies of the time. As pressures for feminism to transform these perceptions grew, and as feminist research focused more heavily on the urban environment, the housing needs of much more diverse groups of women became critically apparent. Critique centered especially on U.S. housing policies and the creation of the urban ghetto, which was predominantly African American, even as researchers explored the intersecting issues of class, race, ethnicity, and nontraditional families. *The Unsheltered Woman,* edited by Eugenie Birch, grew out of a three-year Women and Housing Seminar at the racially and ethnically diverse Hunter College in New York in the early 1980s. The book features essays by a variety of academics, professionals, and activists engaged in housing issues, including those in architectural history, architecture and planning, housing and community development, and environmental psychology, focusing both on problems and on plans for change.[20] The issue of single-parent households is taken up by Sherry Ahrentzen in a collection she edited with Karen Franck in 1989, *New Households, New Housing,* in which she offers several examples of housing that is more than just "shelter for an 'emergency'" being developed to meet single parents' needs unaddressed by government agencies.[21]

Such work in the 1980s also emphasized the importance of developing cooperative and participatory processes. Matrix, a London-based collective of women architects, in its *Making Space,* published in 1984, describes the collective's processes and designs to produce workable, affordable housing for marginalized groups, notably for the city's families from Asia and the India-Pakistan subcontinent.[22] *Making a Place for Women,* published in the late eighties, offers an invaluable resource handbook on women and the built environment. It was produced by the Women's Design Service, also in London, a unique organization dedicated to providing such resources, especially for the less advantaged.[23] Jacqueline Leavitt and Susan Saegert's aptly titled *From Abandonment to Hope,* published in 1990, describes how tenants in New York City's Harlem were able to organize and save their deteriorating buildings from the wrecker's ball. In *More than Housing: Lifeboats for Women and Children,* published in 1991, Joan Forrester Sprague describes the work of the Boston-based Women's Institute for Housing and Economic Development, which she founded, in developing, designing, rehabilitating, and maintaining housing among various groups of disadvantaged women, such as the homeless, single mothers, and those with substance abuse problems.[24] Roberta Feldman, whose work on women in Chicago public housing

Joan Rothschild and
Victoria Rosner

12

is represented in this volume, has published a number of other ar-
ticles on such efforts, including, with coauthor and colleague Susan
Stall, "The Politics of Space Appropriation: A Case Study of Wom-
en's Struggles for Homeplace in Chicago Public Housing."[25]

Much of this feminist work about spatial arrangements is re-
viewed and synthesized in Leslie Kanes Weisman's *Discrimination
by Design,* which was published in 1992.[26] Chapters 4 through 6
highlight the historic record for the domestic landscape, bringing
the story up through recent projects and future "fantasies."

Important in this literature on spatial designing was the aca-
demic/practice mix, activists and practitioners joining with aca-
demics across their fields and disciplines to explore and then bring
to a wider public their concerns about housing and spatial arrange-
ments as they affected the lives of the people who used and occu-
pied those spaces. Work up through the eighties often stressed the
ways designed environments help to reinforce a woman's roles as
wife, homemaker, and child-carer, ignoring and/or impeding her
participation in activities beyond the confines of home and neigh-
borhood. Writing in the mid-nineties, Joan Ockman points out that
while the old gender stereotypes and dichotomies have eroded, our
architecture still reflects the ideologies built into the Levittowns
and the consumer culture of the immediate post–World War II pe-
riod.[27] At the same time, in certain contexts and cultures, women's
confinement to interior spaces can actually have liberatory effects.
In "Gendered Spaces in Colonial Algiers," appearing in the same
collection, Zeynep Çelik analyzes the symbolic and practical import
of Algerian women's spaces in the Casbah as sites of both commu-
nity and political resistance to French colonial rule. The privacy
and freedom of movement that Islamic women found on the roof-
top terraces of the Casbah allowed them to control their own space
for work and socialization.[28] The overcoming of dichotomies—
such as work/home and public/private—is critical to designs and
to theoretical constructs in recent literature, as articles in this vol-
ume illustrate.[29]

In looking at spatial arrangements, analysis starts from women's
experiences, the findings becoming a springboard for redesigning
those arrangements. In moving from critique to vision to action,
theoretical concepts are explored, questioned, and revised in a pro-
cess of continuous feedback. Practice generates theory generates
practice.[30]

Theories of Architecture and Gender

This interplay of practice and theory—central to feminist re-
search—characterizes the work described above. Conceptually

grounded, it reflects and contributes to the development of theories about architecture and gender. In the seventies and eighties, the gendering of architecture tended to be examined in terms of female/male and feminine/masculine differences, whether in symbol or form or in practice. As "difference" multiplied into a range of differences that constitute identity, new theoretical work in the nineties has similarly broadened and complicated ways of understanding the relationship between gender and architecture. Many of these authors seek to analyze the ways in which changing ideas about gender can underwrite different aspects of architectural theory and practice, or even how feminist architecture can challenge assumptions about gender. Theoretical work approached from cultural theory and postmodernism is at times in tension with more socially and historically oriented approaches.

In a coda to the final section of *Women in American Architecture* (1977 and cited above), "Women's Spatial Symbolism," Susana Torre contrasts two opposing archetypes in architectural design: the Pyramid, representing architecture as an absolute in pursuit of the ideal, and the Labyrinth, architecture as an "evolving form of *desire*" as it modifies and changes with use. Corresponding to "culturally defined ideas of masculinity and femininity and . . . patterns commonly attributed to men and women," these two symbols further assign spaces of sensuality and confusion to the Labyrinth and spaces of spirituality and certainty to the Pyramid. Like order/disorder, outside/inside, public/private, these polarities are viewed as unreconcilable rather than complementary opposites in architectural discourse. According to Torre, the "synthesis of prescription and pleasure has been a rare architectural event."[31]

In the 1981 issue of *Heresies* cited above, the editors note that several articles address the issue of whether "women design differently from their male counterparts." For example, Margrit Kennedy, describing differences between female and male principles in architecture, sees them not as "exclusive categories, but rather poles defining a continuum." Thus the female is "more user-oriented than designer-oriented," "more flexible than fixed," "more organically ordered than abstractly systematized," "more holistic than specialized," "more complex than one-dimensional." At the root of architectural problems, writes Kennedy, is the dominance of male principles, not the inherent value of the female. She, too, calls for synthesis, suggesting that women architects, who are first socialized in the female attributes and then professionally trained in the male, are better equipped to carry out such a synthesis, since they combine both sets of attributes.[32]

By the end of the eighties, there were a number of attempts to apply these gendered qualities to projecting a feminist and fe-

male architecture. In *Architecture: A Place for Women,* cited above, Karen Franck drew from the feminist literature in psychology, psychoanalysis, philosophy, and philosophy of science to propose seven characteristics of "women's way of knowing" that were applicable to developing a feminist approach to architecture. These qualities include an underlying connectedness to others and to knowledge, a desire for inclusiveness and overcoming dualities, an "ethic of care," valuing everyday life and experiences, subjectivity as a strategy for knowing, accepting and desiring complexity, and accepting change and a desire for flexibility. Franck offers a number of examples of alternative approaches and models, both proposed and in practice, that draw on women's social-architectural research and projects.[33]

Also prevalent in the literature at this time were sexual analogies and metaphors for architectural forms. Pointing to the American skyscraper as the "pinnacle of patriarchal symbology and the masculine mystique of the big, the erect, the forceful," and to the house as a "maternal womb," Leslie Kanes Weisman reviews this literature in the opening chapters of her *Discrimination by Design,* cited above. She argues further that the dichotomization of space sets up a "spatial caste system," illustrating how building forms and arrangements, as well as spatial divisions in the urban and suburban landscape, reflect power differentials and perpetuate social inequalities of sex, class, and race.[34]

In the nineties, this binary approach to architectural form and practice was increasingly called into question, reflecting charges of essentialism directed at cultural feminists. Feminist critics in architecture have argued that enumerating qualities of the feminine risks limiting women's self-definition and excluding women who do not identify with the listed qualities. For example, at a 1992 symposium, "Architecture and the Feminine: Mop-Up Work," women architects participated in a roundtable discussion in which Elizabeth Grosz asked the provocative question "Can you have a feminine space?"[35] Grosz responded to her own query by calling for a shift in focus from questions such as whether the architect was a man or a woman to "ways of occupying space and producing places that somehow contest, challenge, and problematize the dominant modalities of organization, of space and place."[36] In other words, Grosz suggests critics try to overturn generalizations about femininity and masculinity, lest these generalizations be used to constrain opportunities for women. Ann Bergren turned Grosz's question on its head to ask if the absence of the feminine would even be possible, much less desirable. For Diana Agrest, who moderated the discussion, avoiding definitions of the feminine leads to "a more powerful position."[37] In *The Architect: Reconstructing Her*

Practice, cited above, editor Francesca Hughes contends that for feminist critics to claim to represent the "feminine" risks reinscribing the very value-laden categories that need scrutiny. Many of the contributors to her volume seek to show how architecture metaphorically represses the feminine.

The nineties have seen an outpouring of work that has sought to conceptualize gender as one of an intersecting number of elements—including class and race, as well as age, religion, sexual orientation, and ethnicity—that comprise identities. Much of this work takes a broad definition of feminist perspectives, beginning in 1992 with the publication of *Sexuality and Space,* edited by Beatriz Colomina.[38] Colomina notes in her introduction that in spite of the widespread appropriation of "contemporary critical theory" into architecture, "the issue of sexuality remains a glaring absence." Contributors to *Sexuality and Space,* including Victor Burgin, Meaghan Morris, and Laura Mulvey, address their subject in diverse contributions that range from a consideration of a photograph by Helmut Newton to readings of the spectacles presented by King Kong and the Human Fly. Mark Wigley concludes the collection by asking for future work that would examine how arguments can be underwritten by unexamined assumptions about space. Wigley argues that the critical task of "reading space sexually" should be supplemented by projects that pay attention to the spatial concepts we unthinkingly use to describe identity.

In *Architecture and Feminism,* one of several collections published in 1996, a number of the authors take up the project of reading spaces for their masked sexual or gendered content.[39] In "The Knowledge of the Body and the Presence of History—Toward a Feminist Architecture," Deborah Fausch looks at the relationship of the body to a series of constructed public spaces. Other contributors present architectural projects designed for feminist intervention into well-known buildings. In Christine Magar's "Project Manual for the Glass House" and Amy Landesberg and Lisa Quatrale's "See Angel Touch," the architects intervene in works by Philip Johnson and Louis Sullivan respectively, their projects resulting in meditations on the relationships between structure and ornament and on the analogy of the female body in building. Working from a historical perspective, Susan R. Henderson's "A Revolution in the Woman's Sphere: Grete Lihotzky and the Frankfurt Kitchen" looks at how Weimar kitchen design was influenced by a state policy of "female redomestication" in the wake of the seeming threat to masculine control posed by the figure of the New Woman.

Most of the essays in *Architecture and Feminism* focus on showing how built environments participate in the construction of gendered identitites, an interest shared by many of the contributors to

The Sex of Architecture, also published in 1996 and cited above. This collection originated from a 1995 conference held at the University of Pennsylvania, "Inherited Ideologies: A Re-examination." Reflecting the exchanges built into the structure of the conference, the essays are paired with responses, providing for development of the themes. For example, Alice T. Friedman, who looks at the active and collaborative role played by some women clients of modernist architects, is paired with Ghislaine Hermanuz, who discusses projects for housing designs that speak to the redefining of women's role beyond domesticity in varied social, cultural, and economic contexts. In their introduction, the editors note that one concern of many of the contributors is the unsettling of some long-held architectural "truths" ["inherited ideologies"]: "that man builds and woman inhabits; that man is outside and woman is inside; that man is public and woman is private; that nature . . . is female and culture . . . is male."[40] By challenging these outdated "gender-based assumptions," the authors can take a fresh look at the ways gender stereotypes are manipulated in creating and inhabiting built environments and open the way to transcend these binary modes of thought and practice.

In a critically important article, "The F Word in Architecture," which appeared in 1996, Sherry Ahrentzen explores how three kinds of feminist postures—liberal, cultural, and contextual—respond to a gendered architecture whose masculinized concepts and practices exclude and marginalize women. She concentrates on the third, or "contextual," the most recent type, which takes difference beyond the binary categories to conceive of a multiplicity of differences. Dividing the contextual into two strands, she criticizes the "textual" for theorizing about difference in abstract terms, using inaccessible language, and remaining disengaged from social and historical realities and contexts. Rather, Ahrentzen supports contextual feminism's "transformative" strand, which, without denying the existence of difference, stresses the social conditions that make difference matter. Placing the concept of a multiplicity of differences in social context, transformative feminism can work toward *"changing those institutions that structure the gendered contexts in which we live."*[41] Ahrentzen's analysis, in showing how the tensions within feminisms' current approaches to architectural theory and practices can be reconciled, seeks to engage such approaches in the project of reconstructing a socially responsible architecture.

City Living and Urban Planning

Although she might not view herself a feminist, Jane Jacobs has been called "the mother of us all" by more than one feminist

working in the field of urban planning and architecture. Her groundbreaking book *The Death and Life of Great American Cities,* published in 1961, took on the planning and housing establishments, introducing an entirely new set of principles for city planning and rebuilding, built on diversity of use and complexity.[42] Reviewing the actual uses of sidewalks, parks, and neighborhoods, she found that the principle that "emerges so ubiquitously . . . is the need of cities for a most intricate and close-grained diversity of uses that give each other constant mutual support, both economically and socially." She proposed changes "in housing, traffic, design, planning, and administrative practices" so as to deal with "the *kind* of problem which cities pose—a problem in handling organized complexity." Coming as it did when crises over housing, crime, and congestion, signaling a decline in the quality of life and the decay of our major cities, were becoming too blatant to ignore, her critique had a profound effect on those who wanted to take action, including among them feminists.

The 1976 *Signs* review essay by Hayden and Wright, cited above, documented the early and sparse feminist work on cities and urban planning. But by 1980 a special supplement to *Signs*'s Spring issue would be entitled "Women and the American City," with several of the pieces dealing with spatial concerns and arrangements.[43] Most important was Gerda Wekerle's thirty-one-page review essay, "Women in the Urban Environment," documenting the "explosion of research and writing" since the mid-seventies.[44] Noting the degree to which such work crosses a number of disciplines, she grouped current studies under three dominant paradigms, each offering critique and ways to change: (1) the public/private split and how to integrate the two spheres; (2) environment and behavior, concerned with the "fit" between women and their various environments and how women might participate more fully; (3) environmental equity, especially emphasizing women's right to equal access to public goods and services such as transportation, housing, and social services.[45]

The issue offers pieces providing both contemporary and historical analysis. Applying the concept of polarities to city and suburb, Susan Saegert in "Masculine Cities and Feminine Suburbs" shows how the urban/suburban split mirrors the public/private, work world/domestic sphere, male/female patterns of life, expectations, and satisfactions.[46] Even though the reality is otherwise, the image is the "guiding fiction" for public and social policy, which remains detrimental to women, who are kept in low-paying jobs, lack transportation, and are denied the cultural amenities of the city. Saegert calls for a new theory and practice to integrate life for

domestic and productive work—a task she would speak to a few years later in "The Androgynous City."[47]

When Dolores Hayden asks "What Would a Non-Sexist City Be Like?" in the issue, she, too, is responding to the public/private split, to "woman's place is in the home" versus and the reality of women's lives in the paid work force. Drawing on examples of cooperative housing and environments from other countries, she proposes that participatory groups of homemakers and others establish "experimental residential centers," which would "develop a new paradigm of the home, the neighborhood, and the city."[48] For models she also draws on much of her own research on American cooperative housing of the past. Her *Seven American Utopias* was published in 1976, and *The Grand Domestic Revolution,* mentioned above, which would appear in 1981, provides a rich review of the innovative housing and neighborhood and city planning designs by and for women in the nineteenth and earlier twentieth centuries.[49] In 1984, *Redesigning the American Dream* further brought together her visions for the built environment to integrate home, work, and family life.[50]

The number of studies relating to women and the urban environment has increased throughout the eighties and into the nineties. Several of the works cited under "Spatial Arrangements" in the Architecture section above are relevant here, including those by Gerda Wekerle et al., Suzanne Keller, Eugenie Birch, and Leavitt and Saegert. Interest in women and the urban landscape continues to be high. In 1995, Dolores Hayden published *The Power of Place,* which, in situating women's and ethnic history in the urban landscape of Los Angeles, offers new ways of thinking about and writing the social history of urban space.[51]

Several of the articles collected in *The Sex of Architecture* (1996 and cited above) raise important questions about urban space. Esther da Costa Meyer's "La Donna è Mobile: Agoraphobia, Women, and Urban Space," for example, traces the geneaology of agoraphobia and its parodic representation of femininity.[52] The place of women in the American and European modernist city is explored by Elizabeth Wilson in *The Sphinx in the City: Urban Life, the Control of Disorder, and Women* (1991).[53] Insofar as the feminine has been linked to disorder, Wilson argues that the control of women has seemed essential to prevent the degeneration of urban life. But Wilson also finds in the very disruptive and spontaneous aspects of the city a freedom for women not provided in more ordered spaces and contexts.

Traditional planning strategies have come under increasing feminist critique, for example, in the eighties by the work of Jacqueline

Leavitt and of Suzanne Mackenzie.[54] In the nineties, Clara Greed's *Women and Planning: Creating Gendered Realities* elucidates the gender bias in both the theory and the practice of British planning, starting from the nineteenth century; she suggests a complex transformative strategy to repair the "dichotomized world view" that often guides contemporary planners.[55] Gerda Wekerle and Carolyn Whitzman describe in their *Safe Cities* how women are typically most fearful in public urban spaces, often limiting their activities in the city as a result. Detailing specific ways to enhance the safety of public spaces and providing photographs and checklists, the authors caution that physical design is only one component of any program to improve city safety. Urban crime is also very much the result of the "cultural practices and systems of privilege and disadvantage that are ordered by gender, class, and race." Social prevention and design must be addressed together in order for change to occur.[56]

Barbara Hooper traces the history of feminist planning as far back as Christine de Pizan's 1404 allegory *The Book of the City of Ladies*. While acknowledging how earlier critics created the ground for her work, Hooper distinguishes her project by asserting, "It is also important to note that I am not engaged in a reclamation project, the (re)assertion of an excluded women's history: this history has been reclaimed already and is documented thoroughly." Rather, she critiques the power-knowledge relationships that underlie planning tradition and calls for new traditions that, informed by feminism and postmodernism, take account of difference. Hooper shows how "planning's recognition that such modernist concepts as truth, knowledge, and objectivity are context-specific" would seem to be a women-friendly insight but how in fact feminist perspectives often continue to be excluded from the canons of planning.[57]

Hooper's observation that postmodernism's apparent liberalism nevertheless operates from within a masculinist paradigm has been made by other feminist critics in the nineties. In an often-cited article, "Boys Town," Rosalyn Deutsche critiques David Harvey's *The Condition of Postmodernity* (1990) for his totalizing account of postmodern culture, one that "represents difference as sameness" and methodically excludes the specificity of feminist social analysis.[58] Building on Deutsche's insight, several critics have worked to bring feminist insights to bear on the planning agenda. Leonie Sandercock and Ann Forsyth survey five different areas of planning theory and how feminist theory has contributed to each. They stress, however, that feminist theory should be seen not simply as a supplement to planning but as a tool for rethinking the gender-biased foundations of the discipline.[59]

Two recent articles draw on feminist ethics in order to guide the actions of planners. Sue Hendler outlines how different models of

feminist ethics might be applied to diverse aspects of planning, including planning techniques, plan making, and normative planning theory.[60] Beth Moore Milroy, in "Values, Subjectivity, Sex," shows how planning tends to treat women as a specialized subgroup of the population, and men as generic human subjects and offers suggestions for putting an end to this imbalance.[61] The error of deeming a privileged group normative is also criticized by Marsha Ritzdorf, who shows how public policy that favors the nuclear family structure penalizes African American families disproportionately, since they are statistically less likely to conform to that model.[62]

Another field of study that has an important bearing and impact on feminist work in architecture and planning is feminist geography. To review its vast and rapidly growing literature is, however, beyond the scope of this review essay. We will limit ourselves to mentioning a few key works so that readers have tools to explore further. An early articulation of the premises of feminist geography can be found in Shirley Ardener's *Women and Space,* published in 1981.[63] In 1997, Linda McDowell and Joanne P. Sharpe edited a reader of previously published articles in the field, covering five research areas: nature, bodies, everyday space, work, and nations and nationalism.[64] Doreen Massey's essays written between 1978 and 1992, which document the increasing influence of feminist thought within geography studies, were published in her *Space, Place, and Gender* in 1992.[65] Massey is an important and provocative theorist, and her essays offer a compelling account of how patriarchal notions of place are tied to gender, particularly insofar as place is represented as bounded, unitary, and oppositional.

The relationship of feminism to geography is also the subject of Gillian Rose's *Feminism and Geography: The Limits of Geographical Knowledge* (1993), a work that documents geography's intransigent masculinism.[66] As in architecture, a number of collections have appeared in the last few years that explore the intersection of gender, sexuality, and geography from a range of new perspectives. Many of the contributors to *BodySpace: Destabilizing Geographies of Gender and Sexuality* look at the relationship of gender, sexuality, and epistemology under the rubric of a broadly defined feminist perspective.[67] Another recent collection, *New Frontiers of Space, Bodies, and Gender,* edited by Rosa Ainley, offers essays on gender in relation to different kinds of spaces, such as urban, cyber, cultural, communal, imagined, and embodied.[68]

Product and Industrial Design, and Graphic Design

In the field of product design—meaning craft and manufactured objects—women designers have been most closely identified with

the "decorative arts" and in their role as consumers rather than be-ing viewed as professional product designers. Attempts to place women properly into the picture—in the process reconceptualizing the history of design—have received greater attention in Britain, where the field is more developed than in the United States. Start-ing with compensatory history in the eighties, work soon moved on to develop critique and new methods of analysis.

An influential article by Cheryl Buckley, which appeared in 1986 in a design journal rather than a feminist publication, pre-sented an incisive, well-documented critique of the patriarchal character of design.[69] It showed how the "cultural codes" and "rules of the game" have obscured, ignored, or distorted women's roles as both producers and consumers. In order to explore and evaluate the relationship of women and design, she argued, we must apply the social and ideological insights of feminist theory. Reviewing the de-sign history literature a decade later, Buckley has found that in-creasingly, as research has focused on gender, the concern with men and masculinity is erasing women from design history. In a new piece appearing in this volume, she calls for reclaiming femi-nist theory and the category "women" and for placing women and their work in social and historic context.[70]

Feminist historical methodology is also very much at issue in *Women Designing: Redefining Design in Britain between the Wars,* published in 1994. Editors Sedden and Worden warn of the "weak-nesses of a 'me too' approach which merely involves an unearthing of forgotten or neglected female designers," favoring instead "an insight into the ways in which the words 'design' and 'designer' were constructed."[71]

In the eighties in Britain, much of the attention to women and design came through a series of conferences. In 1983 the Design History Society sponsored "Women in Design" at the Institute for Contemporary Art (ICA) in London; "Women and Design" was held at Leicester in 1985, "Women Working in Design" at Central/St. Martins in London in 1986, and "The Cutting Edge" at the ICA in 1988.[72] In 1991, "Cracks in the Pavements: Gender/Fashion/Architecture," held at the Design Museum in London, illustrated a trend to focus on gender and to take a cross-disciplinary perspec-tive. Published work in the mid- and late eighties includes Judy Attfield's "Feminist Designs on Design History" in *Feminist Art News,* her "Invisible Touch . . . What Design History Can Gain from a Feminist Perspective" in the [London] *Times Higher Edu-cation Supplement,* a resource book on *Women Working in De-sign,* edited by Attfield and Tag Gronberg, and the multiauthored *Women and Craft.*[73]

More recently, Attfield and Pat Kirkham have edited the col-

lection *A View from the Interior: Women and Design,* a survey of contemporary work in the field.[74] First published in 1989, it was reissued in 1995 with new material. The broad scope of the articles in this collection is an indication of how much work remains to be done. Several of the contributors present case studies: Lee Wright discusses the manufacture and marketing of the stiletto heel, while Christine Boydell profiles an important textile designer of the inter-war period, Marion Dorn.[75] Other essays look at the arts and crafts movement in Britain, gender dynamics in fashion, and women's role in housing design. As the editors note, a focus on design allows feminist critics to explore gender's relationship to material culture in historically specific ways.

Kirkham is also the editor of a recent collection of articles, *The Gendered Object,* which looks at how "the dynamics of gender re-lations operate through material goods."[76] In a series of fairly short essays, contributors explore gendered aspects of the design, mar-keting, and use of objects such as hearing aids, washing machines, and bicycles. Many of the essays focus on two particular areas, chil-dren and fashion. Fashion is also the subject of Jennifer Craik's *The Face of Fashion: Cultural Studies in Fashion.*[77] Craik analyzes both elite designer fashion and everyday fashion, taking an interdiscipli-nary, ethnographic approach to topics including cosmetics, under-wear, men's fashion, and fashion models.[78]

Recovering the work of women—and putting it into context—has figured recently for industrial design. In *Charles and Ray Eames,* published in 1995, Pat Kirkham demonstrates Ray Eames's central role of collaborator and codesigner in the work of this famous de-signer couple. In 1994, the Association of Women Industrial De-signers in New York organized an exhibit of contemporary women industrial designers, whose work was featured in the exhibition's catalog, *Goddess in the Details.*[79] However, the industrial design lit-erature is still sparse. Even though women were trained as indus-trial designers earlier in the century, their contributions were often trivialized, for example, as providing the "female touch," and/or subsumed under that of male colleagues. Industrial designers who are women—and who identify as feminist—still remain relatively few.[80] Understandably, they have yet to write extensively about their work.

Discussion of industrial design and its relation to women is more likely to be found in the feminist literature on technology, espe-cially as various technologies relate to women as workers and con-sumers. In the mid-seventies, Ruth Schwartz Cowan's "'Industrial Revolution' in the Home" demonstrated that the mechanization of the home in the early decades of this century, far from being labor-saving, brought "more work for mother."[81] This was the title of her

book published in 1983, which expanded the theme from the colonial period to the present.[82] Articles in Rothschild's *Machina ex Dea,* originally published in 1983, those in Martha Moore Trescott's earlier *Dynamos and Virgins Revisited,* and Judy Wajcman's more recent *Feminism Confronts Technology,* a "state of the art" review, give attention to various aspects of women, work, and technology. The Rothschild and Trescott volumes also include the subject of women as designers of technologies, that is, as inventors.[83] Redressing women's omission from the history of invention, Autumn Stanley's massive work, *Mothers and Daughters of Invention,* was published in 1995. Ranging from prehistory to the present, Stanley charts women's vast array of contributions from agriculture to medicine to food processing to machines of varying kinds, including the cotton gin and the sewing machine. Detailed and thorough, the volume is a work of compensatory history, stopping short of placing women's absence and their contributions in a broader historiographic context.[84]

Two recent works on household technologies reveal how gender plays a critical role in the designing and use of a product and thus in the relationship of producers and consumers. Focusing on process, Cynthia Cockburn and Susan Ormrod's penetrating study of a microwave oven in Britain, *Gender and Technology in the Making,* shows the ways gender roles and assumptions inform and change product design, marketing, and use.[85] In the collection edited by Cockburn and Ruža Fürst-Dilić, *Bringing Technology Home,* which dealt with household technologies in eight European countries, Danielle Chabaud-Rychter's focus on the step-by-step designing of a food processor in France is another example of how the designing, testing, and use of a product are intertwined with gender.[86] Offering a quirky look at the house's digestive system in *The Bathroom, the Kitchen, and the Aesthetics of Waste,* Ellen Lupton and J. Abbott Miller argue that the streamlined look of American household appliances in the 1930s reflected a cultural obsession with consumption, both bodily and economic.[87]

While women graphic designers have been contributing to our visual landscape since early in the century, their work has only recently begun to receive attention in the literature. Rather than being singled out, their contributions as artists in more than one medium and genre have been included along with those of men, as Liubov' Popova's was among the Russian Constructivists of the twenties. Liz McQuiston's *Women in Design,* published in 1988, marked a new feminist attention to graphic design, and was a forerunner of her work of history to come.[88] In 1997, her *Suffragettes to She-Devils: Women's Liberation and Beyond* provided a sweeping yet carefully detailed historic review of the work of women graphic de-

signers from 1900 to the present.[89] Stunningly designed and with a foreword by Germaine Greer, the book reveals the highly political story of feminists using graphic design from the early campaigns for the vote to the ensuing struggles for women's liberation among generations that followed.

The literature in the fields of designed environments represented in this essay—as well as those not covered—continues to grow and, more important, to evolve. Crossing disciplines, spanning generations and varying and changing "feminisms," and bringing together the worlds of practice and the academy, this work furthers the feminist project to question the accepted truths and ways of doing and knowing in these fields and so point to new directions for research and practice.

Notes

1. Women's studies developed as the intellectual arm of second-wave feminism. The disciplines of history, literature, psychology, sociology, and anthropology were among the first to develop a feminist literature, which structured women's studies courses and programs as they were established starting in the 1970s. The sizable and growing feminist literature on design, however, has yet to be incorporated into the curricula in women's studies and professional schools. See also Joan Rothschild, "Designed Environments and Women's Studies: A Wake-up Call," *NWSA Journal* 10:2 (Summer 1998): 100–16.

2. Dolores Hayden and Gwendolyn Wright, "Architecture and Urban Planning," review essay, *Signs: Journal of Women in Culture and Society* 1:4 (Summer 1976): 923–33; quotations p. 924.

3. Ibid., p. 925. Perhaps indicating some progress, in an exhibit of the work of Mackintosh that traveled to several venues including the Metropolitan Museum of Art in New York in 1997, the work and significant contributions of Margaret Macdonald were clearly acknowledged.

4. Gwendolyn Wright, "On the Fringe of the Profession: Women in American Architecture," in Spiro Kostof, ed., *The Architect: Historical Essays on the Profession* (New York: Oxford University Press, 1976). The quotations are from Hayden and Wright, "Architecture and Urban Planning," pp. 924, 927.

5. Susana Torre, ed., *Women in American Architecture: An Historic and Contemporary Perspective* (New York: Whitney Library of Design, 1977). The book was designed by Sheila Levrant de Bretteville.

6. "Making Room: Women and Architecture," *Heresies* special issue 11 (1981), ed. Barbara Marks, Jane C. McGroarty, Deborah Nevis, Gail Price, Cynthia Rock, Susana Torre, and Leslie Kanes Weisman.

7. Ellen Perry Berkeley, ed., and Matilda McQuaid, assoc. ed., *Architecture: A Place for Women* (Washington and London: Smithsonian Institution Press, 1989).

8. In 1988, Lamia Doumato, who contributed an article to the Berkeley and McQuaid collection, published *Architecture and Women: A Bibliography* (New York: Garland, 1988).

9. Lynne Walker, "The Entry of Women into the Architectural Profession in Britain," *Woman's Art Journal* 7:1 (Spring/Summer 1986): 13–18.

10. "Drawing on Diversity: women, architecture and practice," RIBA Heinz Gallery, London, June 5 to July 26, 1997.

11. These patron-builders included Barbara Leigh Smith Bodichon, Emily Davies, Elizabeth Garrett Anderson, and Millicent Fawcett. Walker points out that the 1920s and 1930s in Britain brought a new breed of women architects who, in designing public buildings, broke the mold, liberating women from an exclusive association with domestic architecture. A notable coup was Elisabeth Scott's winning design for the Shakespeare Memorial Theatre in Stratford in 1927. Ibid.

12. See Sherry Ahrentzen and Kathryn Anthony, "Sex, Stars, and Studios: A Look at Gendered Educational Practices in Architecture," *Journal of Architectural Education* 47:1 (1993): 11–29; Leslie Kanes Weisman, "Diversity by Design: Feminist Reflections on the Future of Architectural Education and Practice," in Diana Agrest, Patricia Conway, and Leslie Kanes Weisman, eds., *The Sex of Architecture* (New York: Harry N. Abrams, 1996), pp. 273–86; Sharon E. Sutton, "Resisting the Patriarchal Norms of Architectural Education," ibid., pp. 287–94. See also Karen Kingsley, "Rethinking Architectural History from a Gender Perspective," in Thomas A. Dutton, ed., *Voices in Architectural Education: Cultural Politics and Pedagogy* (New York: Bergin and Garvey, 1991); Lynne Walker, "Architectural Education and the Entry of British Women into the Architectural Profession," in Neil Bingham, ed., *The Education of the Architect* (London: Society of Architectural Historians of Great Britain, 1993); and discussion in Sherry Ahrentzen, "The F Word in Architecture: Feminist Analyses in/of/for Architecture," in Thomas A. Dutton and Lian Hurst Mann, eds., *Reconstructing Architecture: Critical Discourses and Social Practices* (Minneapolis: University of Minnesota Press, 1996), pp. 71–118, esp. pp. 79–81.

13. Abby Bussel, "Women in Architecture: Leveling the Playing Field," *Progressive Architecture* (November 1995): 45–49, 86. See also Roberta Feldman, "Women in Architecture: Fitting in or Making a Difference," *Chicago Architecture* 9 (1991): 10–11; John Dixon, "A White Gentleman's Profession?" *Progressive Architecture* (November 1994): 55–61.

14. Francesca Hughes, ed., *The Architect: Reconstructing Her Practice* (Cambridge, Mass.: MIT Press, 1996). Dana Cuff in *Architecture: The Story of Practice* (Cambridge, Mass.: MIT Press, 1991), rather than looking specifically at women's practices, uses a series of on-site examples to examine the process of architectural practice, drawing a portrait of the profession as a social art of design.

15. Claire Lorenz, *Women in Architecture: A Contemporary Perspective* (New York: Rizzoli, 1990).

16. Hemalata C. Dandekar, ed., *Shelter, Women, and Development: First and Third World Perspectives* (Ann Arbor, Mich.: George Wahr, 1993).

17. Labelle Prussin, *African Nomadic Architecture: Space, Place, and Gender* (Washington and London: Smithsonian Institution Press and National Museum of African Art, 1995); Martha Avery, *Women of Mongolia* (Seattle: University of Washington Press, 1996). See further discussion in the Afterword, this volume.

18. Clare Cooper, *Easter Hill Village: Some Social Implications of Design* (New York: Free Press, 1975). For Hayden, see n. 49 below.

19. Gerda R. Wekerle, Rebecca Peterson, and David Morley, eds., *New Space for Women* (Boulder, Colo.: Westview, 1980); Suzanne Keller, ed., *Building for Women* (Lexington, Mass.: D. C. Heath, 1981).

20. Eugenie Ladner Birch, ed., *The Unsheltered Woman* (New Brunswick, N.J.: Center for Urban Policy Research, 1985).

21. Sherry Ahrentzen, "Overview of Single-Parent Households," in Ahrentzen and Karen Franck, eds., *New Households, New Housing* (New York: Van Nostrand Reinhold, 1989), quotation p. 144.

22. Matrix, *Making Space: Women and the Man-Made Environment* (London: Pluto, 1984). The collective closed in 1997.

23. Women's Design Service, *Making a Place for Women: A Resource Handbook on Women and the Built Environment* (Marjorie Bulos, ed., comp. by Jos Boys with Rosa Ainley and Maureen Farish) (© London: South Bank Polytechnic, n.d.). See chap. 11, this volume.

24. Jacqueline Leavitt and Susan Saegert, *From Abandonment to Hope: Community-Households in Harlem* (New York: Columbia University Press, 1990); Joan Forrester Sprague, *More than Housing: Lifeboats for Women and Children* (Boston: Butterworth, 1991).

25. Roberta M. Feldman and Susan Stall, "The Politics of Space Appropriation: A Case Study of Women's Struggles for Homeplace in Chicago Public Housing," in Irwin Altman and Arza Churchman, eds., *Women and the Environment* (New York: Plenum, 1994), pp. 167–99. See chap. 10, this volume, for additional references.

26. Leslie Kanes Weisman, *Discrimination by Design: A Feminist Critique of the Man-Made Environment* (Urbana: University of Illinois Press, 1992). See also Marion Roberts's historical analysis of how housing design is inflected by gender in her *Living in a Man-Made World: Gender Assumptions in Modern Housing Design* (London and New York: Routledge, 1991).

27. Joan Ockman, "Mirror Images: Technology, Consumption, and the Representation of Gender in American Architecture since World War II," in Agrest, Conway, and Weisman, *Sex of Architecture*, pp. 191–210.

28. Zeynep Çelik, "Gendered Spaces in Colonial Algiers," ibid., pp. 127–40.

29. See esp. chaps. 5, 10, and 12.

30. Integrating theory and practice has long been a hallmark of feminist scholarship. See Peggy McIntosh's five phases of feminist research and curriculum transformation: "Interactive Phases of Curricular Re-vision," in Bonnie Spanier, Alexander Bloom, and Darlene Boroviak, eds., *Toward a Balanced Curriculum,* (Cambridge, Mass.: Schenkman, 1984), pp. 25–34.

31. Susana Torre, "The Pyramid and the Labyrinth," in Torre, *Women in American Architecture,* pp. 198–202; quotations pp. 198, 199.

32. Margrit Kennedy, "Seven Hypotheses on Female and Male Principles in Architecture," *Heresies* special issue 11 (1981): 12–13. (The quotation from the editors is on p. 2.) Pauline Fowler has challenged the male bias in Kenneth Frampton's calling for architecture and building to be devoted exclusively to the public realm and the realm of art, excluding social interests, which are private; "Shaking the Foundations: Feminist Analysis in the World of Architecture," *Fuse* 7:5 (1984):199–204.

33. Karen A. Franck, "A Feminist Approach to Architecture: Acknowledging Women's Ways of Knowing," in Berkeley and McQuaid, *Architecture,* pp. 201–16.

34. Weisman, *Discrimination by Design,* esp. chaps. 1 and 2; quotation p. 16.

35. Jennifer Bloomer, guest ed., "Architecture and the Feminine: Mop-Up Work," *ANY* 1:4 (1994): 54–55 quoted. Another journal to devote a special issue to gender was the *Journal of Architectural and Planning Research* 8:2 (1991). See especially Ruth Madigan and Moira Munro, "Gender, House, and 'Home': Social Meanings and Domestic Architecture in Britain," pp. 116–32.

36. Grosz's views are developed at length in her 1995 book, *Space, Time, and Perversion* (New York and London: Routledge), especially in part 2, "Space, Time, and Bodies," pp. 83–140.

37. Both Bergren and Agrest have published important theoretical approaches to the status of the feminine in architecture. For Bergren, see her "Architecture Gender Philosophy," in John Whiteman, Jeffrey Kipnis, and Richard Burdett, eds., *Strategies in Architectural Thinking* (Cambridge, Mass.: MIT Press, 1992). Agrest's essays are collected in Diana I. Agrest, *Architecture from Without: Theoretical Framings for a Critical Practice* (Cambridge, Mass.: MIT Press, 1991). Especially of interest here is the final essay, originally conceived in 1971 and developed in 1986–87, "Architecture from Without: Body, Logic, and Sex," pp. 173–193.

38. Beatriz Colomina, ed., *Sexuality and Space* (New York: Princeton Architectural Press, 1992); Wigley quotation p. 382. This volume grew out of a symposium held at Princeton University in March of 1990. Another important and related conference was held the following spring at Princeton, this one entitled "Architecture: In Fashion" and organized by Paulette Singley and Deborah Fausch. It has also

Joan Rothschild and
Victoria Rosner

yielded a provocative anthology: Deborah Fausch et al., *Architecture: In Fashion* (New York: Princeton Architectural Press, 1994). In the same year that *Sexuality and Space* appeared, Daphne Spain published her *Gendered Spaces* (Chapel Hill: University of North Carolina Press, 1992), which combined an architectural approach with a sociological one. Her cross-cultural method looks at a broad range of culturally and historically specific situations in which the organization of space contributes to the stratification of gender.

39. Debra Coleman, Elizabeth Danze, and Carol Henderson, eds., *Architecture and Feminism* (New York: Princeton Architectural Press, 1996). Several of these collections, plus others published since 1992, cited elsewhere in this review essay, and including important feminist works on geography, were reviewed in a special book review section, "Gender and Design," of *Harvard Design Magazine* (Winter/Spring 1997): 70–85. Among the 1996 collections was one that looked at the male body's relationship to architectural form: Joel Sanders, ed., *Stud: Architectures of Masculinity* (New York: Princeton Architectural Press, 1996). Also published the same year was a British collection: Duncan McCorquodale, Katerina Rüedi, and Sarah Wigglesworth, eds., *Desiring Practices: Architecture, Gender and the Interdisciplinary* (London: Black Dog Publishing, 1996).

40. Agrest, Conway, and Weisman, *Sex of Architecture*, p. 11.

41. Cited n. 12 above; quotation p. 94, emphasis in original.

42. Jane Jacobs, *The Death and Life of Great American Cities* (New York: Vintage, 1961); quotations in this paragraph are from p. 14.

43. "Women and the American City," *Signs: Journal of Women in Culture and Society* 5:3 Supplement (Spring 1980).

44. Gerda R. Wekerle, "Women in the Urban Environment," ibid., pp. S188–214; quotation p. S188. Wekerle notes that while men's relationship to the urban environment has been extensively studied, women's up to this point had not.

45. The essay's appendix on pp. S213–14 is especially valuable for providing a guide to pertinent review essays, books, urban and women's journals, articles, bibliographies, organizations, and networks in what Wekerle characterizes as the still "scattered literature in this rapidly growing field" (p. S189).

46. Susan Saegert, "Masculine Cities and Feminine Suburbs: Polarized Ideas, Contradictory Realities," *Signs: Journal of Women in Culture and Society* 5:3 Supplement (Spring 1980): S93–108.

47. Susan Saegert, "The Androgynous City: From Critique to Practice," *Sociological Focus* 18:2 (April 1, 1985): 161–76.

48. Dolores Hayden, "What Would a Non-Sexist City Be Like? Speculations on Housing, Urban Design, and Human Work," *Signs: Journal of Women in Culture and Society* 5:3 Supplement (Spring 1980): S170–87; quotation p. S171.

49. Dolores Hayden, *Seven American Utopias: The Architecture of Communitarian Socialism, 1790–1975* (Cambridge, Mass.: MIT Press, 1976); *The Grand Domestic Revolution: A History of Feminist Designs*

in American Homes, Neighborhoods, and Cities (Cambridge, Mass.: MIT Press, 1981).

50. Dolores Hayden, *Redesigning the American Dream: The Future of Housing, Work, and Family Life* (New York: Norton, 1984).

51. Dolores Hayden, *The Power of Place: Urban Landscapes as Public History* (Cambridge, Mass.: MIT Press, 1995). See also chap. 3, this volume.

52. Esther da Costa Meyer, "La Donna è Mobile: Agoraphobia, Women, and Urban Space," in Agrest, Conway, and Weisman, *Sex of Architecture,* pp. 141–56. Also see Anthony Vidler's exploration of this subject in his "Bodies in Space/Subjects in the City: Psychopathologies of Modern Urbanism," *differences* 5:3 (1993): 31–51, excerpted from his forthcoming book, *Psychopathologies of Modern Space.* Vidler reads Ayn Rand's *The Fountainhead* (1943) and Virginia Woolf's *Mrs. Dalloway* (1925) for their representations of women's agoraphobic or claustrophobic attitude toward modernity, despite modernist architecture's claims to universality and openness.

53. Elizabeth Wilson, *The Sphinx in the City: Urban Life, the Control of Disorder, and Women* (Berkeley and Oxford: University of California Press, 1991).

54. Jacqueline Leavitt, "Feminist Advocacy Planning in the 1980s," in Barry Checkoway, ed., *Strategic Perspectives in Planning Practice* (Lexington, Mass.: Lexington Books, 1986); Suzanne Mackenzie, "Building Women, Building Cities: Toward Gender Sensitive Theory in Environmental Disciplines," in Carolyn Andrew and Beth Moore Milroy, eds., *Life Spaces: Gender, Household, Employment* (Vancouver: University of British Columbia Press, 1988).

55. Clara Greed, *Women and Planning: Creating Gendered Realities* (London and New York: Routledge, 1994). This work also contains an extensive and partially annotated bibliography on women and the built environment (198–234). *Women and Planning* is in many ways a sequel to Greed's earlier work, *Surveying Sisters: Women in a Traditional Male Profession* (London and New York: Routledge, 1991). Other texts to consult on feminism and planning include Jo Little, *Gender, Planning and the Policy Process* (London: Pergamon, 1994) and publications by the Women's Design Service, 52–54 Featherstone Street, London EC1. See, for example, *Making a Place for Women: A Resource Handbook on Women and the Built Environment,* cited n. 22 above.

56. Gerda Wekerle and Carolyn Whitzman, *Safe Cities: Guidelines for Planning, Design, and Management* (New York: Van Nostrand Reinhold, 1995); quotation p. 154.

57. Barbara Hooper, "'Split at the Roots': A Critique of the Philosophical and Political Sources of Modern Planning Doctrine," *Frontiers* 13:1 (1992): 45–80; quotations p. 50.

58. Rosalyn Deutsche, "Boys Town," *Environment and Planning D: Society and Space* 9 (1991): 5–30; quotation p. 7. Mary McLeod explores the hypocrisy of postmodernism's language of liberation, which can conceal its ongoing exclusivity. She critiques architects who have

relied on Michel Foucault's theory of "heterotopia," or "other" spaces, arguing that their deconstructivist practices of "formal subversion and negation" paradoxically continue to focus on a "white Western male cultural elite" and to omit any discussion of, for instance, women's actual social situation. A shorter version of this argument appears in Agrest, Conway, and Weisman, *Sex of Architecture* ("'Other' Spaces and 'Others,'" pp. 15–28); a longer version in Coleman, Danze, and Henderson, *Architecture and Feminism* ("Everyday and 'Other' Spaces," pp. 1–37). Also see Liz Bondi and Mona Domosh, "Other Figures in Other Landscapes: On Feminism, Postmodernism, and Geography," *Environment and Planning D: Society and Space* 10 (1992): 199–213.

59. Leonie Sandercock and Ann Forsyth, *Gender: A New Agenda for Planning Theory* (Berkeley, Calif.: Institute of Urban and Regional Development, 1990). In addition, Aaron Betsky's *Building Sex: Men, Women, Architecture, and the Construction of Sexuality* (New York: William Morrow, 1995) opens by discussing (somewhat reductively) how the layout of the Champs-Elysées in Paris "represents the body of a man" (p. xi).

60. Sue Hendler, "Feminist Planning Ethics," *Journal of Planning Literature* 9:2 (1994): 115–27.

61. Beth Moore Milroy, "Values, Subjectivity, Sex," in Huw Thomas, ed., *Values and Planning* (Aldershot, U.K.: Avebury, 1994), pp. 140–61.

62. Marsha Ritzdorf, "Family Values, Municipal Zoning, and African American Family Life," in June Manning, ed., *Urban Planning and the African American Community: In the Shadows* (Thousand Oaks, Calif.: Sage, 1997), pp. 75–89. See also Ahrentzen on single-parent households, cited n. 21 above.

63. Shirley Ardener, "Ground Rules and Social Maps: An Introduction," in Ardener, ed., *Women and Space* (London: Croom Helm, 1981).

64. Linda McDowell and Joanne P. Sharpe, eds., *Space, Gender, Knowledge: Feminist Readings* (London: Arnold, 1997).

65. Doreen Massey, *Space, Place, and Gender* (Minneapolis: University of Minnesota Press, 1994).

66. The Massey and Rose books were discussed in the review of recent books on gender and design in *Harvard Design Magazine* and were reviewed by Dolores Hayden in *Signs* in 1997. "Gender and Design," *Harvard Design Magazine,* cited n. 39, 76–77 (Massey), 82–84 (Rose); *Signs* 22:2 (Winter 1997): 456–58.

67. Nancy Duncan, ed. *BodySpace: Destabilizing Geographies of Gender and Sexuality* (London and New York: Routledge, 1996). Also see David Bell and Gill Valentine, eds. *Mapping Desire* (London and New York: Routledge, 1995). Geography has a feminist journal, *Gender, Place, and Culture* edited by Liz Bondi, Lynn A. Staehli, and Gill Valentine, that began publication in 1994.

68. Rosa Ainley, ed., *New Frontiers of Space, Bodies, and Gender* (London and New York: Routledge, 1998).

69. Cheryl Buckley, "Made in Patriarchy: Towards a Feminist Analysis of Women and Design," *Design Issues* 3:2 (Fall 1986): 251–62.

70. See chap. 8.

71. Jill Seddon and Suzette Worden, eds., *Women Designing: Redefining Design in Britain between the Wars* (Brighton: University of Brighton Press, 1994), p. 9.

72. As noted in the introduction to Judy Attfield and Pat Kirkham, eds., *A View from the Interior: Women and Design* (London: Women's Press, 1989, rev. 1995).

73. Judy Attfield, "Feminist Designs on Design History," *Feminist Art News* 2:3 (1985): 21–23; Attfield, "Invisible Touch . . . What Design History Can Gain from a Feminist Perspective," *Times Higher Education Supplement,* June 19, 1987; Attfield and Tag Gronberg, eds., *Women Working in Design: A Resource Book* (London: London Institute, 1986); G. Elinor et al., *Women and Craft* (London: Virago, 1987).

74. Cited n. 72 above. Also see Cheryl Buckley, *Potters and Paintresses: Women Designers in the Pottery Industry, 1870–1955* (London: Women's Press, 1990).

75. Textiles are an important area for women's work in design; see also Sigrid Wortmann Weltge, *Women's Work: Textile Art from the Bauhaus* (San Francisco: Chronicle Books, 1993).

76. Judy Attfield and Pat Kirkham, "Introduction," in Pat Kirkham, ed., *The Gendered Object* (Manchester and New York: Manchester University Press, 1996), p. 1.

77. Jennifer Craik, *The Face of Fashion: Cultural Studies in Fashion* (London and New York: Routledge, 1994). The critical literature on fashion is extensive and growing; see, for example, among recent works, Roszika Parker, ed., *The Subversive Stitch: Embroidery and the Making of the Feminine* (London: Women's Press, 1984); Juliet Ash and Elizabeth Wilson, eds., *Chic Thrills: A Fashion Reader* (London: Pandora, 1992); Deborah Fausch et al., eds., *Architecture: In Fashion* (New York: Princeton Architectural Press, 1994); Shari Benstock and Suzanne Ferriss, eds., *On Fashion* (New Brunswick, N.J.: Rutgers University Press, 1994). See also chap. 8, this volume.

78. While not engaged specifically with design or designers, contributors to *The Material Culture of Gender/The Gender of Material Culture,* ed. Katherine Martinez and Kenneth L. Ames (Winterthur, Del.: Winterthur, 1997) explore the gender of everyday objects, as well as how gendered objects help to produce gendered bodies, both today and in earlier periods of American life. As Michael S. Kimmel writes in his introduction, "Gender is a process—negotiated and interactive . . . and inscribed in the artifacts of material life" (p. 2).

79. Erika Doering, Rachel Switzky, and Rebecca Welz, *Goddess in the Details: Product Design by Women* (New York: Association of Women Industrial Designers, 1994).

80. Women make up only about 10 percent of the membership of the Industrial Designers Society of America (IDSA).

81. Ruth Schwartz Cowan, "The 'Industrial Revolution' in the Home: Household Technology and Social Change in the Twentieth Century," *Technology and Culture* 17 : 1 (January 1976): 1–23.

82. Ruth Schwartz Cowan, *More Work for Mother: The Ironies of Household Technology from the Open Hearth to the Microwave* (New York: Basic Books, 1983).

83. Joan Rothschild, ed., *Machina ex Dea: Feminist Perspectives on Technology* (New York: Teachers College Press, 1992; New York and Oxford: Pergamon, 1983); Martha Moore Trescott, ed., *Dynamos and Virgins Revisited: Women and Technological Change in History* (Metuchen, N.J.: Scarecrow, 1979); Judy Wajcman, *Feminism Confronts Technology* (University Park: Pennsylvania State University Press, 1991). For inventors, see esp. articles by Stanley and Trescott in Rothschild and by Trescott and Deborah Warner in Trescott. See also Helen Deiss Irvin, "The Machine in Utopia: Shaker Women and Technology," in Joan Rothschild, ed., *Women, Technology, and Innovation* (Oxford and New York: Pergamon, 1982): 313–19.

84. Autumn Stanley, *Mothers and Daughters of Invention* (Metuchen, N.J.: Scarecrow, 1995; New Brunswick, N.J.: Rutgers University Press, 1997).

85. Cynthia Cockburn and Susan Ormrod, *Gender and Technology in the Making* (London and Thousand Oaks, Calif.: Sage, 1993).

86. Cynthia Cockburn and Ruža Fürst-Dilić, eds., *Bringing Technology Home: Gender and Technology in a Changing Europe* (Buckingham, U.K.: Open University Press, 1994); Danielle Chabaud-Rychter, "Women Users in the Design Process of a Food Robot: Innovation in a French Domestic Appliance Company," ibid., pp. 77–93.

87. Ellen Lupton and J. Abbott Miller, *The Bathroom, the Kitchen, and the Aesthetics of Waste: A Process of Elimination* (New York: Kiosk, 1992). This book was prepared in conjunction with an exhibition of the same name held at MIT List Visual Arts Center in Cambridge, Mass. in 1992.

88. Liz McQuiston, *Women in Design: A Contemporary View* (London: Trefoil; New York: Rizzoli, 1988).

89. Liz McQuiston, *Suffragettes to She-Devils: Women's Liberation and Beyond* (London and New York: Phaidon, 1997). See also Karrie Jacobs and Steven Heller, *Angry Graphics: Protest Posters of the Reagan/Bush Era* (Salt Lake City: Peregrine Smith, 1992).

In the mid-1970s, when manifestations of male domination in American society were under attack as part of a large and diverse social movement against all forms of social injustice, feminist scholars and policymakers turned their attention to the limitations of women in traditional urban settings. One reason for this focus was that women's increased access to education and their large numbers in the work force altered the separation of male and female roles, challenging the segregation of public and private worlds exemplified by low-density suburban communities. Pioneering studies showed the relationship of housing and community design to economic opportunity and sociability for women.[1] Researchers found that the spatial organization of the suburbs benefited men and encumbered women, who were left isolated not only from the urban activities enjoyed by their commuting husbands but even from one another. But while cities offered greater opportunities for everybody—including shorter travel to work and increased family use of public and cultural facilities—the growth of the suburbs seemed an irreversible trend.[2] Scholars, architects, and community activists therefore promoted the idea that American suburbs should become more like cities, that is, denser and more urbanized, providing better access to public transportation and placing services and amenities within walking distance of homes.[3]

Changes in zoning were seen as a priority in this effort because zoning was (and is) being used to exclude innovative uses of space to respond to the needs of working women. Examples include the sharing of homes by single parents of different families, working for pay in the home, and the presence in the neighborhood of convenience stores and child care centers. Advocates of the poor urged women to join the challenges to restrictive zoning, which had the effect of limiting cooperative housing, battered women shelters, and other facilities to marginal neighborhoods, where there were higher crime, poorer schools, less public transportation, and fewer amenities.[4]

In the decades since, designers have introduced a multitude of initiatives to transform the suburb, including mixed-use zoning to create neighborhoods with decentralized public services and many new housing types. No initiative has been more visible or

Expanding the Urban Design Agenda: A Critique of the New Urbanism

Susana Torre

influential than the New Urbanism, whose annual congress seeks to become the broadest possible umbrella to effect urban change in America.

Although the terms "New Urbanism," "neo-traditional planning," and "Traditional Neighborhood Development (TND)" may refer to works in a variety of urban settings—from infill structures to the replanning of obsolete shopping malls—the most influential of New Urbanist projects have been new residential communities built beyond the edge of metropolitan areas and initiated by commercial developers.

The guiding ideas of the movement were laid out in the so-called Ahwanee Principles, which envision an urban pattern that is decentralized and where residential developments are small and dense enough so "that housing, jobs, daily needs and other activities are within easy walking distance of each other." The community should also have a "center focus that combines commercial, civic, cultural and recreational uses." Streets should be designed to slow down cars; bicycle paths and convenient public transportation stops would increase pedestrian movement. Each community or cluster of communities should be protected from development in perpetuity by "well defined edges such as agricultural greenbelts or wildlife corridors." As for the communities' social composition, "a diversity of housing types [would] enable citizens from a wide range of income levels and age groups to live within its boundaries."[5]

The population of built TNDs was estimated in 1996 at two thousand people.[6] But New Urbanist planning principles are becoming very influential, through both their adoption by national and local planning organizations and their diffusion through distorted applications by developers anxious to profit from a new trend.

Celebration versus HOMES: Contrasting Partial Visions

Although Seaside, Florida, was the first example of a new paradigm for urban and suburban design, what will likely be remembered as the most accomplished example of a TND is Celebration Village, a neighborhood within the Disney-owned development of Celebration, Florida.[7]

Celebration Village comprises many key features of the New Urbanist planning credo: school, recreation, and convenience shopping (in an upscale supermarket catering to exotic tastes) are within a short walk of homes. The single-family houses have considerable variety, in terms of both visual appearance and price range.[8] Lots, regardless of house size, are small, resulting in higher densities and more shared open space than is typical in the suburbs. The Disney

Corporation also provided rental apartments, and many houses feature very small studios for live-in help above the garages. Also in conformity with New Urbanist principles, Celebration Village is within walking distance of Celebration Place, an office park—although Village and Place are not connected by sidewalks.

Celebration Village and the adjoining neighborhoods of West Village and Lake Evalyn occupy over 900 acres, with 342 lots for single-family homes in five sizes, called Estate, Village, Cottage, Garden, and Townhome in the promotional literature.[9] Two- and three-story apartment buildings line Celebration Village's four-block-long axis between the Golf Clubhouse and the Downtown. This axis comprises a narrow lineal park with the state-required drainage channel picturesquely landscaped with flowers and grasses and lined with benches. The residential districts on both sides of the axis have a mixture of four of the five lot types, from "estate" to attached townhouses.[10] Houses in the same price range face each other and share alleys with houses in the next lower price range. Each district includes its own diminutive park, filled with play equipment or ornamental plantings. The Downtown area comprises approximately nine acres and includes parking lots for shoppers surrounded by apartments. Downtown's block-long Main Street is a continuation of the axis (minus drainage channel), extending it from the Golf Clubhouse to an artificial lake surrounded by a promenade and a jogging trail. Though houses are the only structures in Celebration that can be built by independent contractors, Disney provides the plans and details and does not allow owners to alter the look of their homes. In addition to the lake, the extensive infrastructure includes an eighteen-hole golf course and a Disney-sponsored School Academy where teachers can be updated on teaching methods and technologies. The public school operates in a building provided by Disney.[11]

Celebration's safety for children, enforced through low speed limits on the gently curving streets and constant supervision by security cars, is advertised through the corporation's logo—a girl on a bicycle, followed by her dog, next to a protective tree and a picket fence. Celebration Village is reached from the strip by a long, winding road, which progressively narrows until the slow crossing of a steep bridge and a glimpse of imposing homes and tasteful landscaping indicate arrival.

Celebration, then, does address some of the concerns raised by feminist critiques of the suburb, specifically the creation of a safe environment for children where homes are close to work and within walking distance of convenience stores and amenities. But it does so in the context of a rigid, controlled social machine of the type satirized in the movie *The Truman Show*—which may be satisfying

to most of Celebration's current inhabitants but can hardly be taken as a model for the long term or on a wide scale in a nation founded on the right to cranky individualism.

To understand what concerns regarding the options for working women and their families remain unadressed by TNDs, we turn to Dolores Hayden's blueprint for a feminist-influenced neighborhood design, presented in 1980, just before the public emergence of New Urbanism. Hayden's plan assumed as radical a remodeling of the suburb as the New Urbanists propose, but on very different premises. She envisioned an "experiment in meeting employed women's needs" that would "maximize their personal choices about child rearing and sociability."[12] The experiment, requiring proximity to an urban area, would be initiated by homemakers' organizations, formed by men and women; hence the project's acronym, HOMES (Homemakers Organization for a More Egalitarian Society). Hayden's blueprint encompassed a program and a proposal for physical design. She described a hypothetical HOMES group made up of forty households representing the actual composition of American households in 1980: 15 percent single parents and their children, 40 percent two-worker couples and their children, 35 percent one-worker couples and their children, and 10 percent single residents. The total population would consist of sixty-nine adults and sixty-four children.

A HOMES community would combine collective installations with private dwellings and outdoor spaces. The shared activities and spaces would include a day care center; a laundromat; a kitchen supplying take-out meals, meals for the elderly, and lunches for the day care center; a food cooperative with grocery; a garage with two vans for distribution of meals and transportation; garden allotments for the growing of food; and a home help office. All services would be run like businesses available to customers in addition to the members of the community. Most important in her scheme was her calculation that the collective activities would generate at least thirty-seven jobs for the residents.

Hayden considered the remodeling of the existing suburb to be a higher priority than the construction of new residential developments. To effect this transformation, she proposed the replacement of single homes' front lawns without sidewalks with building additions to obtain multiple units. Ancillary structures such as porches, garages, and tool sheds would be converted to community facilities, and the center of the block would be turned into a shared parklike open space.[13] By "turning the block inside out" and pooling land, the duplication of amenities and equipment characteristic of suburban communities could be avoided: there would be no need to have six inflatable swimming pools, ten garden sheds, and thirteen

lawn mowers belonging to individual houses on a block when one of each of the appropriate size and type should suffice.

Race and Class: Two Repressed Issues

Disparate as they are, these two communities—one actual, the other imagined—share some important strengths and weaknesses. The ideas informing both plans emerged from academic environments rather than marketing studies or social surveys and thus reflect more the ideology and value systems of their creators than the expressed desires of the potential end-users—which are more likely to be more complicated and contradictory. Both plans were conceived as complete entities and proffered as alternatives to suburban sprawl. And both proposals ignore the political complexity that is embedded in real urban communities, especially the intractable difficulty of integrating uneducated, poor, and mostly African American or Hispanic households within or in close proximity to predominantly white middle-class neighborhoods. Exclusive residential single-family zoning is eschewed in favor of neighborhoods that integrate basic services and shopping within walking distance of homes. In both cases, a shared, public environment is made an integral part of the community, although in very different ways.

And here the similarities cease. Celebration Village—like other TNDs—is a private, for-profit development based on single-family homes standing on private lots as its predominant residential type. Home ownership in Celebration Village requires well above the median annual household income.[14] Since its diminutive "downtown" district is not directly connected to a major commercial thoroughfare, the economic feasibility of shops can only be assured by a sizable development. The exceedingly high degree of control that Celebration residents must accept in their physical environment is seen as a self-selecting condition. The HOMES neighborhood, instead, was conceived as a cooperative undertaking initiated by a nonprofit developer such as a tenant cooperative organization, a union, or a church. It assumed cooperative ownership and use of the land in conjunction with private ownership of the homes and private yards. It required the involvement of residents as managers of the collective services; it included employment within the residential cluster; and the projected level of services could be implemented with forty households, 12 percent of the number in Celebration Village. Although not explicitly stated, the look of such a neighborhood would be influenced by negotiation among residents. And unlike TNDs, HOMES was envisioned as a remodeling of existing suburban and urban housing stock, requiring change in zoning.

Celebration Village represents the high end of a consumer-based model for the production of domestic life, available for purchase in the form of cleaning services, domestic servants, nannies and au pairs, and ready-to-eat well-balanced foods. The HOMES neighborhood represents a model based on cooperative management of services accessible to families of modest resources and on the creation of jobs in close proximity to homes.

Challenge of a New Feminist Urbanism

The comparison of Celebration Village and the HOMES neighborhood highlights an ongoing dilemma for women: their continued responsibility for the production and maintenance of domestic life.[15] Much has been made of the increased participation of men in the production of the domestic environment, but women continue to be the primary, if not exclusive, caretakers of the home. Food preparation and child care, two traditionally female concerns, have been increasingly taken over by large-scale industries as women become integrated into the labor force and do not have the time to be personally involved in them. Outside of large cities, working families have limited choices, and when convenience at a low price is a major issue, they become captive consumers to the national food chains and their inferior food products, resulting in unbalanced diets and obesity.

Traditional Neighborhood Developments are available to a tiny minority. The majority of working women and their families are still left to devise their own, usually inadequate, solutions to the production of their domestic environments, including child and elder care, cleaning and food preparation, the integration of personal life with work, and time spent driving. This dilemma is particularly difficult for women isolated in poor neighborhoods without adequate public transportation to reach desirable jobs.

During the past twenty years, the most visible efforts toward economic and racial integration in residential communities across the country have been infill development of affordable housing in middle-class neighborhoods and the rebuilding of decayed parts of cities by inserting a suburban residential pattern. Nonprofit housing providers made great advances in breaking down the resistance of middle-class residential districts to having subsidized housing in their midst. The small scale of developments, and designs for multifamily housing that emulated the look, scale, and materials of large single-family residences, have been credited with increased acceptance. This approach to incremental integration has proven more effective than large-scale projects. In some states that require the provision of affordable housing as a percentage of a market resi-

dential development, developers have been allowed to avoid the integration presumed in this requirement by transferring the affordable homes to other communities.

The introduction of suburban patterns to rebuild decayed urban fabric has received mixed reviews, and there is no conclusive evidence that suburbanites have chosen to move to these neighborhoods; in Detroit, for example, where this pattern has been tried, the extreme racial and class segregation between the black city and its white suburbs is, in effect, reproduced on a smaller scale within the city boundaries. It is not surprising, then, that these developments are separated from surrounding neighborhoods by a high fence and a gate. These neighborhoods appear to attract safety-minded people already living in the city. Although their scale is similar to that proposed for the HOMES neighborhood, the gated suburban pattern used does little to provide the kinds of choices and proximity to services envisioned in that model.

In 1980, Dolores Hayden's thought experiment raised issues that the New Urbanists have so far managed to avoid. If the New Urbanism is to become truly urban, larger problems and more diverse populations will need to be addressed. Other replicable urban patterns must be created to counterbalance the vision of encapsulated communities that epitomize New Urbanist designs. These patterns should provide solutions to the problem of how to design good edges and points of contact, so that adjacencies between different kinds of communities can happen without walls, gates, or greenbelts.[16]

Where radical thinking of urban design is most urgently needed is throughout our cities, seen in their specific regional contexts. The necessary allies of a truly new urbanism will be community organizations and coalitions, nonprofit developers, politicians, and agencies rather than commercial developers.

Notes

1. See Gerda Wekerle, "Women in the Urban Environment," *Signs: Journal of Women in Culture and Society* 5:3 Supplement (Spring 1980): S188–214.
2. Robert Fishman has argued that the suburbs' growth has resulted in a new kind of city, which he calls "technoburb," where "both work and residence [are contained] within a single decentralized environment" and the single-family house is "a convenient base from which both spouses can rapidly reach their jobs." See Robert Fishman, *Bourgeois Utopias* (New York: Basic Books, 1989).
3. See Wekerle, "Women in the Urban Environment," for relevant bibliography on this subject.

4. See Karen Hapgood and Judith Getzels, eds., *Women, Planning, and Change* (Chicago: American Society of Planning Officials, 1974).

5. For analysis of New Urbanist planning principles, see Heidi Landecker, "Is New Urbanism Good for America?" *Architecture* (April 1996) and William Fulton, *The New Urbanism: Hope or Hype for American Communities?* (Cambridge, Mass.: Lincoln Institute of Land Policy, 1996).

6. See Fulton, *New Urbanism*, p. 3.

7. The town of Celebration, Florida, consists of several neighborhoods. Celebration Village is the only one where different lot types are combined. Adjoining and satellite neighborhoods are based on older suburban layouts, including neighborhoods segregated by lot type and, in North Village, an enclave of stately homes on lanes ending in cul-de-sacs.

8. Home buyers can select from a range of nineteenth-century–inspired architectural styles, such as Colonial or Victorian, that are approved by Disney for the different lot types.

9. I have based my calculations on the area encompassed in Celebration Realty's "Site Plan. Celebration Village, West Village, Lake Evalyn," 1995 (Walt Disney Company). Fulton, *New Urbanism,* states that the entire town of Celebration will comprise 4,900 acres and eight thousand residential units.

10. The lot type not included, called "Garden," is for small cottages of the type found in early American suburbs. This suggests, ironically, that the neighborhood of Garden Cottages is a kind of suburb of Celebration Village.

11. Regarding a controversy focused on Celebration's public school, see Michael Pollan, "Disney Discovers Real Life," *The New York Times Magazine,* December 14, 1997.

12. Dolores Hayden, "What Would a Non-Sexist City Be Like?" *Signs: Journal of Women in Culture and Society* 5:3 Supplement (Spring 1980): S170–87.

13. Hayden acknowledges her debt to Henry Wright and Clarence Stein's plan for Radburn, New Jersey. Regarding services, Wekerle, "Women in the Urban Environment," describes a proposal by Nona Glazer, Linda Majka, Joan Acker, and Christine Bose for federally funded neighborhood service houses; Wekerle found it significant that the community was held responsible for supporting people in their daily functioning, not just emergencies.

14. According to the March 1996 "Current Population Survey" of the U.S. Bureau of the Census, the 1995 median income of all households in the United States was $34,076; for all white, non-Hispanic households, $37,178; for black households, $22,393.

15. For a current perspective, see Elizabeth McGuire, "Still Seeking a Perfect Balance," *New York Times,* op-ed, August 11, 1998.

16. For a challenge to New Urbanism regarding regional scale and context, see Armando Carbonell, Harry Dodson, and Robert Yaro,

"Expanding the Ahwanee Principles for the New Regionalism," a 1995 self-published statement. Harvey Gantt, an architect and former mayor of Charlotte, North Carolina, also issued a challenge in his plenary speech to the 1998 Congress for New Urbanism: to address the survival of neighborhoods in the city, where poorer, nonwhite populations are concentrated.

Layered with the traces of previous generations' struggles to find their livelihoods, raise children, and participate in community life, the vernacular urban landscape, as John Brinckerhoff Jackson has written, "is the image of our common humanity—hard work, stubborn hope, and mutual forbearance striving to be love," a definition that carries cultural geography and architecture straight toward urban social history.[1] At the intersection of these fields lies the history of urban space and its public meanings. How do urban landscapes hold public memory? And why should feminists and scholars of women's history struggle to create projects honoring and preserving women's history as part of public culture?

Every American city and town contains traces of historic landscapes intertwined with its current spatial configuration. These parts of older landscapes can be preserved and interpreted to strengthen people's understanding of how a city has developed over time. But often what happens is something else. Cycles of development and redevelopment occur. Care is not taken to preserve the spatial history of ordinary working people and their everyday lives. Instead funds are often lavished on the preservation of a few architectural monuments along with the celebration of a few men as "city fathers." (For example, in New York City, many buildings designed by the architects McKim, Mead, and White at the turn of the century are closely identified with an Anglo-Saxon Protestant male elite who commissioned the private men's clubs, mansions, banks, and other structures from which many citizens were often excluded.) In contrast, modest urban buildings that represent the social and economic struggles of the majority of ordinary citizens—especially women and members of diverse ethnic communities—have often been overlooked as possible resources for historic preservation. The power of place to nurture social memory—to encompass shared time in the form of shared territory—remains largely untapped for most working people's neighborhoods in most American cities, and for most ethnic history, and most women's history. If we hear little of city mothers, the sense of civic identity that shared women's history can convey is lost. And even bitter experiences and fights women have lost need to be remembered—so as not to diminish their importance.

Claiming Women's History in the Urban Landscape:
Projects from Los Angeles

Dolores Hayden

To reverse the neglect of physical resources that are important to women's history is not a simple process, especially if preservationists are to frame these issues as part of a broader social history encompassing gender, race, and class. First, it involves claiming the entire urban landscape as an important part of American history, not just its architectural monuments. Second, it means identifying the building types—such as tenement, market, factory, packing shed, union hall—that have housed women's work and everyday lives. Third, it involves finding creative ways to interpret these modest buildings as part of the flow of contemporary city life. This means finding a politically conscious approach to urban preservation—complementary to architectural preservation—that emphasizes public processes to nurture shared memories and meanings. It also means reconsidering strategies for the representation of women's history and ethnic history in public places, as well as for the preservation of places themselves.

Early in the 1980s, when I was teaching at the Graduate School of Architecture and Urban Planning at UCLA, I founded The Power of Place as a small, experimental nonprofit corporation, to explore ways to present the public history of workers, women, and people of color in Los Angeles. It began as an unpaid effort with a few student as interns; I also had a full-time teaching job. Los Angeles is an ethnically diverse city. It always has been, since the day when a group of colonists of mixed Spanish, African, and Native American heritage arrived to found the pueblo in 1781, next to the Gabrieleño settlement of Yang-Na. It has remained so through the transfer of Los Angeles from Mexican to U.S. rule in the mid-nineteenth century and on into the late twentieth. Residents—more than one-third Latino, one-eighth African American, one-eighth Asian American, one-half women—cannot find their heritage adequately represented by existing cultural historic landmarks. (In 1985, 97.5 percent of all official city landmarks commemorated Anglo history and only 2.5 percent represented people of color; 96 percent dealt with men and only 4 percent with women, including Anglo women.)[2] No one has yet written a definitive social history of Los Angeles. By the early 1980s, however, older works by Carey McWilliams and Robert Fogelson were being complemented by new narratives about ghettos, barrios, and ethnic enclaves, as Albert Camarillo, Mario Garcia, Vicki Ruiz, Richard Griswold del Castillo, Ricardo Romo, Rodolfo Acuna, Lonnie Bunch, Don and Nadine Hata, Mike Murase, Noritaka Yagasaki, and many others were creating accounts of Latinos, African Americans, Chinese Americans, and Japanese Americans in L.A.[3] The new work suggested the outline the urban history of Los Angeles must one day fill. As a feminist scholar concerned with the history

of the urban landscape, an academic transplanted from New England to Los Angeles, I was excited by the new, ethnic urban history. It enabled me to broaden my teaching in a professional school whose students were concerned with the physical design of the city, with preservation, physical planning, public art, and urban design. (I was looking for ways to enable students to take something back to their own communities.)

One of the first projects of The Power of Place in 1984–1985 was a walking tour of downtown Los Angeles (coauthored with then UCLA graduate students Gail Dubrow and Carolyn Flynn).[4] Organized around the economic development of the city, the tour looked at some of the working landscapes various industries had shaped over the previous two centuries (fig. 3.1). It highlighted the city's history of production, defining its core and emphasizing the skill and energy workers have expended to feed, clothe, and house the population. These workers included women, men, and sometimes children of every ethnic group employed in citrus groves, flower fields, flower markets, produce markets, oil fields, and prefabricated housing factories, as well as garment workers, midwives, nurses, and fire fighters. The State of California's ongoing research on ethnic landmarks, eventually published as *Five Views,* was then available in manuscript form.[5] The Power of Place ran some public humanities workshops on topics such as Japanese Americans in the flower industry and African American fire fighters. The published walking tour pamphlet finally identified an itinerary of nine major downtown places (and twenty-seven minor ones): some were buildings eligible for landmark status because of their significant social history, some were buildings with architectural landmark status needing reinterpretation to emphasize their importance to social history, and a few were vacant historic sites where no structures remained but where new public art or open-space designs might be possible to commemorate the site's importance.

In 1986, The Power of Place launched into work of a much more experimental kind—combining public history and public art to commemorate an African American midwife's homestead with no historic structure remaining. The site was one of downtown's endless parking lots. At that time, the Los Angeles Community Redevelopment Agency (CRA) was developing a plan for a ten-story commercial and garage building at 333 Spring Street. Because the material in the walking tour had been listed in CRA's computer, the address popped out as Biddy Mason's historic homestead. The Power of Place was invited to propose a component for this new project involving both public history and public art. I served as project director and historian and raised money from arts and humanities foundations. The team included public art curator Donna

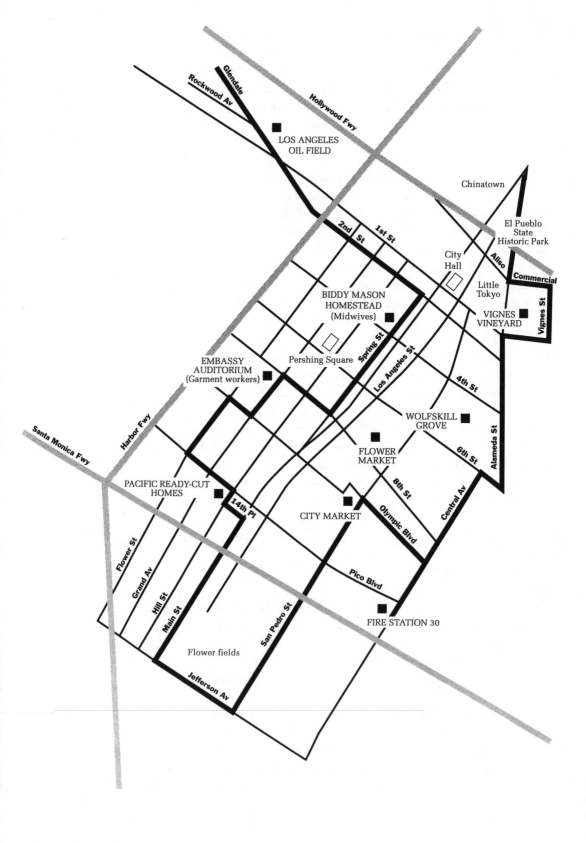

Graves and artists Susan E. King, Betye Saar, and Sheila Levrant de Bretteville. The first public event was a workshop in 1987, co-sponsored by the African American studies program at UCLA and assisted by the California Afro-American Museum and the First African Methodist Episcopal Church (FAME). The team came together with community members to discuss the importance of the history of the African American community in Los Angeles, and women's history within it.

Using Biddy Mason's biography as the basis of the project was the key to finding a broad audience. One pioneer's life cannot tell the whole story of building a city. Yet the record of a single citizen's struggle to raise a family, earn a living, and contribute to professional, social, and religious activities can suggest how a city develops over time. This is especially true for Biddy Mason. Her experiences as a citizen of Los Angeles were typical—as a family head, home owner, and churchgoer. Yet they were also unusual—since gender, race, and legal status as a slave increased her burdens.

Born in 1818, Biddy Mason was the lifelong slave of a master from Mississippi.[6] She had trekked west with his family and other slaves, including her three daughters, herding his livestock behind a Mormon wagon train, first to Deseret (Salt Lake City, Utah) and then to the Mormon outpost of San Bernadino, California. They arrived in Southern California in 1851. Biddy Mason brought suit for freedom for herself and thirteen others in court in Los Angeles in 1855. When she won her case and chose to settle in the small town of Los Angeles in 1856 as part of the very small African American community there, her special medical skills, learned as a slave midwife and nurse, provided entry for her into many households. She became the city's most famous midwife, delivering hundreds of babies. She lived and worked in the city until her death in January 1891.

The Biddy Mason Project focused on the changing experience of being African American in Los Angeles, the problems of earning a living as a free woman of color in the city, and the nature of home as one woman created it. Although Mason at first lived with another family, then rented on her own, the homestead she built in Los Angeles in the 1880s, a quarter century after her arrival, was a surprisingly urban place, a brick commercial building with space for her grandsons' business enterprises on the ground floor and for her own quarters upstairs, where the early organizational meetings of the local branch of the First African Methodist Episcopal Church were held.

A working woman of color is the ideal subject for a public history project because in her life all the struggles associated with class,

Fig. 3.1. The Power of Place, itinerary of historic places in downtown Los Angeles

ethnicity, and gender are intertwined. Although she herself was unable to read and write, the history of Biddy Mason was not lost. Through Mormon records of colonization, I was able to trace her journey west. Through the account of her suit for freedom in the local newspaper, I followed the legal proceedings. Some diaries and a photograph from the family her daughter married into provided personal details. Then, using work in the history of medicine concerning other African American midwives and women healers, I constructed an account of what a successful midwife's medical practice was probably like. (A few years later, Laurel Ulrich's *A Midwife's Tale,* a marvelous book about a Maine midwife's diary, confirmed the social importance of women's medical work.) Finally, using detailed records of the built environment, I was able to unlock the narrative of how Biddy Mason created her urban homestead. The records of her property happened to be particularly significant since the growth of the Spring Street commercial district in Los Angeles between 1866, when she bought her land, and 1891, when she died, proceeded right down her street and included her property. Thus her life story spans the wider themes of slavery and freedom, family life in pioneer times, women in the healing professions, and economic development in Los Angeles between the 1850s and 1890s.

The Biddy Mason project eventually included five parts. First, Betye Saar's installation, *Biddy Mason's House of the Open Hand,* was placed in the elevator lobby of the new structure. It includes a photomural, motifs from vernacular architecture of the 1880s, and an assemblage on Mason's life. Second, Susan King created a large-format artist's letterpress book, *HOME/stead,* in an edition of thirty-five.[7] King incorporated rubbings from the Evergreen Cemetery in Boyle Heights, where Mason is buried. These included vines, leaves, and an image of the gate of heaven. The book weaves together the history of Mason's life (drawing on my research and some by Donna Graves) with King's meditations on the homestead becoming a ten-story building. Third, an inexpensive poster, *Grandma Mason's Place: A Midwife's Homestead,* was designed by Sheila de Bretteville. The historical text I wrote for the poster included midwives' architectural rituals for welcoming a newborn, such as painting the shutters of a house blue or turning a door around on its hinges. Fourth, *Biddy Mason: Time and Place,* a black poured-concrete wall (eighty-one feet long) with slate, limestone, and granite inset panels, was designed by Sheila de Bretteville to chronicle the story of Biddy Mason and her life, as well as the history of urban development in Los Angeles from 1818 to 1891 (fig. 3.2). The wall includes a midwife's bag, scissors, and spools of thread debossed into the concrete. De Bretteville also included a

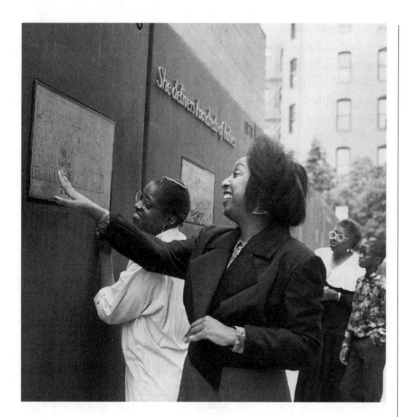

picket fence, agave leaves, and wagon wheels representing Mason's walk to freedom from Mississippi to California. Both the deed to her homestead and her "Freedom Papers" are among the historic documents photographed and bonded to limestone panels. Fifth, the project included prose in a journal. My article "Biddy Mason's Los Angeles, 1856–1891" appeared in the Fall 1989 *California History.*

Everyone who gets involved in a public history or public art project hopes for an audience beyond the classroom or the museum. The poster was widely distributed. The wall by Sheila de Bretteville has been especially successful in evoking the community spirit of claiming the place. Youngsters run their hands along the wagon wheels. Teenagers trace the shape of Los Angeles on historic maps and decipher the old-fashioned handwriting on the Freedom Papers. People of all ages ask their friends to pose for snapshots in front of their favorite parts of the wall. Since the project opened in late 1989, we who worked together on this project have had the satisfaction of seeing it become a new public place, one that connects individual women with family history, community history, and the city's urban landscape, developing over time.

The next project that The Power of Place sponsored involved the Embassy Theater as a site of union organizing and community

Claiming Women's History in the Urban Landscape

organizing among Latina workers in the 1930s. This project was directed by Donna Graves while I remained as president of the organization. It suggests some ways an existing architectural landmark can be reinterpreted in terms of its importance to women's history, labor history, and ethnic history. Designated a Los Angeles Cultural-Historic Landmark (as part of a real estate deal) for its indifferent neoclassical architecture designed by Fitzhugh, Krucker, and Deckbar in 1914, the Embassy Theater is far more important as the historic gathering place for labor unions and community organizations—including Russian Jewish and Latina garment workers, Latina cannery workers, and Russian Molokan walnut shellers. Unions, especially women's unions, met inside and marched outside the Embassy between the 1920s and the 1940s, as did El Congreso (the Spanish Speaking People's Congress), the first national Latino civil rights organization.[8] By the 1990s it had become a residential college for the University of Southern California (USC).

The Embassy in its heyday was frequented by many of that era's most colorful organizers, including Rose Pesotta of the ILGWU (International Ladies' Garment Workers Union), who led the 1933 dressmakers' strike, Luisa Moreno of UCAPAWA (United Cannery, Agricultural, Packing, and Allied Workers Association), and Josefina Fierro de Bright of El Congreso. All three reached Los Angeles after epic journeys of the same proportions as Biddy Mason's—from Russia for Pesotta, Guatemala for Moreno, and Mexico for Fierro de Bright. All three experienced the height of their careers in Los Angeles, recruiting thousands of Spanish-speaking women into their organizations—but it must be added that their work was so controversial and disturbing that Pesotta resigned as ILGWU vice president and Moreno and Fierro left for Mexico during the red-baiting years.

Graves's project highlighted these three organizers. Artist Rupert Garcia created a poster with their portraits to advertise a public humanities workshop, "La Fuerza de Union," held in the historic main auditorium in the spring of 1991. Participants included two artists, Garcia and Celia Alvarez Munoz, a restoration architect, Brenda Levin, and historians George Sanchez and Albert Camarillo (Moreno's biographer), as well as union leaders, students, and retirees. (Historian Vicki Ruiz, whose wonderful book *Cannery Women, Cannery Lives* had first drawn attention to Moreno, also worked on the team briefly.)

Following the workshop, Celia Alvarez Munoz created an artist's book, *If Walls Could Speak,* which intertwined public and private story lines in English and Spanish, beginning: "If walls could speak,

these walls would tell/ in sounds of human voices, music, and machines/ of the early tremors of the City of Angels." On the same three pages, she wrote: "As a young child, I learned my mother had two families./ One with my grandmother, my aunt, and I./ The other at la fabrica, the factory." The endpapers were union logos, and so was the conclusion. A typical spread included historic images of Rose Pesotta with her arm around a worker, and another worker stitching a banner reading, "Win the war," or Josefina Fierro organizing for El Congreso, and workers with linked arms. The small artist's book was distributed free to several thousand people, including union members, retirees, and students.[9]

At the same time, architect Brenda Levin proposed the recreation of two traditional showcases in front of the Embassy Theater to carry history text, as well as sculptural representations of the workers' sewing machines, spools, and hammers, while union logos were to be pressed into a new concrete sidewalk. In a storefront adjoining the sidewalk, the faculty hoped to open the Luisa Moreno Reading Room for students interested in social history. It was a disappointment to us all that although the permanent art was fully funded, plans by the owner, USC, to sell the building prevented installation. Then the January 1994 earthquake hit the building so hard it had to be evacuated, so perhaps another site for a permanent commemoration is preferable.

Today many of us who worked together in L.A. continue activities in other cities, but some subsequent projects in Los Angeles go on too. In Little Tokyo, a UCLA student working with me and The Power of Place, Susan Sztaray, helped to plan a project for a public art sidewalk wrapping the First Street National Register Historic District. Sztaray wanted to recall the scale of small, traditional Japanese American businesses flourishing there before the forced relocation during World War II of all Japanese Americans on the West Coast. The Los Angeles Community Redevelopment Agency took up Sztaray's plan and ran a public art competition. Working as an independent artist, Sheila de Bretteville, who designed the Biddy Mason wall, won the commission along with artists Sonya Ishii and Nobuho Nagasawa. Construction has recently concluded. Los Angeles will then have three cultural heritage projects—one African American, one Latina, one Japanese American—in three very different kinds of settings, ranging from a lost homestead to a reinterpreted theater building to a National Register Historic District, that demonstrate some of the new ways artists can work with preservationists and historians on parts of the public landscape.

The projects discussed here are all located in the area of our 1984 walking tour, close to the center of downtown Los Angeles,

set near the high-rise buildings of the Bunker Hill redevelopment area. They have challenged the idea that only massive commercial development can provide a downtown with an identity. The Power of Place presented an alternative account of the process of building a city, emphasizing the importance of people of diverse backgrounds and work—both paid work and work in family life—to urban survival. In a city where half the residents are women and more than 60 percent are people of color, these small projects struck a responsive chord.

The projects straddled several worlds: academic urban history and public history, urban planning, public art, preservation, and urban design. Every project had a multiethnic, multidisciplinary team. Teamwork is difficult, especially across disciplines. But there are rewards. First, public space has a resonance for local history no other medium can match. Second, locking women's history into the design of the city exploits a relatively inexpensive medium. Over time the exposure can be as great as a film's or an exhibit's. Third, as projects like Biddy Mason and Embassy show, when you have one significant public place, there is less pressure to divide history into academic categories (such as women, ethnic, or labor) that often trivialize and marginalize urban stories. For the university there are also benefits. A fieldwork program like The Power of Place connected students to urban history and at the same time gave them the chance to work as interns on local projects with diverse organizations as cosponsors.

For the city itself there are also rewards. Putting working people's history into downtown expands the potential audience for all urban preservation and public art. The recognition of important cultural heritage in diverse working people's neighborhoods can support other kinds of community organizing—including neighborhood economic development and planning for affordable housing. Teachers can bring classes to the sites to launch educational projects on women's history. Last, but not least, public space dedicated to women's history and ethnic history, especially to projects focused on working women of color, claims political territory in tangible ways. Women can meet in these historic places and work together on new issues, with the collective knowledge of earlier struggles. And this fosters a public realm where, at last, we as women are free to be ourselves and to see ourselves as strong and wise people, because we have represented ourselves that way.

Across the country today, I see many successful preservation projects focusing on women's history, such as the Seneca Falls Women's Rights National Historical Park. At the same time, promoting ethnic diversity in preservation has become a goal many

organizations, including the National Trust for Historic Preservation, share, so projects involving African American, Asian American, and Latina/Latino history are receiving higher funding and visibility. Artists, too, are working on many more public projects exploring spatial history. The 1990s offer many opportunities for reclaiming women's history and ethnic history in the urban landscape. Today there are hundreds of architects, landscape architects, and artists, as well as historians and preservationists, who enjoy these challenges. Finding the stories of diverse working women and inscribing them in public space is one small part of creating a public, political culture that can carry the American city into the next century.

Notes

An earlier version of this essay appeared in the *Journal of Urban History,* August 1994. A full account of the work is Dolores Hayden, *The Power of Place: Urban Landscapes as Public History* (Cambridge, Mass.: MIT Press, 1995).

1. John Brinckerhoff Jackson, *Discovering the Vernacular Landscape* (New Haven: Yale University Press, 1984), p. xii.

2. Gail Dubrow made this count.

3. A pioneering work with a multiethnic approach is Carey McWilliams, *Southern California: An Island on the Land* (Salt Lake City: Peregrine Smith, 1983). This is a classic from the 1940s. Other recent overall treatments include Robert M. Fogelson, *The Fragmented Metropolis: Los Angeles, 1850–1930* (Cambridge, Mass.: Harvard University Press, 1967); Scott L. Bottles, *Los Angeles and the Automobile: The Making of the Modern City* (Berkeley: University of California Press, 1987); and Mike Davis, *City of Quartz: Excavating the Future in Los Angeles* (New York: Verso, 1990). For a few examples of ethnic studies: Rudolfo Acuna, *A Community under Siege: A Chronicle of Chicanos East of the Los Angeles River, 1945–1975* (Los Angeles: UCLA Chicano Studies Center, 1980); Richard Griswold del Castillo, *The Los Angeles Barrio, 1850–1890: A Social History* (Berkeley: University of California Press, 1979); Ricardo Romo, *East Los Angeles: History of a Barrio* (Austin: University of Texas Press, 1983); Lonnie G. Bunch III, *Black Angelenos* (Los Angeles: California African-American Museum, 1989); and Noritaka Yagasaki, "Ethnic Cooperativism and Immigrant Agriculture: A Study of Japanese Floriculture and Truck Farming in California," Ph.D. diss., Department of Geography, University of California, Berkeley, 1982.

4. Dolores Hayden, Gail Dubrow, and Carolyn Flynn, *Los Angeles: The Power of Place* (Los Angeles: Power of Place, 1985).

5. State of California, Department of Parks and Recreation, *Five*

Views: An Ethnic Sites Survey for California (Sacramento: Department of Parks and Recreation, 1988).

6. Dolores Hayden, "Biddy Mason's Los Angeles, 1856–1891," *California History* 68 (Fall 1989): 86–99, carries the full documentation.

7. Susan E. King, *HOME/stead* (Los Angeles: Paradise, 1987).

8. Mario Garcia, *Mexican Americans* (New Haven: Yale University Press, 1989).

9. Celia Alvarez Munoz, *If Walls Could Speak/Si Las Paredes Hablaran* (Arlington, Tex.: Enlightenment Press, 1991).

Each day on the street we are confronted with a bombardment of messages. They constitute a communications space in which numerous voices vie for our attention, whether by renting advertising space or by claiming blank walls and construction fences to launch an "informal" visual assault. The mix of signs on the street shows how graphic design is mobilized by competing social interests—civic, corporate, commercial, activist, and underground.

The world of symbols, typography, and imagery is a visual language in which most members of contemporary society are literate, recognizing and investing various icons and styles with meaning. Typography, the design of letterforms for reproduction and the organization of letters in space and time, appears in nearly all forms of graphic communication, from street flyers to electronic billboards. Designers use the distinctive character of a typeface to convey subtle or even subliminal messages that may be authoritative, insurgent, tactful, or aggressive.

Sometimes a letterform becomes an icon, a symbol that stands for an idea or an issue. Consider the letter *X,* a character with roots more ancient than the alphabet; its crossing diagonal bars can mark a spot, condemn a property, or locate a signature. In 1992, Spike Lee and graphic designer Art Sims used the letter *X* not only in the title of the film *Malcolm X* but also as the iconic symbol for the black power movement. Past and present meanings of the symbol are simultaneously recognized by the monumental mark embossed onto posters, hats, and T-shirts, so as to transform an everyday item into a symbol of personal and communal struggle. No longer a phonetic bead in a string of alphabetic characters, *X* became a sign in its own right, signifying its own cultural meaning.

Lee and Sims also drew on an established system of corporate identifiers in order to invest the letter *X* with a new level of potency. Logos and brand names constitute a kind of *second alphabet* that parallels the primary phonetic one. Although reading involves a process of recognizing individual letters and assigning phonetic values to them, literacy necessitates using and categorizing separate characters into whole units of language. A literate person has the ability to identify letterforms through internalizing the alphabet to such a degree that it operates like a transparent internal software

Graphic Design in the Urban Landscape

Ellen Lupton

Fig. 4.1. Time Warner eye/ear symbol, designed by Steff Geissbuhler, Chermayeff & Geismar Associates, 1990

for the communicating brain, a code whose physical form remains in the background of conscious use.

Contemporary consumer society has internalized a "second alphabet" of logos and symbols. We have assimilated a vast series of images into our visual vocabularies to the degree that recognizing them has become as automatic and as spontaneous as knowing our ABC's. Children too young to read often learn to recognize logos by grasping their distinctive colors and configurations. During the course of a lifetime, a person will learn to recognize hundreds of logos, brands, and images, associating a company or product not only with a name but with a particular typeface, color, or pictorial device.

Since the explosion of consumerism in the late nineteenth century, companies have used trademarks and brand images to build national recognition for hundreds of products. The logo became a stamp of familiarity in a world where shopkeepers were no longer advocates of the goods they sold but were merely mediators in the corporate production and promotion of goods. Symbols like the Betty Crocker spoon, designed by Lippincott & Margulies, represented the modernization of corporate identity in the 1950s when professional design consultants created a legion of simple, cleanly designed marks that eschewed elaborate decoration and detailed illustration. Such marks, which aspired to achieve the familiarity of the alphabet itself, often constituted a company's most valuable commodity: its identity. Cake recipes could change from generation to generation, but the Betty Crocker name, emblazoned by her bright red spoon, would remain virtually unchanged.

Expressing the identity of corporations, products, and ideas is the primary function of graphic design. The term "corporate identity" is known in the trade to be the fictionalized "personality" of an organization conveyed through the use of symbols, colors, typography, and other design elements. Corporate identity design reached its maturity in the 1950s, and it continues to be a lucrative business area for graphic designers.

The corporate identity for CBS was initiated in 1951 by William Golden; the unblinking stare of Golden's eye logo remains riveting today, even as the trinity of networks lose their monopolistic grip on the field. More recent designs in this field include Steff Geissbuhler's evocative eye-ear symbol, created as a trademark for Time Warner in 1990 (fig. 4.1).

The visual expression of "identity" is not limited to vast organizations such as CBS. The language of graphic design is accessible to people and groups across the social spectrum. The staring eye created by Bethany Johns and Marlene McCarty for the Women's

Ellen Lupton

Fig. 4.2. Poster, "WAC Is Watching" for WAC (Women's Action Coalition), designed by Marlene McCarty, published by WAC, 1992

Action Coalition (WAC) in 1992 converts the staring cyclops eye of CBS into a symbol for the political act of observation (fig. 4.2). WAC, founded in New York City in response to the Clarence Thomas/Anita Hill congressional hearings, staged a series of public demonstrations that combined performance art techniques with media-savvy graphics. For these demonstrations, known as Actions, held in cities such as New York, Washington, and Houston, Johns and McCarty designed strong, direct graphics—with witty slogans and simple, bold photographs clipped from news and advertising sources—that amplified the group's image and inspired participation (fig. 4.3). The WAC logo appeared on posters and buttons, becoming a branding device for the events and ideas of the group.

The design strategy adopted by WAC grew out of the success of the AIDS activist design collective Gran Fury, founded in the late 1980s. Marlene McCarty was the only female member of Gran Fury, and she kept women's issues firmly on the group's agenda (fig. 4.4). ACT UP and Gran Fury deliberately used the visual language of mass media to get their messages across. They chose not to adopt a crude "alternative" look but directly tapped into the authoritative aura of the official media. They used familiar commercial

Graphic Design
in the Urban Landscape

Fig. 4.3. Poster, "I'm with Her,"
designed by Bethany Johns,
published by WAC, 1992

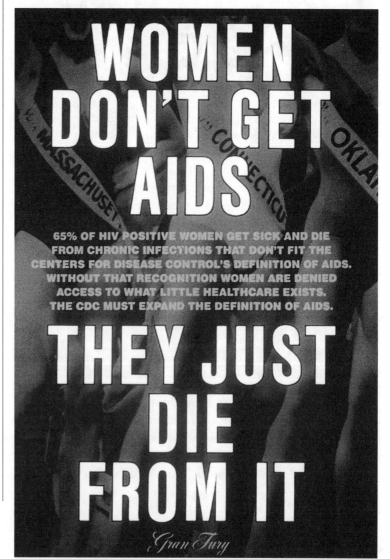

Ellen Lupton

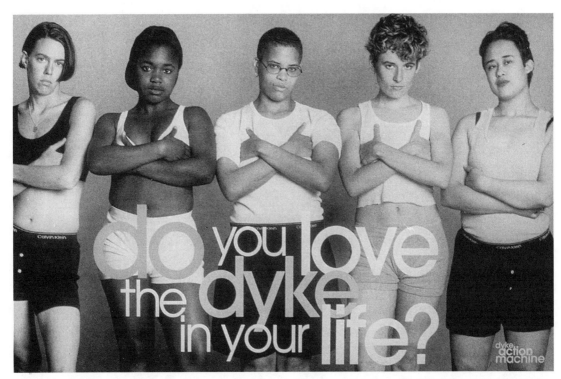

Fig. 4.5. Poster, "Do You Love the
Dyke in Your Life?" designed and
published by Carrie Moyers and
Sue Schaffner, DAM Dyke Action
Machine, 1993

languages in order to publicize urgent personal issues such as
health, privacy, and civil rights, fundamental issues they perceived
to have come under attack as a result of the AIDS crisis and the
government's refusal to acknowledge the disease and provide sup-
port for the care of its victims and money for drug research.

The idea of reclaiming and revising the privately owned but pub-
licly experienced landscape of advertising and corporate identity
has been adopted by various subgroups and organizations. Dyke
Action Machine created posters in the early 1990s that parodied
mainstream advertising campaigns, hijacking everything from Cal-
vin Klein's sexy underwear promotions to *Family Circle*'s claim to
represent the "new families" of the 1990s (fig. 4.5). SisterSerpents
in Chicago is another collective of feminist artists and designers
whose work included the appropriation of the public language of
the media (fig. 4.6). The artist Tom McGlynn has produced paint-
ings, T-shirts, and street posters that take familiar corporate logos
and "edit" them into new marks: for example, he trimmed down the
logotype for Mobil, with its distinctive red *o*, so that it would read
"Mob." McGlynn gave the corporate mark a sinister new message
while allowing it to retain its unmistakable visual origins.

Several urban youth cultures, including skateboarders, rock
bands, and rave promoters, have sought to hijack this "second

Graphic Design
in the Urban Landscape

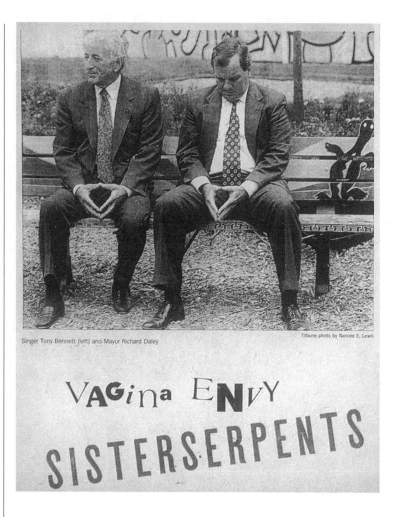

alphabet" of corporate identity over the last decade, by simply re-making national brand images. They have managed to reroute the powerful familiarity of mass-cultural commodities, whose code has become as familiar as CBS's (fig. 4.7). The mixture of pleasure and irony in these product appropriations can be seen in the entrepreneurial efforts of organizations like Poot, a clothing company run by designer Keva Marie, who specializes in skateboard clothing for girls (fig. 4.8).

The standards of professional corporate identity design that were established by the 1970s promoted the consistent, omniscient use of symbols, colors, and typography. Retreats from this approach in the late seventies reflected a growing dissatisfaction with modernism as a monolithic system, as evidenced in the feminist, postmodern, and multicultural movements of the era. In 1979, the California graphic designer April Greiman created an identity program for the boutique Vertigo that consists of a changing series of

Fig. 4.7. Logos for the band
Lotion, designed by band member
Tony Zajkowski

Fig. 4.8. Crappy Panties clothing
tag, designed by Keva Marie

Fig. 4.9. Identity program for Vertigo clothing store, designed by April Greiman, 1979

Fig. 4.10. Identity program designed by and for Modern Dog

logos (fig. 4.9). More recently, the Seattle-based studio Modern Dog created an identity for itself that consisted not only of one recognizable logo but also of a flexible "deck of cards" governed by a shared family appearance (fig. 4.10). Such open-ended approaches to identity design are part of a loosening of the rigid values of the profession and a broadening of its participants and audiences.

Graphic designers traffic in the realm of the commonplace. They draw on familiar symbols, from the letters of the alphabet to the hieroglyphs of commercial trademarks, to make new symbols invested with the familiarity of the old. A corporate logo becomes the private property of a corporation, protected by trademarks and a system of laws and restrictions on their use. Yet because of its presence within the public sphere, the corporate logo is part of a communications space where it participates in the cultural dialogue of personal experience. From global corporations to political activists and underground rock bands, groups and individuals seek to gain literacy in the language of modern media, by learning to write as well as to read the codes and symbols of this visual language. Proliferating, changing, adapting the symbols and icons of graphic design, their mixed messages transform the public sphere and our experiences of the urban landscape.

Notes

This essay was researched and written in conjunction with the exhibition "Mixing Messages: Graphic Design in Contemporary Culture," organized by Cooper-Hewitt National Design Museum, Smithsonian Institution, 1996, curated by Ellen Lupton.

The past three decades have brought about remarkable new ideas for combining home and work, ideas conceived by women who have been forced to rethink the use of their private space in economic terms. These changes may have transformed the traditional concept of the work landscape forever, for both women and men. But more important, they have demonstrated that women, and in particular poor women, have much to gain from redefining the domestic realm as economic space, and therefore from new ways to design the space that is called home.

Home spaces have special meanings for women. Not only is the home an anchor against life's uncertainties; it is also often the only space a woman can control sufficiently to use for the self-generated activities on which the survival of her family depends. For many women, and particularly for the poorest ones, the home is and will remain the primary source of economic empowerment. Because a home entitles women to the basic support society can offer, it can be seen as a social investment. Moreover, when a home makes a place for women in the production system, it can also be seen as an economic investment. From a woman's perspective, then, the right to a home is the right to define her environment and thereby all the policies that affect the quality of her life, from land use decisions to design standards.

Home and Work: Myth and Reality

A critical opening question is whether the home should be the place of choice for women's nondomestic work. Western culture fosters the belief that most women become part of society's "productive forces" by stealing time away from their domestic responsibilities and by stealing space from the domestic environment. Thus the notion of "the corner of the kitchen table": that mythical place where, by force rather than by choice, novels have been written, design competitions have been won, scientific problems have been resolved, while at the same time children's homework is supervised, socks are mended, and meals are prepared (fig. 5.1). The advent of the computer and of electronic communication has made

Outgrowing the Corner of the Kitchen Table

Ghislaine Hermanuz

Fig. 5.1. (European Charter for Women in the City)

performing productive work at home even more prevalent and feasible. It raises the questions of whether working at home enhances women's lives; how to allocate space, and maybe even time, for the performance of productive tasks; whether work spaces are better integrated in the home or in its extensions: the neighborhood or the city. In other words, can new forms of urbanism express the role of work as a socializing and empowering tool for women?

An analysis of design proposals focused on the transformation of the dwelling unit, the residential building, and the neighborhood to accommodate work will highlight appropriate forms of work spaces, which address the need for women to be self-sustaining in a post–Jane Jacobs society. An urban polemicist who influenced generations of urban designers and housing providers, Jacobs has made notions such as the visibility of open spaces from the kitchen window, allowing mothers to keep an eye on their children at play while performing domestic tasks, the cornerstones of good communi-

ties.[1] But how many families enjoy a kitchen with a window? How often do apartment layouts allow a view of the playground from the kitchen? How many people live in developments where play spaces are an integral part of the design scheme? How many mothers can actually afford to spend time in their kitchens watching their children at play, when they have to go to work or to school or be otherwise busy with productive tasks? For a woman, to be a full-time homemaker, as was once the norm even in working-class neighborhoods, is now a luxury that only a few can afford. Clearly, instructive design schemes are those that recognize the significant cultural, societal, and economic changes that have stretched the concept of "domestic environment," as synonymous with women's space and kitchen tables, beyond the confines of a singular economic class or, better, beyond the traditional assumptions of the Western cultural system.

Choice and Consequences

Home and work space have not always been separated. The traditional farm of early agricultural societies, the African compound, the medieval workshop in front of its owner's residence—all are familiar examples of the successful integration of home and work. It is the urbanism of the industrial revolution, along with the division of labor it engendered, that has cast in stone the separation of productive and reproductive spaces. In this relatively new framework, home is the exclusive domain of women, while the rest of the city and its opportunities for remunerated work constitute the domain of men. As a sanctuary separate from the work space, home has generated specialized roles for women; there work is essentially domestic work. Indeed, illustrators of spaces for "productive work at home" in trade books—architectural graphic standards, for instance—always choose to depict men in environments labeled as "home-office," while women are only shown using domestic conveniences, such as laundry rooms or sewing corners. This division of labor is the basis of the postwar suburban dream house, where housewives were enticed away from employment opportunities into domestic consumerism.[2] But how many women today still fit that suburban stereotype?

In reality, most of the women who stay at home must use their homes, out of necessity rather than by choice, as a source of economic support. Yet rarely do they have homes spacious enough to allow them to carry out both productive and domestic activities. Those who can afford a private space larger than their domestic situation requires—young professionals, artists, and craftspeople,

for instance—can merge home and work creatively and comfortably. But for the majority of women, this solution is neither affordable nor feasible. In fact, it may not be practical or even desirable, as work has the greatest potential to take women out of domestic isolation and into a larger world which they can make their own. Obviously, a meaningful redefinition of the integration of home and work must go beyond redefining "houses." It must become a way to define inclusive "communities."

Labor, Work, or Action?

In *The Human Condition,* philosopher Hannah Arendt discusses the concept of work, for her the fundamental principle of life. She breaks it down into its three constituting aspects: labor, work, and action. "Labor" is defined as the vital activities necessary to reproduce and maintain life. It is the changing process of survival. "Work" is what provides us with the artificial world of things, as distinct from the world of nature. "Action" pertains to transactions or relationships between men. When these concepts are matched to the types of physical support they require, "home," as the private realm, becomes the place of choice for labor, whereas the "production space," as the place of work, and the "community," as the place for action, form the public realm. In real life, Hannah Arendt adds, the quality of most people's *vita activa* is defined by the integration of these principles. Similarly, our built environment should exhibit various ways of creating integration of and continuity among homes, work spaces, and neighborhoods.[3] Because of women's dual role as nurturers and producers, the ideal conceptualization of a "good" community for them is one where homes, production spaces, and neighborhood are one and the same.

Mixing home and production space, or labor and work, is perhaps the most common combination. It is frequently the foundation of utopian design proposals. Examples abound in all forms of vernacular architecture too. Today, it stands as a response to a new global reality: in a society structurally unable to provide enough jobs for its socially, economically, and politically disenfranchised population, residential space must become again flexible enough to accommodate self-generated economic activities. And since combining the spheres of labor and work is not a new effort, much can be learned from history and the evolution of experiments, particularly those of the recent past, so as to advance a viable formula for the present.

In the late 1700s, the French architect Claude Nicolas Ledoux, in his proposal for the design of the Saltworks of Chaux (1775; Arc-et-Senans, France), used the idea of breaking down barriers be-

tween production and residential realms as a basis for designing the ideal city, a place where space and time relationships were to be forever transformed. In this project, the production spaces form the center of the new city. The workers' residences surrounding them define and contain the public, communal space in between. The design allows for private spaces to develop beyond the outer circle created by the residential blocks (fig. 5.2a). The closeness of all the parts and their easy accessibility generated leisure time for the workers, and therefore the possibility for them to enjoy the cultural and recreational activities provided in the city. The continuity created between work spaces and living spaces allows residents to finally reconcile labor, work, and action, spatially and temporally.

A variation on Ledoux's concept, and perhaps the beginning of the devaluation of his idea, inspired a later development, namely the Familistère of Guise (Guise, France). The Familistère is a company town built as a workers' cooperative by the stove manufacturer Jean-Baptiste Godin between 1859 and 1889 (fig. 5.2b). Here, separation between living and working begins to appear: homes and workplaces are clearly located in different, albeit closely related, sectors of the plan.[4] The shared public space ties these two uses together. Guise's Familistère anticipates the planning model adopted for numerous company towns of the industrial revolution, from Saltaire to Pullman Village, where work spaces and living quarters are completely separate. The legacy of Guise is still visible today in the notion of zoning as a tool to legally codify the separation of commercial, industrial, and residential realms. It has been taken a step further in the proposals of the New Urbanists: towns like Seaside, Florida, or Laguna West, California, reproduce the same separation of uses but also introduce patterns of economic and social segregation, which negate any pretense of inclusiveness.

Yet while company towns proliferated in the late nineteenth century, a different model of occupation of the urban space had appeared in working-class areas of northern Europe. A block pattern called *courée* (from the French *cour*, courtyard) constitutes the basic element of the urban fabric. A *courée* is a block of approximately sixty to one hundred thousand square feet. Work and flexible living spaces are organized around its interior courtyard, while a formal facade rings its outer perimeter with buildings two to four stories in height. Larger structures, including community buildings, stand at the block's corners. In this model, the block is more than just an odd aggregate of buildings or the principle of the city's morphology: it is a microscopic mixed-use community, combining residences, open spaces, work spaces, and public spaces.

A century later, a community-based organization in Roubaix (France) reinvented the *courée* as an alternate model for the

Fig. 5.2. From their central position at the Saltworks (a), work spaces at Guise's Familistère (b) have been moved to a location opposite the workers' residences, although they are still part of an integrated city. (5.2a from C. N. Ledoux, *L'Architecture Considérée sous le Rapport de l'art, des moeurs et de la législation,* 1804; 5.2b from engravings published by Jean-Baptiste Godin in 1870)

renewal of the Alma-Gare neighborhood (1980). Initially designed as a "Towers in the Park" scheme, in the tradition of Le Corbusier's Charter of Athens, the plan was rejected by the community. They organized APU, the Atelier Populaire d'Urbanisme (Popular Urbanism Workshop), to conceive, sponsor, and build a neighborhood where spaces for meeting and working with others are the principles of spatial organization and where workplaces and services define the public realm. Open spaces, APU suggested, can be programmed for their economic potential when play spaces are not the most essential need. APU's concept recognizes work as a socializing element: thus it needs to have a public face, albeit in close relationship with residences and the residents. In fact, the new development borrows from the *courée* not just its form but its very raison d'être. It achieves a modern interpretation of a mixed-used community which revalorizes home and work for the working classes.

APU's proposed design features for the Alma-Gare were particularly critical because a majority of the working-class families scheduled to move into the complex were immigrants from the Maghreb. The semiprivate courtyards forming the interior of the blocks afforded these North African women an opportunity to lead a more independent life in a controlled yet quasi-public setting. The block's design was a key to their freedom of movement, limited as it was, between home and work. The numerous walkways con-

Ghislaine Hermanuz

72

b.

necting residences, work spaces, and public meeting spaces, in the interior of the block, were modern versions of the *moucharabiehs,* the Arabian screens traditionally used to protect women from the public eye. These semiprivate streets-in-the-air were also the formal principles of an architectural composition that owes its modernity to a successful interpretation of the population's sociocultural needs rather than to the use of contemporary stylistic icons.

The Alma-Gare project learned from its precedent, the *courée,* to allow for the evolution of activities within the same space and to manage the occupation of a block's interior by work, commerce, and services without diminishing the quality of public spaces and private dwellings.[5] To the De-Urbanists of suburban living, who have atomized the city in response to the use of electronic communication, and to the New Urbanists, who merely reinterpret and reinforce the segregative precepts of traditional planning, the designers of APU offer Re-Urbanization, a healing form of intervention based on the principle of reconciling workspace and residential space.

Opportunities for Change

The principles of the French *courée* are unlikely to facilitate the creation of socially relevant relationships between residential and work spaces ("labor" and "work") in twenty-first-century America.

But the *courée* is not the only model of successful integration. For example, in the work it participated in, the City College Architectural Center (CCAC), a community design center located at the City College of New York, discovered and explored emerging opportunities to achieve a viable interface and a better fit between home and work for inner-city communities. The strategies outlined here summarize a few of the lessons learned from research and proposals developed at CCAC.

- The simplest of design interventions would be one that does not preclude the integration of workspaces into a residential setting; in other words, one that makes integration possible without imposing it, as in the design of flexible apartments for Frederick Douglass Boulevard in Harlem.

In this first example, a special apartment typology is proposed, in response to the expressed need of moderate-income families to use their homes for income-producing activities.[6] A portion of the living space, Space X, can be sectioned off and made into an extra room. The use of this extra space can change with the economic circumstances of the household. For instance, coupled to a well-designed kitchen, Space X can accommodate a small catering business; a computer terminal might generate a word-processing or a design office; a sewing machine turns it into a dressmaker's workshop (fig. 5.3a).

- Questioning the traditional domestic program, on the other hand, can lead to much more complex design changes, as present building programs reflect the needs of the nuclear family and its characteristic division of labor.

When the collectivization of domestic tasks becomes a programmatic requirement, as in the brief for a facility to house women just released from prison, all the spaces, from the most private bedrooms to semiprivate living rooms, are affected.[7] Here, living spaces are shared by two households. Children's spaces can be easily connected to the communal living room, turning it into a semipublic space which then acts as a mini–day care facility, where one of the mothers can be gainfully employed. Similarly, the cooking spaces spill into the living area, making it usable as a catering enterprise, without interfering with each mother's need to prepare meals for her family in relative privacy (fig. 5.3b).

In another design proposal, the mandate to restructure family relationships leads to an apartment type in which parents redefine

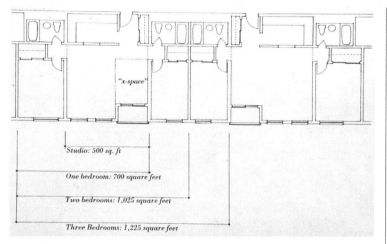

"x-space"

Studio: 500 sq. ft

One bedroom: 700 square feet

Two bedrooms: 1,025 square feet

Three Bedrooms: 1,225 square feet

a.

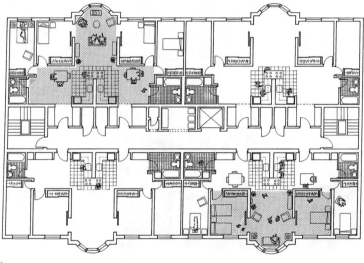

b.

Fig. 5.3. The integration of work spaces within the dwelling itself can happen when a portion of the living room is made into a separate room (a) or when amenities, such as kitchens or living rooms, shared by two households encourage informal economic activities (b). (Courtesy Ghislaine Hermanuz)

their private space as a bed-sitting room, away from the children's bedrooms and the living room.[8] The parents' new domain, the master bedroom, changes in size and in function: it is now the largest space in the apartment; it faces the public street and occupies the building corner. The bedroom has become a multipurpose space where there is room for work, not just recreation.

- The integration of work into the residential realm leads eventually to the creation of new prototypical buildings and a new urban block morphology.

Back-to-back layers of work and residential spaces generate a unique building type.[9] The building itself becomes a seamless

Outgrowing the Corner
of the Kitchen Table

Fig. 5.4. The integration of work spaces within the building can be achieved by creating vertical (a) or horizontal (b) layers of residential and production spaces. New block configurations (c) emerge from these building prototypes. (Courtesy Ghislaine Hermanuz)

a.

Third Floor

Studio Studio

Studio Studio

Second Floor

Workshop

BR BR

LR LR
1-Bedroom Apt. 1-Bedroom Apt

Ground Floor

Workshop

Storage

Workshop or Rentable Space

b.

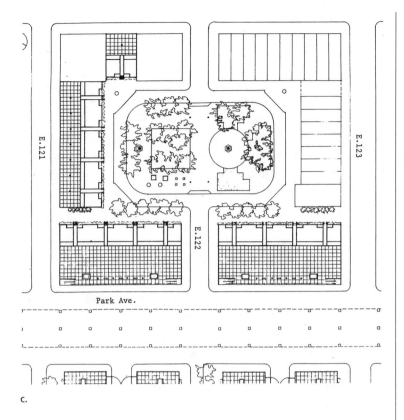

c.

transition, mitigating abrupt land use changes without the need for buffer zones (fig. 5.4a). This building type can be used to create a new superblock morphology: an inner residential facade surrounds a central public square, while formal work-related facades are found along the outer perimeter (fig. 5.4c).

For the infill of small vacant lots in a dense urban fabric, new prototypical rowhouses propose to relate work spaces to the building's street frontage while focusing activities on the private rear courtyard. Here, horizontal rather than vertical layering allows work spaces and residential spaces to coexist in comfort (fig. 5.4b).

An entire building, set in a residential block, can also be devoted to production activities, as a business incubator. The small business incubator represents a new prototype responding to infill conditions, from a physical development standpoint, and, from a socioeconomic perspective, to the need for planting in the neighborhood the seeds of work opportunities. No zoning code allows the insertion of community production spaces into a primarily residential zone, where they clearly belong. Nor would their development generate a bonus for the sponsors.

Sharing the Wealth

Opportunities to achieve a meaningful integration of work and home exist also at the neighborhood scale. As the nexus of people's social and cultural life, neighborhoods offer numerous possibilities to combine economic activities with social interaction. Often hidden in the neighborhood's nooks and crannies, these small spaces hold the potential of transforming the residential space into a community space. Opening work spaces to the public realm rather than hiding them in private homes can create public spaces of greater significance for residents, spaces not just decorative or monumental but which validate the lives of working people. Guise was described by its creator, Jean-Baptiste Godin, as a "social palace" or the equivalent of riches, and so a form of redistribution of wealth. A good neighborhood, too, is a form of sharing the wealth.

In developing urban design guidelines for the Bradhurst neighborhood, a large residential reconstruction project in the northern section of Harlem, CCAC was offered a chance to explore systematically the mixing of production spaces with community spaces, so as to revive the local economic base and re-create the social fabric of an inner city neighborhood.[10] Bradhurst's primary need is for rehabilitation rather than reconstruction, and thus it only offers modest opportunities for inserting new elements into a preexisting landscape. The challenge was to demonstrate that by searching for ways to introduce places of work in the residential fabric, one could radically transform old settings, not just rehabilitate them. Furthermore, linking such spaces into a network reinforced the principles of change and created a new sense of place.

Various prototypical strategies were explored:

- The backyards of apartment buildings are made into the forecourts of basement-level work spaces, thereby turning leftover spaces into prime amenities.

Adjacent backyards slightly below street level are aggregated to create a sizable shared communal space, which in turn becomes the focus of basement-level work spaces. These work spaces, available to the building's residents, can also be directly connected to apartments above. If so, they might qualify for an "artist housing" classification, which would make it possible for their rehabilitation to be funded under current guidelines for subsidizing residential redevelopment. Here, integrating production spaces into the residential realm becomes a financial strategy for the production of workplaces, allowing government subsidies to be applied to the cre-

ation of work spaces for which no direct, public subsidies could otherwise be found.

- A clear articulation of residential spaces and work spaces at ground level generates the new formal vocabulary of an active street.

As opposed to commercial spaces, which must reach out to customers, workshops for community productive activities can be set back from the street and the building line. Here, a five-foot setback is proposed, carving an arcade out of the ground floor of contiguous tenement buildings. The arcade recess gives privacy to these ground-level work spaces and differentiates them from the residential entrances, which, on the other hand, reach out to the street. The added privacy of the work spaces allows more flexibility for their use. Design attention can be extended to the patterning of the sidewalk, which can be shaped to accommodate deliveries as well as garbage pickups in a way that does not create conflicts between the residents' needs and the constraints of work (fig. 5.5a, b).

- Where partial demolition makes the interior of a block visible and accessible, a small parking lot located therein can become the service focus of ground-level work spaces opening onto this interior court.

When replacing a building missing from the block perimeter is not possible, there is an opportunity to reverse traditional relationships of private and public spaces by making of the block interior a small parking lot giving access to ground-level work spaces. Alternately, if a portion of the unbuilt space in the block perimeter is made into a small park, the ground level of structures adjacent to the park can be used as community service space, such as a small day care center or a senior citizens' workshop. Thus the center of the block, usually a passive area, has been turned into an active mixed-use space (fig. 5.5c).

- Unbuilt or underutilized spaces, related to the circulation system are also opportunities for economic activities.

Circulation-related spaces represent up to 40 percent of the available, unbuilt land of a neighborhood. Often this land is not all necessary to support circulation activities. Under a viaduct at 155th Street, a green market is proposed. The location is very accessible by car and subway but also on foot, as it is adjacent to

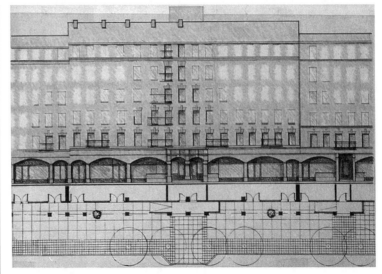

a.

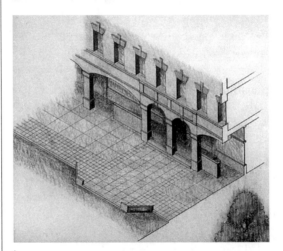

b.

one of New York's largest public housing developments: the Polo
Grounds Towers. The viaduct provides a natural protection for the
market activities. The green market can also easily connect, eco-
nomically and physically, to the layer of industrial buildings that
faces one side of the street, and therefore it can be conceived as an
outlet for products that would be manufactured there (fig. 5.6a).

• Strategically located small community business incubators can
 become the public focus of a residential neighborhood and gen-
 erate its new public spaces.

As the kitchen and its table were the heart of the dwelling unit,
so can workshops and business incubators located off public open

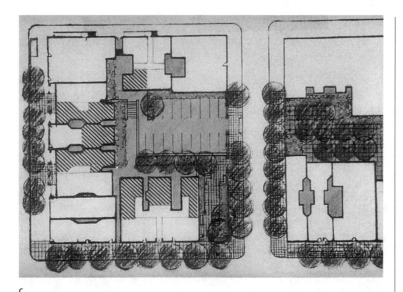

c.

spaces become the hearts of residential neighborhoods, thus making the insertion of workplaces the principal element for re-creating the sense of community and of place (fig. 5.6b).

The continuity of the urban fabric sought for the Bradhurst neighborhood in these proposals is not just stylistic: it stems from the mix of uses that the culture and the local resources of the community can support. The neighborhood becomes the place where living and working are articulated. The same attention should extend to less formal types of work and work opportunities. For instance, sidewalk edges can be redesigned to allow vending points along a street. A hydrant transformed into a water fountain can add quality and hygiene to the catering services of a hot-dog stand. Wrought-iron fences concealing vacant lots or protecting small playground areas can be the temporary display window a street vendor needs. Turning a vacant lot into a productive community garden can be the beginning of a successful summer green-market project.

The globalization of the economy has created new potential for informal economic activities. These activities, whether household-based or neighborhood-based, can become fundamental contributions to economic development, and thus to the transformation of neighborhoods.

Building the Communities of Civil Society

Women have traditionally been the driving force behind neighborhood development and transformation in both industrialized and less developed countries. Obviously, they will be the primary beneficiary of this interspersing of many small work spaces

Fig. 5.6. Found space under a viaduct (a) or a small vacant site off an intersection (b) can become the location for markets or business incubators, respectively. (Courtesy Ghislaine Hermanuz)

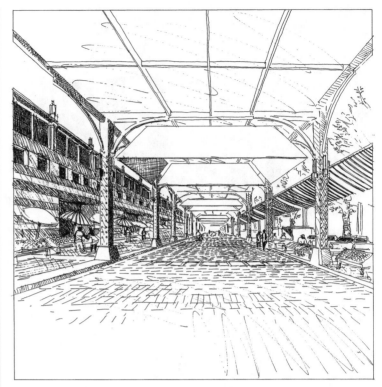

a.

Ghislaine Hermanuz

b.

throughout their communities. By linking labor to production activities, housing holds the key to women's economic empowerment. Each time another housing project is designed, there is an opportunity to redefine appropriate relationships between the realm of home and the realm of work.

Today's social and economic conditions will lead to a different urbanism and a different understanding of home. A work-based urbanism is the building block of sustainable communities. It is one that recognizes where construction norms, building standards, and zoning regulations conflict with the economic behavior of families and communities. It leads to a different way of occupying an urban space, which must include economic development opportunities and ensure equity of access to resources. It can make people feel rooted again in their communities.

Notes

1. Jane Jacobs, *The Death and Life of Great American Cities* (New York: Random House, 1961).

2. Joan Ockman, "Mirror Images: Technology, Consumption, and the Representation of Gender in American Architecture since World War II," in Diana Agrest, Patricia Conway, and Leslie Kanes Weisman, eds., *The Sex of Architecture* (New York: Harry N. Abrams, 1996), pp. 191–210.

3. Hannah Arendt, *The Human Condition* (Chicago: University of Chicago Press, 1958).

4. R.-L. Delevoy and Annick Brauman, *Le Familistère de Guise ou les Equivalents de la Richesse* (Gand: Editions des Archives d'Architecture Moderne, 1976).

5. Ghislaine Hermanuz, *Advocacy: A New Role for Urban Design,* a report to the German Marshall Fund of the United States, May 1981.

6. Hermanuz, Ltd., *Frederick Douglass Boulevard: A Strategy for Revitalizing Morningside Valley,* a report to the Harlem Urban Development Corporation (HUDC), New York, July 1989.

7. The City College Architectural Center, in collaboration with Conrad Levenson Architects, *Women's House* (308 East 8th Street, New York), 1987.

8. The City College Architectural Center and Columbia University Community Design Workshop, *A. Philip Randolph Village,* a proposal for the Inner City Labor Alliance, Spring 1991.

9. Community Design Workshop, *A Housing Platform for Harlem,* New York, 1985.

10. The City College Architectural Center, *Bradhurst Urban Design Guidelines,* a report to the Consortium for Central Harlem Development (CCHD), New York, 1992.

Real choices about how they are going to live elude most women and their families. Even for the most privileged and powerful, social structures and cultural systems limit creative thinking and constrain choices. In the United States and in Europe, conventional housing designs tend to separate and allocate space according to a patriarchal model, regardless of the needs and preferences of individual clients and households. This essay discusses how these norms can be subverted when middle- and upper-class women with access to financial resources and ideas about architecture and social change are empowered to make choices. I focus on two twentieth century houses designed by architects for women clients. My examples are drawn from a larger study of design strategies embraced by women heads of household when they are given the chance to rethink their living and working spaces.[1]

Although even wealthy or independent clients meet with roadblocks to what they want, the designs for their houses share four characteristics which have wider impact. The first and most important point is that whether we talk about housing for the many or houses for the few, program drives design. This is particularly important for the houses I am focusing on, many of which are by well-known male architects, where the myth persists that design is independent from program, from culture, and from the politics of program. Second, these projects blur the boundaries between traditionally defined private space, domestic space, and work space in unconventional ways. Third, the projects highlight renegotiated relations, or redefined relations, both among household members and between the household as a unit and the "outside world." The alternatives range from closer spatial relationships than in traditional families to the existence of more barriers (both physical and emotional) which act as deterrents to closeness and communal activity. In building renegotiated relationships between parents and children into spatial design, for example, the houses in my study (and to some extent this is the case in the first of the examples discussed here) reject and offer alternatives to the conventional typology and conventional structuring of the home. Fourth, as a

Shifting the Paradigm: Houses Built for Women

Alice T. Friedman

group, these houses contest the basic tenets of patriarchal relations, including conventional attitudes toward women and family, women and work, and women and technology.

The female client and the female head of household represent, de facto, unconventional and atypical programming challenges because of the dominance of patriarchal models in design typology. The unconventional demands of these clients as a group stimulate innovative planning and design, both for new types in planning and new forms in design. Some of the most famous houses of the earlier decades of the twentieth century illustrate this: Aline Barnsdall's Olive Hill home and theater complex, designed by Frank Lloyd Wright in Los Angeles in 1919; Gerrit Rietveld's house for Truus Schröder and her children in Utrecht of 1924; Le Corbusier's Villa Stein de Monzie at Garches outside of Paris of 1927; or Mies van der Rohe's Farnsworth house in Plano, Illinois, of 1947–1951. All were designed for women clients in unconventional households, yet although all would most likely be included among the ten most important architect-designed houses in survey texts of twentieth-century architecture, they would ordinarily appear without any discussion of program and client.[2] What we need to look at is how these houses came to be designed and built, and the politics of those circumstances and conditions.

Houses designed for female heads of households, with and without children, demonstrate a radical shift away from the conventional domestic program and the values and power relations structuring that program: the separation of home and work; the focus on reproduction in the family and socialization of children; hierarchies based on categories of sex, age, race, class, and servant versus served; focus on the heterosexual family and an overarching embrace of heterosexual privilege. Female-headed households obviously challenge these values. Sometimes this challenge occurs in spite of a woman's original intent or self-image as an individual outside of mainstream society. For example, it is not uncommon to find that when women, regardless of income or social status, attempt to make changes in social and political life, they discover that they are still subject to the same gender rules and restrictions as everyone else, conventions that limit individual choices and protect established categories. Usually the first indication of a struggle occurs in defining the contested boundaries between established roles and spheres of activity: home and work; family life and responsibility for children; heterosexual privilege; and divisions of social and economic class. And the first defender of that line is usually the architect, who represents the values embedded in the increasing specialization and artistic status of the professional designer in twentieth-century European and American culture. The

architect is neither the servant of the client, nor is he or she free of the values of the dominant culture.[3]

In many of the earlier projects, there is evidence of conflict between architect and client over the ways in which the categories are going to be translated into formal structural relations. For example, when women want to incorporate work space and private space in the home they are sometimes challenged by a designer who may be unwilling or incapable of responding to their needs as workers. Clearly, this is far less frequent in recent examples, but my suspicion is that the contested boundaries have simply shifted to other aspects of the program.

Further, the sexuality of single women throughout much of this century has been viewed with fear, ambivalence, and homophobia. Issues relating to privacy, physicality, and the body are problematized: private spaces are sometimes eliminated altogether or are made more transparent, more available, more centrally placed and visible than the clients want. In one well-known example, the Farnsworth weekend house designed by Mies van der Rohe, this was a major source of conflict. The house's glass walls and open plan rendered the client completely visible, particularly at night, where the rectangle of light glowed like a television set in the rural Illinois countryside with the miniaturized figure of Edith Farnsworth inside. There were misunderstandings on both sides, but Mies's failure to confront Farnsworth's needs as a single woman were at the heart of the problem.

Despite these conflicts, there are valuable lessons to be learned from the most successful partnerships involving women clients and male architects. These relate not only to innovative planning but also to the question of how uses of technology might affect the spatial and conceptual divisions between home and work.

Villa Lewaro in Irvington, New York (fig. 6.1), was built in 1916–1917 for Madam C. J. Walker (1867–1919).[4] The founder and head of the Madam C. J. Walker Manufacturing Company, she was the first African American woman millionaire. Walker made her million by combining scientific planning and an innovative marketing strategy. Devising a line of hair care products attractive to a clientele among African American women, she marketed and sold them through the customers themselves. Prefiguring the Avon lady's home visits and Tupperware parties, her successful sales strategy depended on product users who offered in-home demonstrations to prospective clients. Walker Company "agents" studied the Walker System of hair care and shared in the pride and profits of the company.

Madam C. J. Walker chose an African American architect, Vertner Woodson Tandy, a graduate of Cornell University's College of

Architecture, to design her home.[5] A straightforward example of the American Beaux Arts style, the house is most significant for the program it proposed and followed, in light of Madam Walker's personal history and the house's dual role as corporate headquarters and luxurious private residence. Born in Louisiana in 1867, Walker worked in the cotton fields; from there, as she herself described it, she was "promoted to the washtub." A resourceful, independent woman, she then promoted herself into "the business of manufacturing hair goods and preparations."[6] Her house offered a focus and a corporate identity which was embraced by the workers in her company (fig. 6.2). Because it was the type of mansion usually associated with the wealthy magnates of New York and Boston—one thinks immediately of the "cottages" at Newport, Rhode Island—its significance for Madam Walker and her employees as African American women was all the more resonant. As Walker explained, "My object in life is not to make money for myself or to spend it on myself. I love to use part of what I make in trying to help others."[7] Walker saw herself not only as a successful businesswoman and philanthropist but also as a role model for other African Americans in matters of patronage and culture. Through her participation in such organizations as the NAACP and the YWCA, she made her home a center of cultural and social activity, a meeting place where the most progressive ideas of her time could be discussed and shared.

At the point in her life when the Villa Lewaro was being built, Madam C. J. Walker was single: she had been divorced for some time, and she had a grown daughter who worked with her and sometimes lived with her. At Villa Lewaro, mother and daughter had ample bedrooms on the second floor, separated by a sitting

Alice T. Friedman

Fig. 6.2. Walker agents at Villa Lewaro in the 1920s (Madam C. J. Walker Collection; Indiana Historical Society)

room and large bath. Each had a sleeping porch and terrace over-looking the Hudson River. The ground-floor rooms included a library, reception rooms, a dining room, and Madam Walker's office. Guests were accommodated in small bedrooms on the second floor and on the third floor, where there was also a billiard room. Madam C. J. Walker also had a townhouse in Manhattan, on 136th Street, which was remodeled by Tandy in 1913. This also served multiple functions: it housed a modern beauty salon, as well as Lelia College (where Walker agents studied), meeting rooms, and a private residence.

Built on a hill overlooking the Hudson River, Villa Lewaro cascades downward in a series of stepped blocks reminiscent of an Italian Baroque villa. While Tandy's design is certainly solid and appealing, the most interesting changes to conventional domestic planning seem to have come from the client; these are especially evident in the plan (fig. 6.3), and in particular in the way in which servant-served spaces are handled. In the design of the house, much of the new technology is geared for the benefit and convenience of the servants; not surprisingly, given Walker's own experience, this is especially so in the laundry facilities. Walker went to great lengths to create a healthy and safe work environment for her workers, providing, for example, a large walkout yard adjacent to the service area in the aboveground basement. There was also a

Shifting the Paradigm:
Houses Built for Women

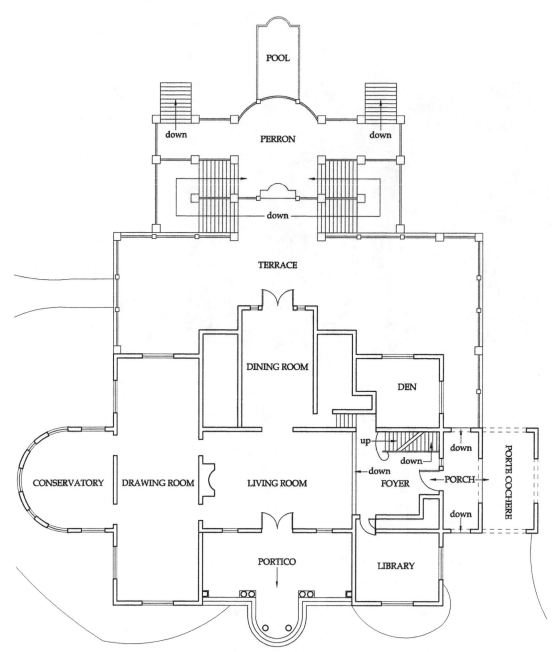

POOL

down PERRON down

down

TERRACE

DINING ROOM

DEN

up down

down

CONSERVATORY DRAWING ROOM LIVING ROOM down FOYER PORCH PORTE COCHERE

down

PORTICO LIBRARY

Fig. 6.3. Plan of the Villa Lewaro
(by Etain Fitzpatrick after Carson
A. Anderson, The *Architectural
Practice of Vertner W. Tandy*)

Alice T. Friedman

gymnasium in the basement, and exercise equipment. The laundry occupied a large space, and there was a forced hot water system that drove the heated water through pipes in the drying racks for the sheets so that ironing time would be reduced. Moreover, to deal with the house's steep vertical dimension, Walker had a service elevator installed for the use of the ten or so household help that she had in the house.

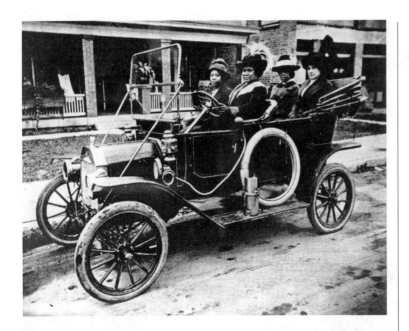

There was separate accommodation for the chauffeur and gar-
dener in a free-standing garage, and also room for Madam Walker's
four cars. Madam C. J. Walker was herself a driver (fig. 6.4), which
was not usual for women at the time. To her authority in the board-
room, where she dealt with two traditionally male preserves, fi-
nance and technical knowledge and processes, she added power
behind the wheel. Both figuratively and literally, she could drive
herself when and where she chose to. When she turned her atten-
tion to her own house, she focused on creating an image of which
she and her associates could be proud, on providing accommoda-
tion for her close relationship with her daughter, and on making the
most modern conveniences available to those people who worked
for her in her home.

My second example is a house in Pasadena, California (fig. 6.5),
designed in 1954 by Richard Neutra for Constance Perkins, a
professor at Occidental College.[8] Perkins was also single and the
head of her own household, although she was at a very different
economic level from Madam C. J. Walker. An art historian, Pro-
fessor Perkins was drawn to Neutra's work through her interest
in modern European architecture of the 1920s and 1930s, and
she frequently took her architecture students to visit Neutra's
home and studio in nearby Silver Lake. It was during a lecture
by Neutra at Occidental that Perkins challenged the architect
to come up with a design for a small house which she could afford
and which would accommodate the way in which she wanted
to live.

Shifting the Paradigm:
Houses Built for Women

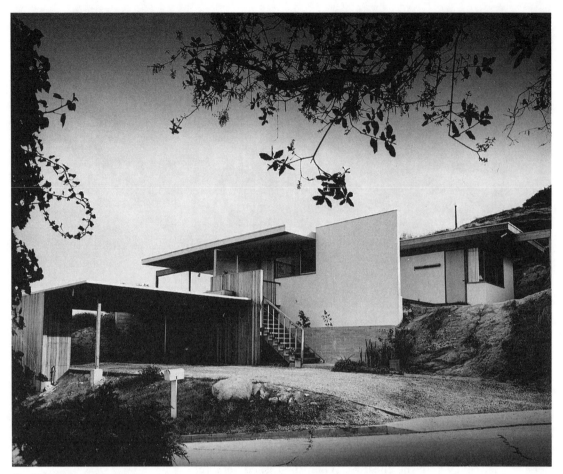

Fig. 6.5. Constance Perkins House, Pasadena, Calif., in 1954; Richard Neutra, architect (Julius Shulman)

The plan and elevations show the siting of the house he designed (fig. 6.6). Neutra used the flat part of the site for the carport, then stepped the house up the hill, since the back edge of the lot was a steep, unbuildable incline. The tiny house was constructed of inexpensive materials—wood, plaster, and glass; a spiderleg beam (fig. 6.7) extended the space by projecting out into a small reflecting pool that meanders through one of the glass walls of the house.

The way Neutra worked at this stage of his career was to ask his clients to make up a list of "likes and dislikes," i.e., materials, colors, music, types of spaces, kinds of light. He was something of an environmental psychologist, having published *Survival through Design* in 1954. He also measured the physical dimensions of his clients. Constance Perkins was a small woman, so he scaled the house to her.

What was her program? Perkins proposed to Neutra that she wanted a house without a separate bedroom. She wanted to sleep next to her drawing board to be close to her creative work. While Neutra accepted this plan, the bank would not, arguing that you

Alice T. Friedman

92

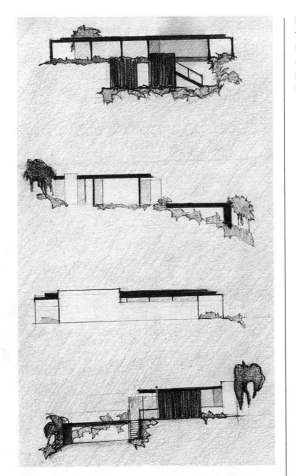

a.

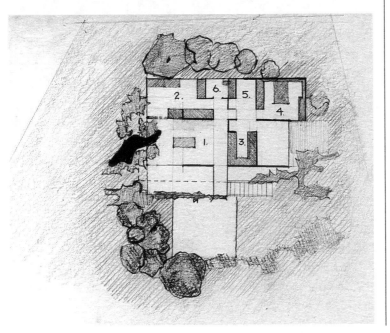

b.

Fig. 6.6. Elevations and plan of the Perkins House (by Etain Fitzpatrick after Richard Neutra): (1) living room, (2) studio/bedroom, (3) kitchen, (4) guest bedroom, (5) utilities, (6) bath

Shifting the Paradigm: Houses Built for Women

Fig. 6.7. Constance Perkins House, view of reflecting pool (Constance Perkins Collection: Archives of American Art, Smithsonian Institution, Washington, D.C.)

couldn't resell a house without a bedroom. In an example of a decision controlled from outside the client-architect relationship, the house ended up with a so-called guest room as an add-on. It is a beautiful room, characteristic of Neutra's best work in the 1950s, but Perkins never used it; she was adamant. She did get the sleeping and work arrangements she wanted for herself: the room with her drafting table had a single bed that pushed into the wall to make a studio couch. The drafting table had an adjustable light (specified by Perkins herself) and shelves below; bookshelves also ran along the back wall of the room. A second, lower desk next to the drawing board was used for paying bills, separating this type of activity from design and artistic work.

Perkins started out with very little. The floor plan shows an open living room area, plus the alcove, kitchen, and bath. Perkins acquired one of Neutra's so-called camel tables (with legs that flip up so it can convert from a coffee table to a dining room table) within a few years of moving in. Between the kitchen and living room there is a pass-through to allow conversation to continue from room to room. Taking account of Perkins's size, the design placed the cabinets in such a way as to allow her to see through the opening in the wall. Most visitors to the house today (it is owned by the Huntington Library) find the view from the kitchen to the living room blocked because the cabinets are too low. But it worked perfectly for her.

Her intention for the house went beyond her desire for flexible work and sleeping space, which meant suppressing the master bedroom convention. As Madam C. J. Walker mixed work and home, public and private, Professor Perkins wanted her home designed to be a place where friends, students, and colleagues could meet. Since she was a member of an art department, she specifically asked Neutra to provide her with enough wall space to show her colleagues' work. She had quite a number of pieces, including prints and sculptures, which she exhibited in an ever-changing display.

Constance Perkins was the ideal client for Neutra. They were very respectful of each other, reflecting their shared interest and experience in the arts. But she was also prepared to do a lot of the work herself, acting as her own contractor. The success of the house is based on the commitment she made to it from the beginning, inventing a new program, describing it in detail, working with the architect on design, insisting on changes when she disagreed with him, and overseeing every aspect of construction and interior finish.

Ultimately, what these case studies suggest to us is that even the projects we think we know best often contain secrets, usually secrets having to do with gender, sexuality, ethnicity, and relationships of power. Madam C. J. Walker's house looks like a typical mansion sitting on the banks of the Hudson, until we learn about it and see the ways in which the client subverted the conventional meaning of these forms, associating them with herself as a black woman and with the workers in her company as women, as workers, and as African Americans. We learn also that Walker modernized her home with new technology which made her own life and those of her household staff easier and, one might add, less divided by relations of power.

At the Perkins house, we see the importance of work and living

space that is private, beautifully designed, small in scale, and proportioned to a woman of small stature. Further, what the Perkins house reveals is something about women's ingenuity in navigating two traditionally male domains: money and architecture. Financing for the project came from two sources: ten thousand dollars from the bank, and a loan of three thousand dollars from the wife of the chairman of her department at Occidental. In 1950s society, as a "woman alone" Perkins was not entitled to many of the privileges which American society offered married women, to say nothing of her lack of access to the independence and authority claimed by men. Yet we must not overlook the advantages that Perkins had as a middle-class, educated white woman who spoke her own mind, knew how to talk to professionals, and lived her own life. She had a good job (albeit hard won) and drove her own car. This allowed her to move easily between her suburban home and her workplace at Occidental College, providing her some measure of freedom to redefine the American dream in feminist terms. Her modest house, like that of the millionaire Madam C. J. Walker, has lessons to teach us as we look for feminist alternatives in design.

Notes

1. See Alice T. Friedman, *Women and the Making of the Modern House: A Social and Architectural History* (New York: Harry N. Abrams, 1998).

2. For further discussion of this point, see my "Not a Muse: The Client's Role at the Rietveld Schröder House," in Diana Agrest, Patricia Conway, and Leslie Kanes Weisman, eds., *The Sex of Architecture,* (New York: Harry N. Abrams, 1996), pp. 217–32.

3. See Dana Cuff, *Architecture: The Story of Practice* (Cambridge, Mass.: MIT Press, 1991).

4. For Walker, see A'lelia Perry Bundles, *Madam C. J. Walker: Entrepreneur* (New York: Chelsea House, 1991). Madam Walker's papers are held by the Indiana Historical Society; access to personal documents, including those relating to the house, has been restricted by the trustee for an indefinite period. I am grateful to the current owners of the Villa Lewaro, Mr. and Mrs. Harold E. Doley Jr., for taking me on a lengthy tour of their home and for sharing their knowledge of Walker's life with me.

5. For Tandy and Villa Lewaro, see Carson Anthony Anderson, "The Architectural Practice of Vertner W. Tandy: An Evaluation of the Professional and Social Position of a Black Architect," M.A. thesis, School of Architecture, University of Virginia, 1982, esp. chap. 2, pp. 120–43.

6. Bundles, *Madam C. J. Walker,* p. 14. The quotation comes from

a speech delivered by Madam Walker before the National Negro Business League in 1912.

7. Ibid.

8. For the Perkins house, see Thomas Hines, *Richard Neutra and the Search for Modern Architecture* (New York: Oxford University Press, 1982), pp. 227, 262–63. The house is also the subject of a chapter in my book, cited n. 1 above. This section is based on research and interviews with Constance Perkins conducted in 1989 and 1990.

"Special Needs" and

Housing Design:
Myths/Realities/

Opportunities

Barbara Knecht

For the past fifteen years I have been engaged as an architect in design and development of housing designed to respond to the escalating crisis of homelessness in the United States. Seeking to understand what works and what does not in providing such housing, I undertook a research project to study other examples; its purpose is to enhance the tools of architectural practice and to influence the decisions of the financing agencies by offering evidence of successful designs. This essay offers a general discussion of some of the findings and ideas arising from this research.[1]

Traditional multiunit housing design has been standardized around construction conventions and an idealized nuclear family, without specifically considering how human beings interact, how they age, how they carry out daily activities, how they suffer infirmity, and how they celebrate. In recent years, what is often designated "special needs" housing, by contrast, has been designed to meet diverse human needs—including the desire for a sense of community—with thoughtful design. The term "special needs" is based on the assumption that there are people who require designs that are specialized and uncommon because they have extraordinary needs different from those of "ordinary" people who live in "regular" housing. Recent designs for "special needs" housing reveal uncommon, but highly desirable, features that accommodate a variety of human needs, features that have been ignored historically both at the individual living unit level and in the overall planning of building developments. Examples include lower windows so that a person sitting in bed can see outside, double appliances in shared kitchens, view windows that allow someone to preview a common space before entering, a variety of rooms for informal socializing, "semiprivate" alcoves or spaces within larger ones, ramps integrated into overall design, and laundry rooms adjacent to lobbies and play areas. Incorporating such features reflects the fact that over the past two decades we have become more conscious of issues of accommodation and accessibility in all our building design and have come to understand that design which supports the needs of vulnerable people enhances the environment for all. Many more people would benefit from the incorporation of these design elements into overall standards for housing and community design.

There is a measure of irony in this situation. Such innovative designs are the fortunate result of unfortunate public policies and housing programs. People who live in the housing are often segregated and stigmatized because they are identified as "special." Organizations, different regions of the country, and government agencies use the term "special needs" to refer to a variety of different groups, many of which carry stigma to start with. Generally, "special needs" housing is intended for people with one or more of the following characteristics: a history of chemical dependency, mental illness, or MICA (mental illness and chemical abuse); a physical disability including AIDS; a history of homelessness or imminent danger of homelessness. It may describe multifamily housing, and it frequently describes Single Room Occupancy (SRO) housing for adults living alone.

The social service world is organized into government departments and related not-for-profit organizations which act on specific social problems. Funding flows through these channels to deliver services, including housing, to people. A government mental health department provides funding to a not-for-profit organization to house people with histories of mental illness; a general social services department provides funds to house homeless families temporarily; a housing department is responsible for permanent housing; and many localities have special departments to administer and develop housing for people living with AIDS. Many jurisdictions categorically divide housing for families from housing for adults living without children.

Most housing developed for people who have been homeless depends on these public funding streams which separate and categorize people within their jurisdictions. Thus, for example, there are twenty-two units of housing for people living with AIDS in a new building in West Hollywood, twenty-three units similarly designated in a combination of renovation and new construction in Atlanta, twenty-four units specifically for people diagnosed with mental illnesses in a renovated building in Los Angeles, and examples of housing for women with alcohol or drug addictions and their children. In many instances across the country a fixed percentage of each "category" is designated for a building. In at least one example, the building is *physically* divided as well, into three separate sections for temporary housing for families, SRO housing for adults, and a community residence for mentally ill adults.[2] The physical separation of people into categories and specific structures according to how they are financed illustrates a new axiom: form follows funding.

Barbara Knecht

The evolution of SRO housing in the last fifteen years provides a good example of how funding and policies, joined with architects'

rethinking, have influenced housing designs. SROs have become the primary living situation for many single adults identified with "special needs," providing wonderful and supportive environments even as they separate and stigmatize their residents. Reflecting architects' heightened sensitivity to a whole range of human needs, this housing typifies housing specifically designed for various "special" populations. SRO housing has become the setting for design innovation because its creators strive to produce more than housing. They expect to create a community.

The traditional SRO hotel was a modest, affordable, living situation in which the residents, with their own rooms, had a high degree of social independence from one another.[3] A lobby lounge, bathrooms, and sometimes cooking facilities might be shared but, by and large, social interaction was limited and invisible. Amenities such as gardens and terraces were nonexistent. Days were passed either behind closed doors or elsewhere than the hotel. Mirroring most private and multiunit housing, the traditional SRO had a clear demarcation of public and private space. The front door divided the residents from the street, a minimal lobby and corridors served as passageways, and the door to each unit shut out the semipublic world of neighbors.

The design of the new generation of SROs is much more elaborate. It resembles the old model only in that each person has his or her own room behind a locked door. Now, as often as not, that room is a self-contained studio apartment where all cooking and bathing are done completely in private. Furthermore, the buildings generally now include an array of semipublic spaces, services, and amenities which substantially change the residents' relationship to one another and to the building in which they live.

These new designs provide a much more complex set of spatial relationships and opportunities for social interaction. There are many more places where people can interact informally and formally—places specifically created to encourage socializing. Rather than a small, insignificant ground-floor lobby, a building may have two lobby sitting areas and a dining room on the ground floor, plus one or more smaller lounges on the upper floors often equipped with televisions, pantries, and so on (fig. 7.1).

An extraordinary array of services and amenities can be found in many of these developments. They include psychiatric and social service counseling offices, meeting rooms, medical suites, and a selection of rooms which may house libraries, personal computer facilities, fitness centers, "clubhouses" for sports teams, television and video monitors, smoking lounges, even pool tables and shuffleboards. By combining residential and service functions, life within the building becomes organized by a variety of public and

semipublic and private spaces which differ from traditional SRO and multiunit housing. Bringing together unrelated adults, the spatial designs and services seek to create a culture that encourages people to connect and communicate in shared activities.

Redundancy of spaces is common. Redundancy provides residents with choices about where and when and with whom to socialize. For example, different options may be provided for one of the most important daily activities: meals. Residents may choose to cook for themselves, in a shared or private kitchen, or they may have meals that are prepared by cooks in an on-site cafeteria. Small kitchens shared by several residents are usually associated with a living/dining area either adjacent or in the same space (fig. 7.2). People can choose to be in one of these semipublic spaces with other people or to use it only when no one else is there and retreat to the privacy of their rooms to eat. A commercial kitchen where meals are prepared by professional staff and are available to residents for free or for a nominal charge functions as an inexpensive restaurant. Participating in the rituals and routines of making and sharing meals is a way to promote nonthreatening and casual social interaction; the variety of options allows each resident to choose how to participate.

Gardens, terraces and courtyards, once considered a luxury, are often an essential element of "special needs" housing design (fig. 7.3). Their prevalence has arisen from a recognition of the healing effects of proximity to nature, often justified because people with "special needs" will spend more time at home. Extraordinary variety exists: from rooftops to balcony walkways to courtyards. Movable furniture allows tenants to choose a place in sun or shade, away from or with other people. Planting beds, in the ground or

Barbara Knecht

Fig. 7.2. Accessible shared kitchen/dining area on either side at corridor end overlooking the street, Parker Hotel, Los Angeles; Hatch and Colasuonno, architects; A Community of Friends, sponsor (opened 1994) (Barbara Knecht)

raised to make them accessible to people in wheelchairs, permit residents to grow flowers, herbs, or vegetables as they choose. Most important is the opportunity these options provide for residents to control and personalize parts of their environment traditionally controlled and serviced by management. This personalization, the right to identify oneself in the environment, extends to placing exuberant murals in public stairwells and hallways and on front doors—transposing the front porch and walkways of the single-family dwelling to SRO dwellings.

Although the term "SRO" is still used to describe this housing, it is hard to recognize the traditional model in this new version, which it resembles neither physically nor socially. The following array of influences has intersected to create this new version, characterized by the profile of the residents who live there, this so-called special needs population.

The not-for-profit sector and government are not always motivated by the same goals. In this instance, divergent forces converged to lead to the creation of the category of "special needs" housing. The not-for-profit sector and numerous advocacy groups, having identified real discrimination, inaccessibility, and lack of resources, successfully pressured government to increase housing through dedicated funding streams for various specific groups

"Special Needs"
and Housing Design

Fig. 7.3. Courtyard adjacent to dining and recreation rooms, Gouverneur Court, New York; Peter Woll, architect; Community Access, sponsor (opened 1992) (Barbara Knecht)

of people. Each organizational group lobbied for housing for its constituent group. Government, faced with housing shortages and growing numbers of homeless people, sought ways to prioritize (and ultimately limit) how poor people, especially those living in shelters, would get housing. Homelessness is the result of poverty, but other circumstances, such as mental or physical illness and substance abuse, are interrelated contributors. Giving priority to people who can be identified by their "special needs" provides a way to establish eligibility for housing. The focus shifts from the social problems of poverty and housing shortages to an individual problem which is "treated" in this setting.

"Special needs" housing, despite its obvious benefits, has thus created another way to separate and stigmatize poor people. In order to get housing, you must be identified not simply by the lack of resources to obtain housing in the marketplace but by some other attribute that defines and distinguishes you from some unnamed norm. We have created housing which segregates people according to categories that are used to artificially prioritize the need for housing and to require those who are in that category to live together. Unlike some European social welfare states, we have lacked a fundamental commitment to adequate and affordable housing for all. Instead, we create systems by which we choose who, among poor people, is more deserving of the scarce resources.

"Special needs" appeared as an opportunity to increase funding for housing in the community for people who have no influence in the market. Until the advent of the deinstitutionalization movement of the 1970s, many people who fell into this category lived their lives isolated in institutions. People with physical disabilities

Barbara Knecht

104

grew up and lived in rehab hospitals; people with chronic mental illness lived in large state hospitals; people with chronic health problems lived for long periods in acute care hospitals; elderly people lived in nursing homes. Prohibitive costs and enlightened social attitudes have slowly transformed thinking about institutional living. Efforts have been made to integrate people into the community instead of removing them from society. Housing has been envisioned by its sponsors and their architects as a setting in which the residents will be able to develop community ties among themselves and integrate into neighborhoods. Unfortunately, more often, people have been placed in neighborhoods but have not become a part of them. "Special needs" has become another label. Some labels identify people as superior and apart: respected and admired. In other cases, society creates labels which identify people as inferior and apart: stigmatized and undesirable. Formerly homeless adults with complex histories are thus categorized by advocates whose intention is to help them improve their lives, by government that has conflicting mandates, and by communities contemplating them as neighbors. Seemingly contradictory forces, those intending support and others attempting control, have caused the circumstances, reinforced in the building designs, that threaten to isolate people from, rather than incorporate them into, their surrounding communities.

Many of the newly designed SROs are self-contained communities. Motivated by good intentions and the knowledge that services are key to helping people maintain their housing, sponsors have compensated for lack of community services by building them into the dwellings themselves. While residents come and go daily to jobs or day programs, their various social and service needs are met within the building complex. They have no need to participate in or use the resources of their larger neighborhood. Nor do the on-site services become a common community resource. Public funding and NIMBY (Not in My Backyard) attitudes often ensure that the building and neighborhood residents will remain separate. Funding restrictions limit eligible participants in these services to building residents. Surrounding neighborhoods, with attitudes ranging from simple fear to outright contempt of people who are perceived as different, want nothing more than to be assured that "those people" will not be walking the streets of their neighborhood, shopping in their stores, or using their scarce community services.

There is a further irony in that many of the characteristics of this SRO housing can be compared to housing that very wealthy people create for themselves. Their communities, too, are self-contained,

rich in amenities and supportive design features. Gated communities and luxury housing encourage socializing by providing recreation facilities, social rooms, or libraries. Individual living units have kitchens, but there may be a club or restaurant which provides meals as well. Design features that enhance physical accessibility are integrated. Air-conditioning and individual temperature controls, justified in "special needs" housing because medications taken for psychosis cause problems regulating body temperature, are common in market-rate housing. Redundancy of spaces, private bathrooms, outdoor space, and formal and informal places to socialize are all design features that respond to complex and changing human needs. They only become "special needs" features when they are included in housing for poor people. These features measurably improve the physical environment of these SROs; it is the circumstances by which people are provided them that I criticize.

Strong communities have grown up within many of these new developments. People do feel safe; many residents have their own home and a measure of stability for the first time in their lives. But despite the spatial and visual variety of SRO housing, its limitations underwrite an obvious and astonishing inequity. Intended as a permanent home for people with virtually no other choice save the streets or shelters, it is—unlike the old model—not affordable without subsidy. Further, it is inflexible in the restrictions and requirements that must be met to live there.

Identifiable restrictions make it easier for funders even if the restrictions do not suit the intended users. A study by Barbara Knecht, Inc., conducted for the Corporation for Supportive Housing, examined reasons why homeless mentally ill adults chose the streets over housing program alternatives which would lead to permanent housing.[4] A significant barrier was the requirement that the person submit to analysis and to classification as someone with mental illness in order to be eligible for the housing. People want the basic need of safe housing to be met before they are likely to face personal, social problems. For some people, to acquiesce to a classification which would significantly decrease their autonomy proved too high a price to pay to obtain the available housing.

Not only does it rigidly exclude all who do not fit a specific profile of need, the new SRO housing nearly always excludes anyone but an adult living alone—no children, no couples, no complexity. Separate but equal. Many women and men who live in this housing are quite young, and some have children living elsewhere. Reunification—temporarily or permanently—is not possible if you have no place for your children to live. Is it really your space to control if

someone else is telling you with whom you may live? Much effort has gone into creating warm, safe, and communal places to live, and many of these projects have succeeded admirably. What is lacking, I believe, is alternatives. There are limited options for moving to a different *kind* of housing. As people stabilize and are ready to develop their personal ties and create families, they must move out of the housing they now occupy and possibly out of the neighborhood. And the dilemma of giving up newly found community stability in order to pursue personal stability presents an unacceptable set of choices. To have to choose between the safety of community you have helped to create and the family you want to build is no choice at all.

This is not a call to abandon housing with on-site social services. Housing which permits people to come together with a measure of independence in a stable, structured environment is a fine option which will be housing of choice for some people. It is a plea to recognize its shortcomings, to challenge the limitations imposed by rigid funding streams, and to take responsibility to expand the options available to people with limited choices. It is an appeal to raise the standards of design—spatial and aesthetic—that we expect in all housing. The design sensitivity of much of the new SRO housing is evident from the publicity it has received and the satisfaction of the residents. Many people have "special needs" at various times in their lives; bringing this design awareness to a larger audience will create housing that is appropriate for a wide range of people. The problem is not how to design good housing. There are many excellent examples. The problem is deciding what to design, and the challenge is for us, as architects and planners, to become participants in those decisions.

As we think about expanding the array of solutions, it should be possible to combine the best of both: move the commercial kitchens and dining rooms to the street and open them up as inexpensive restaurants to the community; mix up unit types so families and single adults can live side by side; include a variety of public spaces so communal activities can take place. Exploit the lessons that we have learned from SRO and similar designs for environments that support informal socializing, that enhance safety without guards and cameras because they encourage people to use them, that acknowledge that complex lives need readily available support systems. We need to enhance the resources available in all communities. We can use housing development to accomplish this. And we can incorporate spatial variety and rich environmental experiences into all housing because it meets human needs, not "special needs."

Notes

1. This essay is based on research carried out with funding from the Graham Foundation for Advanced Studies in the Fine Arts under the title "Mainstreaming Special Needs Housing." Further publication detailing and expanding this research, to include case studies, is forthcoming.

2. Examples are case studies from "Mainstreaming Special Needs Housing."

3. See Paul Groth, *Living Downtown: The History of Residential Hotels in the United States* (Berkeley: University of California Press, 1994) for an excellent history of SRO and other hotel housing.

4. Barbara Knecht, Inc., "Flexible Housing Models: Proposals to House Homeless Mentally Ill People," Final Report, July 1993, prepared for the Corporation for Supportive Housing, New York.

Made in Patriarchy: Theories of Women and Design— A Reworking

Cheryl Buckley

This essay reconsiders some of the arguments raised in my earlier article "Made in Patriarchy: Towards a Feminist Analysis of Women and Design," which was first published in *Design Issues* in 1986.[1] That article, prepared over ten years ago, had two main aims. The first was to analyze the patriarchal context within which women interact with design as practitioners, theorists, consumers, historians, and as objects of representation. The second was to examine the methods used by historians to record that interaction.[2]

These methods, which involve the selection, classification, and prioritization of types of design, categories of designers, distinct styles and movements, and different modes of production, are inherently biased against women and, in effect, serve to exclude them from history. To compound this omission, the few women who make it into the literature of design are accounted for within the framework of patriarchy: they are either defined by their gender as designers or users of feminine products, or they are subsumed under the name of their husband, lover, father, or brother. Feminist theory, I argued, offered the theoretical tools to challenge the ways in which women's interaction with design was recorded. In particular, feminist theory enabled us to delineate the operation of patriarchy; it provided a method for conceptualizing gender and femininity, the sexual division of labor, and the hierarchal positioning of certain aspects of design over others.

The impetus for the article came from the growing interest within design history, practice, and theory in the relationship of women to design and was the culmination of related research, teaching, conferences, and publishing. At the time, it seemed as though the expansion of the field would bring about substantial changes to the various disciplines associated with design.[3]

In retrospect, this was overoptimistic. Arguably, although feminist interventions in design and design history still contribute to the debate, women's agenda has yet to be integrated into the mainstream. Questions about women's role in design remain tangential to the discipline and are tackled with reluctance. In design history, for example, women's position is still sidestepped, and in architectural and design practice women's needs as consumers/users

often remain unaddressed. My aim, then, is to look at how the debate regarding women's relationship to design has developed since the mid-1980s in Britain within the context of design history and theory, and to offer some thoughts as to how we might progress beyond the millennium.

My intention is not to argue that women remain hapless victims, incapable of challenging the vagaries of patriarchy. There is much to celebrate in terms of women's achievements over the last decade. The conference "Re-Visioning Design and Technology: Feminist Perspectives" for which this essay was first produced is evidence of the continuing debate.[4] And yet it seems to me that we are at a critical point. In some respects the debate is faltering and we are losing our original focus. We risk disempowerment and marginalization particularly at the hands of postmodern theorists who pay scant attention to women. As Meaghan Morris has argued, "In a number of recent discussions of postmodernism, a sense of intrigue develops around a presumed absence—or withholding—of women's speech in relation to what has certainly become one of the boom discourses of the 1980s."[5] This sense of absence is especially worrying within a theoretical framework which ostensibly challenges established values. Perhaps, as Susan Faludi has argued in *Backlash,* an "anti-feminist backlash has been set off not by women's achievement of full equality but by the increased possibility that they might win it."[6]

As an academic discipline, design history has been eclectic in its intellectual influences since its inception, and inevitably it has incorporated aspects of postmodern theory. The way that this has shaped accounts of women's role in design can be demonstrated by the recent publication of two books. The Women's Press has reissued Attfield and Kirkham's *A View from the Interior: Women and Design,* first published in 1989 but in preparation from the mid-1980s.[7] This book made a major contribution to the development of a feminist design history by demonstrating the enormous scope of research on women's role in design at the end of the 1980s in Britain. Except for one essay, it concerned itself entirely with women and their relationships at different historical points to design. Coinciding with this reissue was the publication of a new book, edited by Pat Kirkham, entitled *The Gendered Object.* This studies "the ways in which objects, particularly objects of everyday life, are made socially acceptable and 'appropriate' for either men and women."[8]

Between the publication of these two books is a marked change, clearly evident from the titles, in the way that women's relationships to design has been described by design and cultural historians. In the first book, the focus was women and the theoretical

underpinning was clearly feminist, whereas in the second, although there is still a concern with analyzing gender, there is as much emphasis on masculinity as on femininity.

One of the theoretical contexts from which this interest in gender has emerged in addition to feminism is postmodernism, and what is distinctive about this latter context is its emphasis on masculinity: "Much postmodern theory seems to be about a shifting in the postion of masculinity, an uncertainty about manhood, a loss of faith in patriarchal authority."[9] Questioning masculinity is clearly important for feminism, and indeed feminists have been at the vanguard of this.[10] However, as Jane Flax has argued, "Postmodernist discourses, or even commentaries about them, notably lack any serious discussion of feminist theories, even when these theories overlap with, supplement, or support postmodernist writers' ideas."[11]

What interests me here is the question of whether postmodern theory enables the feminist design historian to write histories of women's relationship to design or, as I suspect, works against such work. In questioning postmodernism in this way, I am open to the charge of naïveté, but clarity rather than obscurity is my primary goal in utilizing any theory, whether postmodernist or feminist. In the first part of this essay, I will briefly discuss some of the key literature from design history over the last ten years (mainly from the United Kingdom, but also from the United States), and in the second part I want to explore the interplay between this literature and cultural and feminist theory, particularly as it relates to women and design.

Undoubtedly the feminist agenda in design has continued and developed. At an academic level, literature, research, conferences, and teaching programs have all proliferated in the last ten years. From a practical standpoint, user-sensitive designs have gained more legitimacy as architects and designers realize that the user of products and buildings is not a universalized "type" man but is instead socially and culturally constituted by sex, race, class, age, sexual orientation, and national identity. We have seen a number of important conferences which have provided a forum for developing new ideas, sharing information and research, and establishing common objectives.[12] These emerged within the context of intense interest in design in the latter part of 1980s, and they focused on design to provide solutions to some of the problems facing women.

The literature relating to women and design expanded substantially in the late 1980s and early 1990s. Within this there are different categories and approaches. Some books and compilations of essays focused exclusively on women and design.[13] In addition, there have been major exhibition catalogs dealing with women

designers and architects based on empirical research, which show women's involvement in design mainly as producers, although others look at the effect of design on women consumers.[14] Alongside these, there have been theoretical pieces which have examined the relationships between design and women and between design and feminism, including, in the United States, Martha Scotford's piece on graphic design in *Visible Language* and, in Britain, Judy Attfield's excellent feminist analysis of design in *Design History and the History of Design*.[15] The positioning of Attfield's piece as a supplementary section at the end of the book was very revealing, sending a clear signal about the relationship of feminism to design history as an optional extra—at least in the eyes of some.

Indeed we have to look no further than to the 1995 Spring issue of *Design Issues* for confirmation of this type of backsliding. In this special issue devoted to the question of how to define design history, a bevy of male scholars fought it out.[16] Their central purpose was to determine the nature and boundaries of design history and its relationship to design studies. Significantly, feminist critiques of design history were heavily drawn on by each side in their arguments, but none of the protagonists bothered to ask what had been happening to feminist design history in the last decade.[17] As I read their deliberations, I was struck by two main points. First, their interest in feminism was merely functional in the sense that it enabled them to come to a definition of design history. Genuine interest would have required a more substantial contribution than that demonstrated by a few citations in the footnotes. Second, it was highly frustrating to see how feminist critiques of design history had been ransacked to sustain a particular viewpoint about the nature of the discipline. Feminist arguments, when they were referred to, were incorporated as but one of many "approaches," all potentially valid and equally important.

In addition to those books and journals which have directly addressed women's role in design, there have been numerous books which include aspects of women's relationship to design alongside other subjects, particularly film. This development has been stimulated by organizations such as the British Film Institute and individual researchers who have crossed the subject divide.[18] Fashion often figures prominently in these texts, and although it is an activity still neglected by mainstream design historians, it has been scrutinized by academics from outside the field, frequently with the aim of examining representations of femininity.[19] The neglect of fashion by design historians provides further evidence, in my view, of the intrinsic misogyny of much design history. Fashion is still collapsed into the realm of "the feminine" by all but the most gender-conscious of design historians.

Within the recent literature of fashion history and design history, however, are writings that evidence a growing trend to address gender instead of women. Together with these are books which deal with sexuality and gender within the context of postmodernism.[20] The focus for these is the body, usually the female body, and the processes of representation and consumption associated with this. Indeed, a shift of interest toward consumption rather than production has been a characteristic of design history generally, and this has been important to our understanding of women's role in design. Increasingly, however, the dominant tendency in research and publishing is gender, not women. Gender studies replaces women's studies in academic programs; masculinity is investigated as much as, if not more than, femininity; and the young women academics just starting out are as likely to be writing their Ph.D.'s about masculinity as they are about femininity. The question, then, is why should this be? Has the woman question been answered at long last? Or are we indeed witnessing a backlash in our subject, and if so where did it come from and why?

Arguably, some of my questions can be answered by examining the relationship between recent cultural theory, particularly postmodern, and feminism. A key question for me is where feminism as a tool for cultural as well as political analysis fits into the theoretical rethinking prompted by postmodernism. In fact, it is possible to argue that postmodern theory, although ostensibly challenging the value systems of moribund academic disciplines, has remained largely ignorant of and uninterested in feminism. In two specific ways, it seems to me, postmodernism has delivered a preemptive strike against women disguised as liberation. First, it has replaced one set of patriarchal discourses with another set which is equally patriarchal, as Meaghan Morris has argued: "It would be hard to deny that in spite of its heavy (if lightly acknowledged) borrowings from feminist theory, . . . postmodernism. . . has pulled off the peculiar feat of re-constituting an overwhelming male pantheon of proper names to function as ritual objects of academic . . . commentary."[21] Postmodernism is dominated by yet more "great" men—for example, Baudrillard, Barthes, Lacan, Lyotard—who have introduced a "new kind of gender tourism, whereby male theorists are able to take package trips into the world of femininity."[22]

Second, the postmodern approach to key concepts such as "feminine," "gender," and "subjectivity" poses problems for feminists. One of feminism's main achievements has been to counter essentialist definitions of gender difference and to undermine the notion that gender is rigidly fixed. In this, feminists have turned to psychoanalysis and to some of the same theorists who have proved so influential to postmodernism, although with a different end in view.

The feminist study of gender seeks to highlight the situation of women and the analysis of male domination or patriarchy; it aims to problematize issues of identity, power, and knowledge, leading feminists to recover and explore aspects of social, cultural, and political lives which have been suppressed, remain unarticulated, or have been denied within male-dominated accounts. In contrast, when postmodern theory addresses the issue of gender it seems to do so with the intention of understanding masculinity, and any interest in femininity is there to provide a counterpoint to masculinity. As Suzanne Moore put it, "In deciphering the language of the 'other' and then claiming it for themselves, these theoretical drag queens don the trappings of femininity for a night on the town without so much as a glance back at the poor woman whose clothes they have stolen."[23]

The attack on the subject within contemporary cultural theory poses problems for those who are interested in histories of things and people normally marginalized by mainstream writers. One feminist strategy for writing histories of design has been to articulate women's presence as historical subjects rather than as objects. But in their critique of subjectivity, postmodern theorists consign women yet again to the margins of history. As Flax writes, "Postmodernists intend to persuade us that we should be suspicious of any notion of self or subjectivity. Any such notion may be bound up with and support dangerous and oppressive 'humanist' myths. However, I am deeply suspicious of the motives of those who would counsel such a postion at the same time as women have begun to *re-member their selves* and to *claim an agentic subjectivity* available always before only to a few privileged white men" (my emphasis).[24]

How to frame the subject and subjectivity, and how to respond theoretically to the attack on these from postmodern theorists, are questions at the core of feminist approaches to history and design history. Feminist writers and historians including Sally Alexander, Carolyn Steadman, Rosi Braidotti, Doreen Massey, bell hooks, and Meaghan Morris have consistently tried to think differently about how women's histories can be written, and there are common threads in their work.[25] In particular there is the idea of speaking differently in order to articulate women's voices. For hooks this involves choosing to speak from the margins as a place of resistance, whereas Braidotti uses the terms "figuration" and "nomadic" to articulate the notion of the "situated" nature of subjectivity.[26] In a similar vein, Alexander sees memory as a way of glimpsing individual subjectivities: "Life histories, as they tell us something of what has been forgotten in cultural memory, always describe, or rehearse a history full of affective subjectivity. As with a poem, they

may suggest the metonymic signs of femininity particular to a generation."[27] A sense of place increasingly informs feminist studies of women's lives and experiences. Using Adrienne Rich's term "the politics of location" to theorize the specificity of female subjectivities, Rosi Braidotti argues: "The politics of location means that the thinking, the theoretical process, is not abstract, universalized, objective, and detached, but rather that it is situated in the contingency of one's experience, and as such it is a necessarily partial exercise. In other words, one's intellectual vision is not a disembodied mental activity; rather, it is closely connected to one's place of enunciation, that is, where one is actually speaking from."[28] She goes on to equate the abstract generalities of certain theories (read postmodern) with the "classical patriarchal subject," asserting, "What is at stake is not the specific as opposed to the universal, but rather two radically different ways of conceiving the possibility of legitimating theoretical remarks. For feminist theory the only consistent way of making general theoretical points is to be aware that one is actually located somewhere specific."[29] Throughout, Braidotti and others such as Meaghan Morris and Doreen Massey remind us that within the context of postmodernism women are not merely abstracted, they are nowhere, and although the category "gender" is ostensibly at the core of postmodern discourse, women and femininity have been neatly sidestepped. However, they also propose a variety of theoretical strategies for rethinking and re-articulating women's histories which are relevant for those interested in a feminist intervention in the history of design.

Influenced by cultural studies, film studies, anthropology, and architectural history, design history has been particularly susceptible to postmodernism over the last few years. From the postmodern viewpoint, design is an ideal subject for scrutiny. According to Judy Attfield and Pat Kirkham, "Design is posited here as material artefact, commodity, aesthetic object, aide-memoire, souvenir, lifestyle, political symbol; signifier supreme."[30] All aspects of design are fruitful sources for postmodern investigations, but fashion has a particular appeal for those very qualities that led to its devalution by modernist design historians: "The fashion-object appears as the most chaotic, fragmented, and elusive of commodities, yet it circulates a pervasive and enveloping logic. . . . It constitutes an exemplary site for examining the cultural dislocation and contradictions of the transition from modernity to the late capitalist, new wave, postmodern era."[31] However, from a different, feminist viewpoint, fashion embodies numerous ideas about what it is to be woman, to be feminine, and to be gendered differently than men. Fashion images and advertisments in magazines and on TV are formulated historically, and they relate to specific "located"

feminine identities, not generalized ones. As Pat Kirkham observes, "'Postmodernism' has helped broaden appreciation of the multivalency of objects, but it has made more respectable the study of objects out of context."[32] It is the analysis of design within its context and history which aids our understanding of its significance in women's lives. History enables us to interpret and understand, and perhaps to conceive of change.

In my view, postmodernism has deflected us from these concerns. Whereas the needs of women were our central objective ten years ago, we now deliberate over gender—indeed, theorizing about women and not gender has been intellectually insupportable over the last few years as the old polarities of femininity and masculinity have apparently dissolved. To some extent the problem facing us as feminist design historians is how to rearticulate the categories "feminine," "gender," "woman," and "subjectivity" in order to move beyond postmodern discourse. Taking our cue from feminist historians, geographers, cultural historians, and theorists, we need to remove these terms from the abstract and relocate them in the specificity of history. We must integrate these feminist categories into our discussions of design history, practice, and theory in order to demonstrate that women's experiences of design are still only partially accounted for. If, as a consequence, we are theoretically at odds with our peers, we should recall Jane Flax when she said, "Postmodernists have not offered adequate concepts of or spaces for the practice of justice. What memories or history will our daughters have if we do not find ways to speak of and practice it?"[33]

Notes

1. Cheryl Buckley, "Made in Patriarchy: Towards a Feminist Analysis of Women and Design," *Design Issues* 3:2 (Fall 1986): 1–31, and in Victor Margolin, ed., *Design Discourse: History, Theory, Criticism* (Chicago: University of Chicago Press, 1989), pp. 251–62.

2. Ibid., p. 251.

3. In Britain this began with a conference at the Institute of Contemporary Arts in London in 1983 entitled "Women and Design." This was followed by a number of key conferences throughout the 1980s and early 1990s culminating in "Cracks in the Pavements: Gender/Fashion/Architecture" at the Design Museum in London in 1991. On a personal level it coincided with the period in which I wrote my Ph.D. thesis, which dealt with women designers in the British pottery industry, 1914–1940. This brought me face-to-face with numerous problems of historiography and theory in relation to a feminist design history.

4. "Re-Visioning Design and Technology: Feminist Perspectives," Graduate School and University Center of the City University of New York, November 16–18, 1995.

5. Meaghan Morris, *The Pirate's Fiancée: Feminism, Reading, Postmodernism* (London: Verso, 1988), p. 11.

6. Susan Faludi, *Backlash* (New York: Crown, 1991; London: Chatto & Windus, 1991), p. 11.

7. Judy Attfield and Pat Kirkham, *A View from the Interior: Women and Design* (London: Women's Press, 1989).

8. Pat Kirkham, *The Gendered Object* (Manchester: Manchester University Press, 1996), preface.

9. Suzanne Moore, "Getting a Bit of the Other: The Pimps of Postmodernism," in Rowena Chapman and Jonathan Rutherford, eds., *Male Order: Unwrapping Masculinity* (London: Lawrence & Wishart, 1988), p. 179.

10. See, for example, Lynne Segal, *Slow Motion. Changing Masculinities, Changing Men* (London: Virago, 1990).

11. Jane Flax, *Thinking Fragments: Psychoanalysis, Feminism, and Postmodernism in the Contemporary West* (Berkeley and Los Angeles: University of California Press, 1990), p. 211.

12. As an example, I recently attended a conference at the University of Trier in Germany entitled "Marginalisierung und Geschlechter-konstruction in den Angenwandten Kunsten," October 3–6, 1996. This was the second of three conferences organized by German, Austrian, and Swiss art historians which set out to explore aspects of women's art and design history.

13. See, for example, Rozsika Parker, *The Subversive Stitch* (London: Women's Press, 1984); Cheryl Buckley, *Potters and Paintresses: Women Designers in the Pottery Industry, 1870–1955* (London: Women's Press, 1990); Jude Burkhauser, *Glasgow Girls: Women in Art and Design, 1880–1920* (Edinburgh: Canongate Press, 1990).

14. See, for example, Lynne Walker, *Drawing on Diversity: Women, Architecture, and Practice* (London: Royal Institute of British Architects, 1997); Elizabeth Cumming, *Phoebe Anna Traquair* (Edinburgh: National Galleries of Scotland, 1993); Jill Seddon and Suzette Worden, *Women Designing: Redefining Design in Britain between the Wars* (Brighton: University of Brighton, 1994); Philippa Glanville and Jennifer Faulds Goldsborough, *Women Silversmiths, 1685–1845* (Washington: National Museum of Women in the Arts, 1990).

15. Martha Scotford, "Messy History vs. Neat History: Toward an Expanded View of Women in Graphic Design," *Visible Language* 28:4 (1994); John Walker, *Design History and the History of Design* (London: Pluto, 1989).

16. *Design Issues* 11:1 (Spring 1995).

17. See, for example, the essays by Victor Margolin, Adrian Forty, and Jonathan Woodham.

18. See, for example, Beatriz Colomina, ed., *Sexuality and Space* (Princeton: Princeton Architectural Press, 1992); Jane Gaines and

Charlotte Herzog, *Fabrications: Costume and the Female Body* (London and New York: Routledge, 1990).

19. See, for example, Elizabeth Wilson, *Adorned in Dreams: Fashion and Modernity* (London: Virago, 1985); Juliet Ash and Elizabeth Wilson, *Chic Thrills: A Fashion Reader* (London: Pandora, 1992); Caroline Evans and Minna Thornton, *Women and Fashion* (London: Quartet, 1989); Susan Porter Benson, *Counter Cultures: Saleswomen, Managers, and Customers in American Department Stores, 1890–1940* (Urbana: University of Illinois Press, 1988).

20. See, for example, Arthur Kroker and Marilouise Kroker, *Body Invaders: Sexuality and the Postmodern Condition* (London: New World Perspectives, 1988); Rosa Ainley, ed., *New Frontiers of Space, Bodies, and Gender* (London: Routledge, 1998); Elizabeth Grosz and Elspeth Probyn, eds., *Sexy Bodies: The Strange Carnalities of Feminism* (London: Routledge, 1995).

21. Morris, *Pirate's Fiancée,* p. 12.

22. Moore, "Getting a Bit of the Other," p. 167.

23. Ibid., p. 185.

24. Flax, *Thinking Fragments,* p. 220.

25. Sally Alexander, *Becoming a Woman and Other Essays in Nineteenth- and Twentieth-Century Feminist History* (London: Virago, 1994); Carolyn Steadman, "Landscape for a Good Woman," in Liz Heron, ed., *Truth, Dare, or Promise: Girls Growing Up in the Fifties* (London: Virago, 1985); Rosi Braidotti, *Nomadic Subjects. Embodiment and Sexual Difference in Contemporary Feminist Theory* (New York: Columbia University Press, 1994); Doreen Massey, *Space, Place, and Gender* (London: Polity, 1994); bell hooks, *Yearning: Race, Gender and Cultural Politics* (London: Turnaround, 1991); Morris, *Pirate's Fiancée.*

26. Braidotti, *Nomadic Subjects.*

27. Alexander, *Becoming a Woman,* p. 234.

28. Braidotti, *Nomadic Subjects,* p. 237.

29. Ibid., p. 238.

30. Attfield and Kirkham, Introduction, in Kirkham, *Gendered Object,* p. 3.

31. Gail Faurschou, "Fashion and the cultural logic of postmodernity," in Kroker and Kroker, *Body Invaders,* p. 79.

32. Kirkham, *Gendered Object,* preface.

33. Flax, *Thinking Fragments,* p. 221.

Cheryl Buckley

In the 1930s, industrial design came into its own as a profession in the America of the Machine Age, with roots in the Bauhaus and earlier twentieth-century European modernism. Male-identified and male-dominated, the profession accorded female designers limited welcome and recognition, despite the innovative work of many women in the field. Today, women are much more of a presence in industrial design, even though they remain underrepresented in the membership of professional organizations. With this presence comes a strengthened self-image. Among the growing ranks of women industrial designers practicing since World War II, there is no questioning of their right to work as equals in their profession and to be recognized as such. At the same time, many also identify as female and, for some, as feminists, as do the three designers featured in this chapter.

For Nancy Perkins, a practicing designer for over twenty years, being female and feminist means challenging the stereotypical role of designing "women's products." But for Perkins it also means bringing to bear an understanding of what makes effective design for products that are used mainly by women, such as kitchen equipment or other home appliances. For Amelia Amon, having a feminist awareness means using technology in appropriate, environmentally sensitive, and aesthetically pleasing ways, as in her use of solar power for products which are not gender-specific. For Wendy Brawer, a systems rather than product designer, it means focusing on innovative approaches to city services, such as garbage collection and recycling, that educate for and promote environmentally sound practices, and on fostering collaborative networks. For all three designers, identifying as both female and feminist means that both their technical proficiency and their artistic capabilities are givens. It means promoting, and encouraging the work and advancement of women as a critical part of their commitment to the practice of good design.

On Being an Industrial Designer: Rethinking Practice

Women Designers:

Making Differences

Nancy Perkins

Industrial design is relatively young among the design professions. It was not until 1978 that the Industrial Designers Society of America (IDSA) adopted its definition of the profession, which reads in part:

> Industrial design is the professional service of creating and developing concepts and specifications that optimize the function, value, and appearance of products and systems for the mutual benefit of both the user and the manufacturer.
> . . . The industrial designer's contribution places special emphasis on human characteristics, needs and interests that require particular understanding of visual, tactile, safety and convenience criteria.

The designer works as part of a development group which typically includes management and marketing, engineering, and manufacturing specialists. The industrial designer must be able to convince nondesigners about the merits of the proposed design, because nondesigners are responsible for allocating the usually considerable resources to allow the product's development to proceed.

Between one-quarter and one-third of practicing industrial designers belong to the IDSA. Women comprise only a little over 10 percent of this IDSA membership, although women currently are between 25 and 30 percent of those in industrial design schools, which number about forty-two programs in the United States. More critical is the fact that women are frequently not in influential positions in management, marketing, and manufacturing. On both counts, then, the number of women, as industrial designers or as business or corporate decision makers, who contribute to high-level decisions about product design and development remains small.

There are distinct losses when women are absent. Their presence makes differences. When women are missing from key decision-making processes of product development, criteria for what is comfortable, appropriate, and appealing to women may be overlooked.

Female points of view are currently very underrepresented with respect to the impact women's buying decisions have in the marketplace. Margaret Mead has noted how multiple perspectives are needed:

> Throughout history, the more complex activities have been defined and redefined, now as male, now as female, now as neither, sometimes as drawing equally on the gifts of both sexes, sometimes as drawing differentially on both sexes. When an activity to which each could have contributed . . . is limited to one sex, a rich differentiated quality is lost from the activity itself.[1]

Mead's point also suggests the fallacy of allocating design projects along stereotyped gender lines. Early in my career when asked to design baby-bottle warmers, I protested—and was assigned automotive test equipment. Given the task, what I didn't know I learned, quickly. I went on to design successful products, including automotive batteries, leak detectors for air-conditioning and heating, and mass transportation vehicles.

Yet it is also critical for women to work on designing products whose primary users are women. The experiences that women designers have in gendered roles can give them unique insights. The kitchen designs of my great-aunt, Anna Keichline, which unfortunately were never produced, and my own vacuum cleaner design, which was, are cases in point.

The Anna Keichline Kitchen, 1924

Anna Keichline graduated from Cornell University's School of Architecture in 1911 and became the first woman listed as an architect in Pennsylvania. She not only designed over two dozen buildings; she was awarded seven patents, including one for a notched brick in 1927. The K brick (as it came to be known) was a clay brick for hollow wall construction which featured breaking slots and notches that provided predetermined fracture points for customization at the jobsite. In 1924 she patented her kitchen designs.

Keichline described the special features of her "kitchen equipment":

> In kitchen furnishing, people seem to have been content to place one box upon another, install a few shelves and call it a kitchen cupboard, or to elaborate somewhat on this and call it a kitchen cabinet and to carry out this same unstudied scheme with all other kitchen equipment.
>
> Although this may not be the last word in this line, in considering the large number of inconveniences we have hitherto accepted in the work of cooking and cleaning, in the storage of foods, it is surely a step forward for a more convenient working arrangement, for better sanitation, for minimum cost of operation, and for more attractive design.

Features of Keichline's kitchen-construction patent include an oven with a fireless cooker on one side and a steam cooker on the other side, arranged behind a cooking surface so that the "front forms a working space for the food to be placed in the oven, cooker or steamer." In addition to this convenience feature, the burners were aligned side by side, relieving the user from the burden of lifting

heavy pans of liquid from a rear burner. The cabinets have glass
doors that allow the user to see the contents. There are no shelves
at a low level, "thus rendering it unnecessary for persons to stoop
over to reach articles placed on low shelves" (figs. 9.1 and 9.2).

Just imagine if these design features had set the standards for
kitchen design. If her ideas had prevailed, we would not be enduring
the discomforts that continue to this day. The precedent set and fol-
lowed by the entire major appliance industry has instead become
the only choice available. (The glass-door cabinets of the twenties
and thirties have long been superseded by opaque models.)

As an architect, Keichline extended her work and ideas more
broadly to the design of houses. In an article entitled "More about
the Advantages of Having a Woman as Architect for the Home,"
published in 1936 in *The Philadelphia Inquirer,* newspaper colum-
nist Eleanor Morton quoted Keichline:

In using a kitchen cabinet, ordinarily we lay down a spoon, open the door to a cabinet take out a box of baking powder, take the lid off, take out a spoonful, put the lid back on the box, and close the cabinet door. Imagine a carpenter going through this procedure to get a brad . . . deep doors could be used to hold these materials and a small valve could be operated with one finger; there would be no need to open doors or reach for a box.

. . . The equipment of houses, especially, has been developed by people who seldom have experience using or operating these materials. Women as engineers or architects have immense opportunities there. There should be scientifically built houses and this can be done better by women than men. Indeed this will never be accomplished until women take hold.[2]

Redesigning a Vacuum Cleaner: A Success Story

Technical skills and knowledge of new and rapidly changing technologies and how to apply them are critical for the industrial designer. In 1981, my design for a new canister vacuum cleaner for Sears was one of four tested with consumers. Intended to replace a product in use for fifteen years, the new vac would be judged on how well it contributed to comfort and ease of use. Equally important to its success was how well the appearance communicated to the user the convenience features for performing tasks. In the final design, visual expression of the customer-benefit features had to be so obvious that the product would be self-selling. When the four designs were tested, the market research focus groups overwhelmingly favored my design. It has proved to be a top seller and is still on the market.

One of the most interesting comments made by a woman in the focus group was that my model "looked like it was designed by a woman." Since I was observing in confidence behind the glass, I couldn't ask her what she meant by her remark.[3] Attention to such properties as size, weight, balance, and ease and versatility of use were important design criteria.

Size, weight, and balance. The overall shape of the vacuum is as small as possible to accommodate the motor, bag, and venting requirements, making the product actually, and in appearance, as lightweight as could be.

Weight distribution is best for the user when the motor is in the rear, which becomes the pivot point of the cleaner as the user lifts the product to carry it to the cleaning site. The wheels are also located in the rear, allowing the unit to be rolled into vertical storage without the user having to lift it (fig. 9.3).

Fig. 9.3. Sears canister vacuum
cleaner, in storage position
(Nancy Perkins)

Fig. 9.3. Sears canister vacuum cleaner, in storage position (Nancy Perkins)

The location of the carrying handle optimizes balance because it is nearly centered on the unit, allowing the unit to be held comfortably next to the body.

Operation. The vinyl bumper, which wraps around all sides except the center back, is the vacuum's outermost point, protecting it from abrasion and protecting furniture and walls from damage. The controls are located on the top rear surface and can be activated by the foot or the hand. Tools can be conveniently reached by lifting a lid (fig. 9.4).

Communication. Most of the features that benefit the customer are a contrasting color from the main body. These features become self-selling devices (the wheels, which convey mobility; the bumper; the padded handle; tools; and controls).

Fig. 9.4. Sears canister vacuum cleaner, general view (Nancy Perkins)

Design and Change

As women begin to form a critical mass in the profession, creating our own businesses and networks, perhaps trying to fit in with male-defined norms of what is aesthetically pleasing, of what is most comfortable and easy to use, will become obsolete. We need to continue to document our work, its impact and direction, and to rethink in our own terms the designs required for creative and meaningful change in our physical environments.

The concern in my work is to counter a potentially calamitous direction in technological development, based as much of it is on military and corporate priorities. How can design fulfill human needs while maintaining ecological protection and restoration? How can designers do more than replicate industrial products and policy? How can we create technologies to be more humanistic and more harmonious with the natural environment?

We have reached a point in time when women's influence on technological progress is crucial. This does not mean that feminists become part of a Luddite movement to turn back technology. Rather, it means that feminist designers practice and promote technological thinking and approaches that enhance and improve the quality of life. The use of computers, rather than making production more centralized, should encourage the networking of energy suppliers and niche markets. The combination of environmental technologies and the ability to produce exactly and only what the customer desires may be the essential paradigm shift. The challenge is to move from an economy where designers help corporations push products with the bottom line in mind to one in

The Domestication of Space-Age Technologies

Amelia Amon

which designers have a central role in interpreting people's needs and wants for production.

Appropriate technologies, alternative energy sources which use natural systems, are probably our best hope for long-term sustainability. Solar, wind, and biomass tend to be localized, small-scale, and owned and operated by individuals, families, or communities. Their application is scaled minimally and is very site-specific. To apply them requires patient, careful engineering, in which multiple factors are considered simultaneously. Countering mass-produced overbuilding and redundancy, appropriate design goes against standard methods and goals of governmental and industrial megaprojects. Aesthetics and aesthetic responses, which are integral to appropriate design, would no longer be trivialized.

My own design work has moved toward alternative energy, local manufacturing, and ecologically sensitive products. For example, working with the Parks Council, I have installed a photovoltaic-powered waterfall in a small neighborhood park in the Bronx in New York City. In 1994, I developed a solar-powered vending cart for Ben & Jerry's Ice Cream. Photovoltaic panels run a compressor, which keeps the ice cream cold. When working with solar panels, the whole system must be made more efficient. The electrical system is fairly simple and composed of existing components (fig. 9.5).

As the designer, I worked to create a balanced system. In order to best utilize the trickle of power from photovoltaics, all other systems must be smaller in scale, more efficient, and more direct. Designing with solar requires knowledge of the conditions of the site, the latitude, the orientation to true south, and the prevailing wind conditions. Elements of landscape architecture, biology and botany, anthropology, design, sculpture, and ergonomics must be considered along with the basic electrical mechanics. Maximizing the potential of these systems requires adaptive and contextual thinking.

The newest version of the Solar Freeze ice cream cart was designed and built for NESEA, the North East Sustainable Energy Association. The roadworthy cart frame holds a superinsulated, five-cubic-foot stainless-steel freezer compartment and a complete system for solar refrigeration and energy monitoring and storage. The solar canopy holds four unbreakable photovoltaic panels. The cart is quiet and efficient and requires minimal maintenance (fig. 9.6).

The solar battery charger was designed for home use. Instead of creating another disposable plastic case to be discarded a few years after purchase, we provided a wooden box that looks attractive sitting on a windowsill. Batteries can be left in it all the time, because it delivers a very slow or "trickle" charge. The box is made of scrap wood in upper California, and the interior is made by vacu-forming, which makes sense for small-scale production (fig. 9.7).

Fig. 9.5. Ben & Jerry's ice cream cart (Amelia Amon)

Fig. 9.6. Solar Freeze vending cart: photovoltaic canopy supplies energy to the refrigeration system to keep ice cream frozen (Amelia Amon)

The Domestication of Space-Age Technologies

Another design using photovolatics is a solar streetlight. Designed especially for northern latitudes, the solar panel is mounted at a sixty-degree angle to shed snow and maximize solar gain when the winter sun is low in the sky. The system, of steel construction, is entirely self-powered and can provide light for up to eight evenings, dusk to dawn, even in the worst conditions. It can be easily disassembled for routine maintenance. A garden fountain designed for an exhibit at the Cooper-Hewitt National Design Museum features an innovative use of photovoltaics. The cells are integrated into the design of the fountain itself so that the water flows over the cells (fig. 9.8).

At the Institute for Policy Studies in Washington I have teamed up with the Women's Power Project to explore the potential for solar electrification of a widows' silk-spinning cooperative in West Bengal, India. A small, quiet motor and electric water heater can upgrade the quantity and quality of the fabric produced, allowing local women to sell directly to the market instead of to a middleman. Other possible projects include a rice mill and a rope-making machine, as well as initiating a day care center. The method of Daphne Wysham, who runs the Women's Power Project, is to spend extended time in an environmentally and economically distressed area to listen to people's needs. Our project works specifically with impoverished women who have been left out of economic development. Like the women of the Chipko movement in northern India, these women are actively protecting their nearby forests from poachers. Our aim is to help them and their community to develop an alternative livelihood to cutting timber for commercial sale, and to ensure that livelihood is environmentally sustainable and builds greater equity between the sexes.

Although there is no universal women's value system, that we are seen as less hierarchical, more contextual, and more influenced by relationships and compassion can encourage us to bring these at-

Amelia Amon

128

Fig. 9.8. Garden fountain as included in the exhibition "Under the Sun," Cooper-Hewitt, National Design Museum, Smithsonian Institution, 1998. The fountain embodies the animation of water on an organic form. Energy from the sun runs a small hidden pump to recycle the water from the basin through the stem and over the curved solar panels (Amelia Amon)

tributes to bear in a world that needs them. In our design work, we should recognize and apply our own capabilities, aesthetic sensibilities, wisdom, and concerns. Technology devoid of art and compassion can only be ugly and meaningless.

Although women are often associated with and are active in environmental issues and design, they have tended not to be called on as experts. This is changing. Women are increasingly visible on panels, in organizations and government, and as speakers and consultants when the subject is ecologically and socially responsive design. I think it important that, as designers, we refine our skills,

Sustainability and the City

Wendy E. Brawer

work together as teammates, and encourage the recognition and representation of women and their contributions to these critical areas.

At my company, Modern World Design, among our special concerns is sustainability and the city, New York City in particular. As an industrial designer, I seek systematic design solutions rather than focusing on product design. These are a few of the projects I have been engaged in recently.

The Greening of Manhattan Plaza

I was invited by the management at Manhattan Plaza to set up an environmental program for this 1,700-unit apartment complex. Located on the West Side in mid-Manhattan and built with a combination of public and private funding, it offers subsidized housing for people in the performing arts. The complex is beautifully maintained. The project's goal was to create an inviting pathway to encourage daily habits that would reduce the residents' and staff's environmental impact. The first thing I built was a mobile environmental center. This EcoCart with its friendly attendant goes where the people go, to the building lobbies and to events, places where it is easy to approach. People can get information, ask questions, take materials home, etc. The EcoCart is made of recycled and renewable material and opens up into a display where the theme changes frequently. We try to illuminate all the interconnected elements within a theme, such as tying water conservation at home with appreciating the Hudson River, just three blocks away to the west (fig. 9.9).

The display on recycling featured different kinds of garbage, each labeled to show which bin it belongs in. Locally purchased new products and packaging made of recycled materials on display showed residents the value of their simple act: recyclables actually can have a second life. We showed videos on recyclable sorting and scrap processing, as well. Every apartment received a chart with a bird's-eye view of the floor's recycling room. We ran tours of the bottom of the trash chute, so residents could see where the trash and resources go after leaving their hands. The children who lived there were asked to grade all the recycling rooms. This turned out to be a really powerful thing to do: we gained all these young advocates for recycling and by posting the grades at the EcoCart and on each floor, we generated people's interest in improving (fig. 9.10).

The children did a whole lot more. Among their activities, they mapped the street trees that form the "canopy" for Manhattan Plaza. In their surveys, they found which trees had plastic bags caught in them or otherwise needed some kind of help. They then

Wendy E. Brawer

130

Fig. 9.9. EcoCart, Manhattan Plaza (Laura Wolf)

Fig. 9.10. Manhattan Plaza's EcoClub on field trip to "Garbage!" exhibit on the history of sanitation in New York City, New York Public Library, 1995 (Wendy Brawer)

went on to connect with the global environment. Holding a penny drop, they raised 9,500 pennies—which was enough money to adopt a piece of rain forest exactly the same size as their 2.6-acre housing complex! This land is now protected forever, and the residents know their home is reflected in a rain forest in Costa Rica.

Sustainability and the City

"Everyone Deposits, Anyone Redeems"

When I served on the Solid Waste Advisory Board in New York City, I proposed a recycling concept to the then commissioner of sanitation, Emily Lloyd.[4] I was inspired by the people who go around the city collecting bottles and cans from garbage cans in order to redeem them for deposits, since they are so effective at recycling resources that would otherwise go to the dump. My plan was to help the can collectors by making bins where pedestrians could leave their empties. The bins would encourage those wanting to redeem these empties to take them. Through Commissioner Lloyd I met the president of the Times Square Business Improvement District (BID), Gretchen Dykstra, who hired me to develop and build some of these as a pilot project for Times Square. These Times Square Deposit Banks were made of 20 percent postconsumer recycled plastic and sported the message "Everyone Deposits, Anyone Redeems." Since it was important that people maintain their dignity while collecting bottles and cans, the bins were mounted at eye level on lampposts so most people would not have to bend over to look into them. Collectors can see very quickly if the bin contains the kinds of bottles and cans they want (fig. 9.11).

Wendy E. Brawer

Confetti Redux

Every year there is a big New Year's Eve party in Times Square, which wouldn't be a celebration without the confetti. The Times Square BID uses three tons of confetti each year: the biggest, brightest, most photogenic confetti anywhere. The BID also throws confetti at the annual summertime "Broadway on Broadway" party, an all-day event which features performers from Broadway shows. "Why don't we sweep up the 'Broadway on Broadway' confetti and throw it again at New Year's?" I asked. The BID did—and saved a whole lot of confetti.

Fig. 9.12. Green Apple Map logo, © Modern World Design, 1997

Green Maps

When Modern World Design produced the second edition of the Green Apple Map of ecologically significant sites in New York City, I began to develop a collaborative method to encourage creating Green Maps in cities everywhere. The Green Map System is a globally designed strategy for identifying, promoting, and linking eco-resources within cities. Using the System as the inspiration engine, we are generating the energies to bring people and environmentally elegant ideas together. As of October 1998, eighty-five cities in twenty-four countries have begun making Green Maps for their own cities, with thirteen published so far, including the third edition of New York's Green Apple Map (fig. 9.12).

The local Green Mapmakers who elect to participate in this environmental social project can use the System and its shared set of one-hundred green-site icons at no cost. Locals make all the decisions regarding their Green Map's content, appearance, format, funding, distribution, and accessibility on the System's website. Each map encourages residents and visitors (both real and virtual) to participate and discover their city or towns' environment. The project supports resource-efficient communication techniques that depend on and promote local knowledge, action, and responsibility. The Web site at www.greenmap.org shows the Green Maps and the latest news and ways to foster stewardship and sustainability at the community level.

"Designing Desires"

The Green Map project is an example of the trend toward collaborative networks to promote ecologically and socially responsive design. For designers to switch from an obsolescence-oriented approach to more eco-systematic thinking means rethinking our entire notion of industrial design. Through a variety of workshops,

charettes, special events or ongoing projects, they are turning to each other for help, establishing collaborative networks. Groups within the international O2 Global Network based in the Netherlands, for example, have promoted the idea that designers have a special responsibility in their daily design work and a unique potential for building a more sustainable society. At a recent O2 meeting, one group focused on "Designing Desires." How do we design things or "not-things" that make people not only want them today but also desire to keep them for the long term? Other O2 groups focus on education and training and on technical issues that combine with social, organizational, and cultural impacts. Closer to home, the IDSA, through the efforts of the environmental concerns committee, has officially added ecological impact to the criteria for judging their annual product design competition to those including innovation, user benefits, and aesthetics.

Multidisciplinary collaborative networks are developing into communities of change agents as we shift toward more appropriate, sustainable practices, to change the way competition and traditional hierarchies are viewed within industries, and to further the task of reconsidering and balancing the relation between production and consumption.

Notes

1. Margaret Mead, *Male & Female: A Study of the Sexes in a Changing World* (New York: Morrow Quill Paperbacks, 1967), p. 374.

2. Eleanor Morton, "More About the Advantages of Having a Woman as an Architect in the Home," *Philadelphia Inquirer,* March 12, 1936.

3. More recently, I thought of her comment again when, of a dozen automobile designs by students, I preferred one in particular, which turned out to have been designed by the group's only female student.

4. Mandated by law, the board, made up of a wide variety of professionals, has as its purpose to advise the Department of Sanitation about solid waste, that is, garbage.

Participatory Design at the Grass Roots

Roberta M. Feldman

The community needs to be built by us.

If anything comes up in here for us, it's going to come through us. . . . There just comes a point and a time when there's a need for something, and a group of people gather and decide that they are going to do this for the benefit of their community—they can do it.

We don't give up. . . . We're willing to fight for what we need here and what we want here, and I think that's the strength we have.

Words like these, spoken by public housing residents, never make the headlines. Yet such statements are frequent among residents of Wentworth Gardens, a low-rise public housing development in the South Armour Square Neighborhood on Chicago's South Side. These residents are women community activists, and their words reflect an ongoing commitment to fight for their right to safe and decent shelter.

I have been working with Wentworth women residents to assist their efforts to alter the living conditions that threaten their housing development's viability, focusing in particular on their sustained efforts to design, develop, and manage facilities to meet their daily needs.[1] I will report on their efforts and use these observations to suggest the importance of participatory design and development practices in support of building productive housing communities and, more broadly, social justice.

"Participatory design" is a term that covers a variety of strategies to engage user participation in the decision-making process in architecture and planning, building construction, management, and maintenance of the built environment. Such strategies have been shown to achieve greater user satisfaction, social well-being, and empowerment, as well as a greater sense of and commitment to community.[2] Such strategies are rarely considered in the context of public housing. For policymakers and the public alike, the role that women public housing residents have played and can continue to

play in sustaining and improving their living conditions all too often remains invisible.[3]

"Down" with Public Housing

In the United States today, a sixty-year history of federal support for public housing programs is at risk of being dismantled.[4] Whether or not one deems this program a failure, there is considerable consensus regarding the most pressing problems: the homes of approximately four million Americans are beset by underfunding; related poor management and maintenance; the concentration and social and physical isolation of poor, minority families; inappropriately designed housing located in generally undesirable locations; lack of adequate, accessible services and employment opportunities; and crime and vandalism.

The governmental disinvestment in public housing is having dire effects on its residents, mostly women and their children. The vast majority of public housing residents are single-headed households, most—three-quarters of households nationally in 1989—headed by women.[5] Public housing has become "essentially a women's housing program," a "distinctly gendered urban problem."[6] In fact, the "feminization of poverty" was first recognized in the context of public housing.[7]

Despite its numerous problems, public housing in the United States remains the federal government's primary housing program for low-income Americans, with demand exceeding supply. Most large cities have long waiting lists of applicants anxious for apartments.[8]

Policymakers and designers committed to working towards safe and decent shelter for all are faced with the increasingly daunting challenge of trying to piece together strategies in an underfunded and politically unpopular program. Around the country, redevelopment plans for several large public housing complexes are calling for mixing incomes and redesigning under the New Urbanism model in the hope of restoring "healthy" community life. While the intentions may be good, these are untested strategies. Moreover, the "community life" planners seek to bring to lower-income families is defined by the dominant cultural norm rather than by research on and recognition and support of the existing, constructive community building that exists in public housing and other low-income neighborhoods.[9]

At Wentworth Gardens, women residents have formed a strong community which, for over three decades, has worked to build and maintain services and facilities that have otherwise been neglected by the public housing authority.

Roberta M. Feldman

136

Fig. 10.1. Typical courtyard at Wentworth Gardens showing row houses in foreground and three-story walk-up apartment buildings on the left rear (Roberta Feldman)

Early Design and Development Efforts

Wentworth Gardens, a low-rise, 422-unit development, is one of the nineteen Chicago Housing Authority (CHA) family public housing developments (fig. 10.1). Originally planned for black war workers, Wentworth was occupied in 1947. Its residents were, and continue to be, low-income African American families. Today, Wentworth Gardens is home to approximately 1,300 people, living primarily in female-headed households.

Beginning in the early 1960s, programs and services once provided by the Chicago Housing Authority were eliminated and physical conditions allowed to deteriorate. Since this time resident activists (fluctuating between fifteen and twenty) have engaged in effective organizing campaigns and have formed organizational vehicles, in part to design, develop, and manage several on-site service facilities addressing their unmet community service needs.[10] These services and facilities have included a day care program and a youth recreation program, a laundromat (fig. 10.2) and a convenience store (profits from which are returned to the community; fig. 10.3), community gardens that have produced goods for the convenience store, a spiritual development center, and food programs for the infirm and elderly.

Creating and sustaining the service facilities has not come easily. Residents did not have the space or the funds to support these services. For instance, the activists' first organized effort was in the 1960s, when management closed Wentworth's only community space, the fieldhouse, and dismantled its youth recreation programs. Wentworth activists organized their development to put

Participatory Design
at the Grass Roots

137

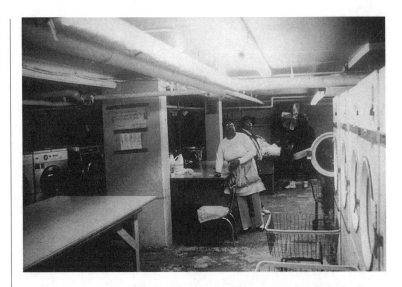

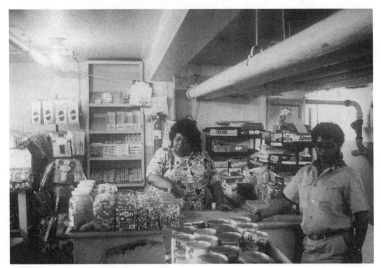

pressure on management to reopen the fieldhouse and reinstate the youth programs:

> Well, I think, the only thing that needs improvement here [can be solved by] the residents coming together and coming up with different things that concern the community. . . . Now, if you want something nice and clean and good, you come together; you start working on it. You don't sit and just leave it like that. (Mrs. Dumas, a long-term Wentworth activist)

But management declined. Residents then requested the right to operate the fieldhouse themselves. Management again declined, deeming the residents unreliable and incapable.

With no options left, the women decided to act on their own with the material resources that they could count on as theirs:

> We didn't have anything. So what we did, we sat down and decided, what could we start with nothing. . . . We decided we'd start a small preschool program because one would bring a ball and different little things that we had at home, and that's how we began. (Mrs. Amey, a Wentworth activist leader)

They managed to get permission to use a small room in the fieldhouse to operate a successful childcare program, accommodating twenty-five to thirty children five days per week for two years, staffed exclusively with resident volunteers, before the CHA finally did officially grant the residents control of the entire fieldhouse facility.[11]

At Wentworth, as in public housing developments across the country, the original designs did not provide adequate space for community services and programs. Daily shopping needs also were not accommodated. Residents have to make do with less than desirable spaces, often in unused basements, which are prone to floods and infestations. To develop these facilities, activists have had to rely on their personal funds and raising monies through bake and food sales. Yet with inexpensive materials, much ingenuity, and their own labor, residents have managed to make these facilities useful and attractive.

Design and Development of a Neighborhood Shopping Center

With each project, resident activists have improved their management skills, sense of self- and group-efficacy, and credibility with local management to move on to other design and development projects. Recently, Wentworth activists chose to extend their efforts beyond the boundaries of their housing development into the surrounding neighborhood. The past abandonment of neighborhood retail facilities and recent demolition of the remaining eleven retail businesses that were torn down to make way for a new White Sox baseball stadium, Comiskey Park, left the community without shopping facilities serving the daily needs of residents.[12] Currently, Wentworth residents, using mass transit with infrequent service, are required to travel a minimum of two miles to the nearest grocery store.

Wentworth activists, as a result of their visibility as grassroots community organizers, served a leadership role in the formation of the South Armour Square Neighborhood Coalition (SASNC) with their neighbors, first to fight to stop the stadium construction, later

to pursue the design and development of a sorely needed retail shopping center directly south of their housing development.

> We need to get the places [stores] built up by there [across the street]. That would be nice. It's somewhere where the teenagers can go and have a little fun. We're going to have a store so we won't have to go so far. Maybe a restaurant, so if somebody wants to get some food or something to eat, they don't have to go so far to get it. It will be right across there [the street]. It would be so nice for a whole lot of things. (Mrs. Butler, longtime volunteer and activist)

While Wentworth activists have brought essential skills and commitment to this project, the technical, economic, and political obstacles have been great.

Accomplishing Technical Challenges through Collaborative Methods

In the past, the residents' reliance on technical assistance was minimal. Given the scope of this project, however, they recognized that their technical skills and resources needed supplementing. They allied themselves with a multiprofessional team of consultants and technical assistants to pursue a collaborative model of working together, one in which SASNC members' skills would be recognized and cultivated to ensure the ongoing success of this and future projects.

The first task was to conduct an extensive survey of existing retail facilities in the market region and to identify a preferred site for the new project. Ownership and zoning regulations for several sites were investigated. Types of businesses that individual members of the SASNC might want to develop and manage were discussed, and coalition members and their technical assistants from the University of Illinois at Chicago (UIC) Voorhees Center visited local examples of these targeted businesses. A market questionnaire was developed by the collaborative team. The involvement of the SASNC members was responsible for a strong response rate in the surrounding neighborhoods, in particular at Wentworth, where 53 percent of all residents responded. Of those interviewed, 87 percent said they would shop at a locally developed center.

SASNC members expressed an interest in developing a cooperatively owned grocery store. A consultant specializing in cooperative ownership of retail facilities was employed by the Voorhees Center to provide an educational program and feasibility study. Coali-

tion members and a technical assistant visited several cooperatively owned food stores in Chicago and evaluated alternative co-op ownership models.

Tensions occasionally arose from different goal orientations. On the one hand, the technical assistants had been asked to bring skills to the collaboration that were future-oriented and geared to securing the technical and economic viability of the project. On the other hand, and not surprisingly, coalition members tended to choose to contend with more familiar tasks and to work on what was most immediate and tangible using the skills they already had. They identified the businesses they wanted to develop and manage, all of which were the same as or similar to those they had operated at Wentworth, but not all of these appeared economically feasible in the market study. Compromises were made. Wentworth SASNC members agreed to drop their plans for a commercial laundromat when it emerged that there was little demand in the surrounding community. The desire for a food store with fairly extensive merchandise was scaled down to a more viable size. But community residents remained adamant about the need for a youth facility, even when the technical assistants offered compelling arguments about its marginal economic feasibility. A large multipurpose room was included in the tenant mix to house both youth activities and rental space for community events.

Investigations into the preferred site continued as the SASNC, with the assistance of an organizer from the Voorhees Center, had an initial discussion with the Archdiocese of Chicago, the owner of the largest piece of property in the site. But it was Wentworth activist leader Mrs. Amey's connection with the archdiocese, specifically in her guiding role in developing and maintaining one of the community gardens on this very land, that gave the team an "in" to get both an appointment and a very encouraging response to the coalition's request for an option to purchase the land.

With the technical information in hand—zoning and site analyses, and program—prepared primarily by myself and the other technical assistants from the UIC City Design Center, we worked with SASNC members in participatory planning and design workshops to develop three alternative schemes and cost estimates for the preferred site (fig. 10.4).

The participatory design workshops further revealed differences between the coalition members' images of a desirable shopping center and the predilections of the professional designers. Fellow architect Jack Naughton and I showed slides of shopping centers in the Chicago region and from around the world, with the unstated hope that an innovative model might be considered. Many of these

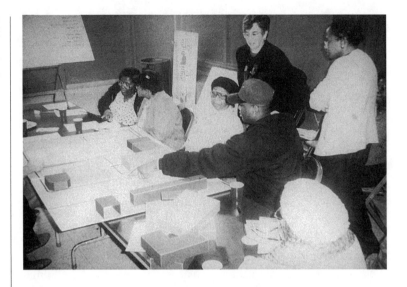

slides portrayed collective markets that could accommodate small, entrepreneurial businesses. But coalition members had a clear preference for a large shopping center, a model they were all familiar with from middle-income African American neighborhoods on Chicago's South Side. This image portrayed what they believed was a proper shopping center, one which fit their aspirations, whereas they described the collective markets as "messy" and "not like the way we live here." The architects were disappointed that the coalition preferred a conventional retail model but also were concerned that the preferred model required stores that were considerably larger than was feasible. Ongoing workshops to develop the schematic design alternatives resolved the disagreement. Materials and massing were used to create a design that resembled the preferred image, while the project feasibility was attended to by accommodating appropriately scaled facilities.

Formal innovation, in fact, was achieved in the elaboration of the preferred scheme chosen from the three schematic design alternatives. Craig Wilkins, a visiting architect at the City Design Center, worked with SASNC members to devise a formal vocabulary derived from what he called traditional African architecture. He created buildings with flat roofs, clad in modular masonry panels with exposed beams, decorative tiles, and window openings that are reminiscent of some vernacular architecture in Africa. All involved were quite satisfied with his redesign of the center's exterior facade. The resulting scheme included a grocery store, restaurant and a multiuse space connected by a Community Economic Square, several small retail facilities clustered in one structure around a central interior court (fig. 10.5).[13]

The process of designing and developing the plans for the shop-

Fig. 10.5. Site perspective of final schematic design for the SASNC shopping center (Craig Wilkins)

ping center not only accomplished the required technical tasks but also assisted in community organizing efforts. Participation in the initial designing and planning of the shopping center helped build and sustain interest in the project. In the words of one coalition member, "It makes it real."

With the necessary information and with the assistance of an economic development planner from the Voorhees Center, the SASNC developed a plan for a $1.5 million shopping center, with a not-for-profit organization comprised of coalition members as owners and operators of the anchor facilities. A subsidiary of this organization would develop, lease, and manage the retail and multiuse space in the shopping center in a joint venture partnership. The parent corporation would develop and implement two initiatives to maximize the economic impact of the commercial development: first, a micro-business development program and retail development institute; second, a work-force preparation program to ensure jobs for neighborhood residents through entrepreneurial opportunities, cooperative ownership in the grocery store, and employment in the proposed retail facilities.

The Struggles for Economic Resources

Since Wentworth resident activists do not have the economic resources to develop the shopping center, the technical assistance required in the initial development stages was donated. Although the SASNC applied for funds from local government and from foundations, the organization received only a minimal planning grant from the City of Chicago (fourteen thousand dollars). The coalition attempted to secure further development funds from two sources. With the assistance of a legal team who contributed their time, they filed a lawsuit against the White Sox Corporation, the Illinois Sports Authority, and the City of Chicago, seeking reparations for the destruction of their neighborhood that resulted from the new stadium development. Pat Wright from the Voorhees

Center also assisted the SASNC in their proposal for both local and federal Empowerment Zone funds. While their Empowerment Zone application was approved by the review panel, it did not receive the Chicago City Council's endorsement. It is believed that the alderman of the ward in which the South Armour Square Neighborhood is located does not view the African American residents in this area as part of his constituency. The lawsuit also has been dismissed, with the conditions for the appeal personally costly for the coalition members.[14] It is clear that without governmental and not-for-profit and/or private corporate support, this project will not be possible.

The Struggles for Power

Public housing residents' rights over the design, development, and management of the material and spatial resources of their housing development and their neighborhood cannot be taken for granted. While the women involved can celebrate the "modest victories" of facilities such as the laundromat and convenience store described earlier, the situation remains tenuous, requiring constant vigilance and attention.[15] Moreover, these enterprises, providing only modest volunteer stipends for the operators and managers, would not be viable businesses in the "open market."[16] Without legal authority and conventional political power, Wentworth activists have had to defy images of their capabilities and overcome institutional regulations regarding their rights to control these settings through ongoing grassroots political action.[17] To do so, they have organized and strengthened both informal resident relationships and formalized not-for-profit organizations within their development. As we have seen, they have sought out alliances with technical assistants from neighboring universities, while at the same time gaining a sense of self-efficacy and individual and collective skills and resources for political action. They have developed understandings of the structural and institutional barriers to their access to safe and decent shelter and have acted to resist these obstacles by continuing their struggles to improve their living conditions.

Wentworth activists' homeplaces have become what bell hooks, adapting Foucault's phrase, has called "sites of resistance."[18] She has argued that African Americans' struggles to make and sustain homes and communities have historically provided more than a domestic service. They have had a "subversive value" as a source of political action. Extending this thesis one step further, I have argued that this ongoing struggle for the appropriation of homeplace not only has created a site of resistance but is an act of resistance.[19]

The Future

The SASNC members, now primarily Wentworth Gardens residents, have not entirely abandoned their plans to develop and manage a shopping center; rather they have put the plans on hold while they work on a more pressing concern. In December 1989, the activists formed a nonprofit organization, the Wentworth Gardens Resident Management Corporation (RMC) and, as of June 1, 1998, have assumed management of their development. These women see resident management as the only way to ensure for themselves a measure of control over their access to secure, safe, and decent shelter, and indeed over the very survival of Wentworth Gardens.

> We don't give up. . . . We're willing to fight for what we need here and what we want here, and I think that's the strength we have; and [we are] learning to pull people together to fight for what is needed. (Mrs. Bryant, Wentworth activist)

The hope is that in the future the Wentworth RMC will assume the leadership in continuing the effort to develop the shopping center in the South Armour Square Neighborhood.

The Politics of Social Reproduction Meets the Marketplace

Women of color with low incomes typically cannot rely on financial resources or electoral politics to achieve their goals, although they do achieve power from the bottom up, through community-based grassroots activism.[20] In particular, these women bring motivations and critical skills to collective grassroots political actions cultivated in part through everyday routine activities of maintaining households and communities, tasks—such as food purchasing and its preparation and serving, child care, laundry, maintenance of social relationships, and so on—necessary to the "social reproduction" of individual households as well as the social arrangements they make to protect, enhance, and preserve the cultural experiences of all members of the community.[21]

Motivated by unmet social reproduction needs, Wentworth activists have further cultivated their political consciousness and grassroots political skills to take on new struggles to ensure the ongoing availability of facilities and services necessary to meet everyday life needs, for example, the design and development of the new shopping center. At Wentworth Gardens, as at resident-managed

housing sites nationwide, the politics of social reproduction has met the marketplace.

Participatory Design as an Essential Strategy in the Revitalization of Public Housing

HUD's and many local housing authority's current, prevalent strategy of imposing public housing redevelopment plans on residents, typically without adequate opportunity for their participation in the environmental decision making that will determine their future housing, is inherently unjust and unwise. Involving residents in the design, development, and management of their housing builds on existing community-building efforts and leads to a higher likelihood of success. For instance, John Turner noted how individual and community pride, capabilities, and commitments are developed in the process of gaining "dweller control" of housing. Similarly, Jacqueline Leavitt and Susan Saegert, in their study of what they called the "community household," described low-income African American and Hispanic collaborative households' action of "staking a claim" to abandoned buildings in Harlem by transforming them into cooperative housing. Lawrence Vale, in his research on the comprehensive redevelopment of three public housing developments in Boston, found that the success of the redevelopment efforts was dependent, in part, on the presence and involvement of long-term resident organizations.[22]

Participatory design is an essential means for achieving social justice by putting control of the creation, modification, enhancement, and maintenance of the physical environment in the hands of the public, and in particular, people such as the women who live in Wentworth, who typically are excluded from environmental decision making and production. The support of public housing women's empowerment through participation in designing, developing, and managing their own housing development, including all the facilities to house necessary services and programs for daily life, has become increasingly urgent as safe, decent, and affordable shelter becomes more scarce.[23]

Notes

1. I have provided technical assistance to Wentworth Gardens resident activists through the City Design Center at the University of Illinois at Chicago and have conducted action research on their efforts with my colleague Susan Stall from Northeastern Illinois University.

Roberta M. Feldman

146

2. Mark Francis, Robin Moore, Daniel Iacofano, Stephan Klein, and Lynne Paxson, eds., "Design and Democracy (Special Issue)," *Journal of Architectural and Planning Research* 4:4 (1987): 271–360.

3. Myrna M. Breitbart and Ellen J. Pader, "Establishing Ground: Representing Gender and Race in a Mixed Income Housing Development," *Gender, Place, and Culture* 2:1 (1995): 5–10; Roberta M. Feldman and Susan Stall, "The Politics of Space Appropriation: A Case Study of Women's Struggles for Homeplace in Chicago Public Housing," in Irwin Altman and Arza Churchman, eds., *Women and the Environment* (New York: Plenum, 1994), pp. 167–99; Jacqueline Leavitt, "Women under Fire: Public Housing Activism in Los Angeles," *Frontiers* 13:2 (1992): 109–30.

4. Jacqueline Leavitt, "Reassessing Priorities: Sixty Years of U.S. Public Housing," *Cite* 33 (1995): 16–18.

5. U.S. Department of Housing and Urban Development, Office of Policy Development and Research, "Characteristics of HUD-Assisted Renters and their Units in 1989" (Washington: D.C.: HUD, 1992).

6. Leslie Kanes Weisman, *Discrimination by Design: A Feminist Critique of the Man-Made Environment* (Urbana: University of Illinois Press, 1992); Daphne Spain, "Public Housing and the Beguinage," in Judith A. Garber and Robyne S. Turner, eds., *Gender in Urban Research* (Thousand Oaks, Calif.: Sage, 1995), pp. 256–270.

7. Diana Pearce, "The Feminization of Poverty: Women, Work, and Welfare," *Urban and Social Change Review* 11 (1978): 28–36.

8. John Pynoss, *Breaking the Rules: Bureaucracy and Reform in Public Housing* (New York: Plenum, 1986).

9. Roberta M. Feldman and Martin Jaffe, "Reformation and Counter Re-formation," *Inland Architect* (September/October 1992): 62–72.

10. For a description of Wentworth activists' other efforts to create and sustain informal social and formal programmatic supports for viable community life, see Roberta M. Feldman and Susan Stall, "Women in Public Housing: 'There just comes a Point . . . ,'" *Neighborhood Works* (June-July 1989): 4–6; Roberta M. Feldman and Susan Stall, "Resident Activism in Public Housing: A Case Study of Women's Invisible Work of Building Community," in Robert I. Selby, Katherine H. Anthony, Jaaepil Choi, and Brian Orland, eds., *Coming of Age*, proceedings of the Environmental Design Research Association Annual Conference, Urbana-Champaign, Ill., 1990, pp. 111–19.

11. Ultimately, with technical assistance the resident activists sought from the Illinois Institute of Technology, the Chicago Park District was pressured to assume responsibility for the youth recreation programs. The Park District is still there today.

12. See Feldman and Stall, "Politics of Space Appropriation," for a description of Wentworth activists' leadership in an unsuccessful political and legal "battle," first to stop the stadium construction, then to win financial reparations for lost businesses.

13. Wilkins also offered a series of seminars to acquaint SASNC members with the principles, phases, and participants of the land development process.

14. When the lawsuit was dismissed, the SASNC plaintiffs were relieved of their responsibility to personally pay for the defendants' legal fees and other costs in preparing the case if they did not appeal the judge's decision.

15. Feldman and Stall, "Resident Activism."

16. Only the laundromat is presently generating additional income, which is given back to the community.

17. Feldman and Stall, "Politics of Space Appropriation."

18. bell hooks, *Yearning: Race, Gender, and Cultural Politics* (Boston: South End, 1990).

19. Feldman and Stall, "Politics of Space Appropriation."

20. Patricia H. Collins, *Black Feminist Thought: Knowledge, Consciousness, and the Politics of Empowerment* (New York: Routledge, 1991); Feldman and Stall, "Resident Activism" and "Politics of Space Appropriation"; Sandra Morgen and Ann Bookman, "Rethinking Women and Politics: An Introductory Essay," in Bookman and Morgen, eds., *Women and the Politics of Empowerment* (Philadelphia: Temple University Press, 1988), pp. 3–29; Nancy A. Naples, "Women against Poverty: Community Workers in Anti-Poverty Programs, 1964–1984," Ph.D. diss., City University of New York, 1988; Randy Stoecker, "Who Takes Out the Garbage? Social Reproduction and Social Movement Research," *Perspectives on Social Problems* 3 (1992): 239–64.

21. Stoecker, "Who Takes Out the Garbage?"

22. John F. C. Turner, "The Enabling Practitioner and the Recovery of Creative Work," *Journal of Architectural and Planning Research* 4:4 (1987): 281–88; Jacqueline Leavitt and Susan Saegert, "Women and Abandoned Buildings: A Feminist Approach to Housing," *Social Policy* (Summer 1984): 32–39; Lawrence Vale, "Public Housing Transformations—New Thinking about Old Projects," *Journal of Architectural and Planning Research* 12:3 (1995): 181–85.

23. Eugenie L. Birch, ed., *The Unsheltered Woman: Women and Housing in the Eighties* (New Brunswick, N.J.: Center for Urban Policy Research, 1985); Breitbart and Pader, "Establishing Ground."

Roberta M. Feldman

Women's Design Service: Feminist Resources for Urban Environments

Lynne Walker and Sue Cavanagh

Several factors in postwar Britain—notably the failure of modern architecture, particularly in high-rise public housing, and the feminist and leftist debates of the 1970s—combined to prompt a reassessment of the nature and values of architectural practice and to stimulate new approaches. Such approaches privileged the user of the built environment in the process of design and planning and focused on the social use of space. The Women's Design Service (WDS), founded in 1986, is an example of these developments and representative of a number of currents in British feminist practice related to the built environment.

By 1986, feminist analysis in various disciplines had established that people experience the built environment in different ways, affected by gender, age, cultural background, race, mobility and wealth.[1] In addition, the claim that women's needs are often unmet in the design of the built environment was substantiated through a series of surveys authorized by feminist politicians in London's governing body, the Greater London Council (GLC). These studies voiced women's concerns about a range of issues—including poor public amenitites, lack of facilities for children, inadequate public transport, and fears about personal safety—and outlined planning principles that would take women's needs into account.[2]

Growing out of these initiatives and in this context, the WDS provides advice and information to address women's needs in the urban environment and to facilitate women's representation in design and planning processes. Funded by the London Boroughs Grant Unit, a successive funder to the GLC, the WDS provides information and resources for women on built-environment issues and produces a wide range of analysis, practical advice, and design guidance relating to women's use of space and buildings.

Why Women?

"Why women?" is an inevitable question. Women, the WDS points out, make up a large proportion of many disadvantaged groups, such as the elderly, carers, and single parents. Women hold many of the least secure and unsafe jobs; they are also among the more

poorly paid workers. Partly for these reasons, women as a group in Britain depend more on public housing and public transportation; they are subject to violence both within and outside the home. But, at the same time, the category "women" is not monolithic: women's needs are diverse. The design requirements of specific women or groups of women—different ethnic groups, young women, or women with disabilities, for example—must be examined to ensure that their needs have not been assumed to be identical to each others', or to men's—or, as often occurs, neglected or dismissed.

Focusing on women's experience and requirements, however, has created a dilemma for the WDS and for others concerned with gender issues. Identifying "women" as a subject and topic of research and concern can project a homogeneous image or, even more detrimentally, foster the idea of biologically determined "woman." When arguments are made that women use the environment differently because their daily patterns of activity are shaped by caring or domestic responsibilities, gender stereotypes of women as domestically based carers are unintentionally reproduced. Similarly, highlighting problems of women's safety in cities can reinforce notions of women as timid victims. Nevertheless, there are common threads: women's experience is that they bear the brunt of poor environments; women are societies' caregivers and do have real, often justified fears for their personal safety. Addressing social and political inequalities that ground these disadvantages is a wider, related project. Meanwhile, the WDS accepts the contradictions and complexities inherent in its approach and addresses issues arising from the lived experience of London women and women's groups through publications, consultancies, and workshops.

As a contact point, the WDS provides access to the complex network of organizations and individuals involved in feminist practice and the built environment, and the WDS library, which is a central resource for the WDS staff, is open to students and specialists alike. A series of WDS Broadsheets is published about six times a year on a variety of topics, such as prioritizing the needs of working-class and black women in the built environment, dealing with issues of safety in public housing and street lighting, explaining and assessing government initiatives ("City Challenge"), and promoting opportunities for women's training and education ("Gender & Race in Architectural Training"). Since 1994 as a part of this series, the WDS has edited and published the quarterly proceedings of the London Women and Planning Forum (LWPF), which seeks to influence and monitor policy and practice related to themes of housing, shopping, leisure and community facilities, and employment and transport.

Lynne Walker and
Sue Cavanagh

Ways of Working with Women

The WDS's research and published work aim at a wide audience: women who live in urban environments; architects, planners, and designers; plus policymakers in local and national government and decision makers in the private sector. Publications vary in format from pamphlets to a series of relatively large-scale publications. Subjects range from town center environments to neighborhood safety. Shopping for food and clothing, child care, and public transportation are persistent WDS themes (fig. 11.1). Taking the perspective of women pedestrians in the inner city, the WDS has investigated the implications of cities planned to prioritize traffic and to provide suburban shopping malls for more affluent motorized customers. In their ordinary, daily lives these women are possibly laden down with heavy bags or pushing children in pushcars, forced down dirty pedestrian underpasses or over footbridges along polluted, crowded sidewalks. Within shops and other public buildings the unnecessary stairs to entrances and narrow rotating doors are treacherous for women with small children and for people with disabilities. Maternity or children's departments in department stores are usually located on upper floors, where women further discover that there are no toilets or baby-changing facilities and find that the store cafe does not allow breast-feeding and does not provide highchairs. To tackle these man-made obstructions, the WDS joined with the We Welcome Small Children Campaign and a local government planning department to produce the first guidelines, aimed at architects, town planners, and managers of city centers for an environment based on the space and circulation requirements of a carer and a double pushchair, thus providing the basis for better access and movement in public space and buildings.[3]

One of the WDS's most successful interventions has been into the chronic, inadequate provision of public toilets for women (fig. 11.2). In many ways it is a perfect WDS subject: marginal, even distasteful to many design professionals and policymakers, but central to women's priorities and needs in town and shopping centers. As part of this research, women were consulted about the design of public toilets virtually for the first time. Women's main complaints were the lack of public conveniences and the threatened closure of many existing facilities. While automatic toilets were generally disliked, many public toilets were shown to be inconveniently sited up or down a flight of stairs and even on traffic circles, with insufficient internal space and frequently no baby-changing facilities. Significantly, WDS research showed that women take almost twice as

long to use toilets as men and argued for toilet provision for women at a ratio of at least 2 : 1 to men. Part of a growing concern, the WDS influenced a revision of the British Standards building regulations and linked into a national campaign for improved access and provision.[4]

The WDS's research and publications program has provided the basis for developing design consultancies and technical aid, which again speak to a range of concerns. These are generated in rather equal parts by women's groups, resourcing, government policy, and WDS priorities, as well as staff expertise. For example, the WDS has advised on making offices accessible to disabled women, and it has given safety advice for town centers, car parks, and housing projects.

As part of a radical rethinking of policy in the early nineties, WDS has focused its resources, in the first instance, on a large housing project in South London known as the Five Estates, providing technical advice to women in the largest urban regeneration program in Britain today. With an overall budget of approximately seventyfive million dollars, this regeneration area covers eleven thousand people, 27 percent of whom are unemployed, and has the highest crime levels and poorest health in London. The WDS worked with the tenants, providing a full-time technical adviser to

Fig. 11.2. Public (in)conveniences. (Sue Cavanagh)

help them through the first stages of the regeneration in partnership with local and national government, architects, and developers.

At a national level, but growing out of the Five Estates project, the WDS has produced a manual of good practice for tenant participation in the design, planning, and regeneration of their homes and neighborhoods.[5] The concept that people who live in buildings should have a substantial say in their design and that architecture designed in consultation with residents and other users produces more satisfactory living and working accommodation is at the heart of British feminist practice and has increasingly informed architectural and planning practice for the last thirty years. While the benefits of tenant participation are recognized, how tenants themselves actually go about full and effective participation was not. This major work, funded by the British government's Department of the Environment, takes tenants step by step through the regeneration process to demonstrate how to achieve what they want at every stage. To avoid reinventing the wheel, tenants are given practical guidelines, including a glossary of people, organizations, and technical terms, the "golden rules of good practice," and action sheets for developing a project, as well as a list of useful contacts and publications. Ten case studies of regeneration projects in England, Wales, and Scotland, researched by WDS, provide examples of

Women's Design Service

good, and bad, practice—with tenants' views on their participation and their concerns central to the assessment.

Feminist Practice and the Future

Those who are developing a feminist practice (among them Frances Bradshaw, Julia Dwyer, Elsie Owusu, and Anne Thorne) still form a tiny minority in contemporary British architecture. Matrix, the best known and most influential feminist architectural firm in Britain, closed in 1997. The number of women in the architectural profession in the United Kingdom is almost three thousand, making up around 10 percent of the profession.[6] Of these, not all are feminists or involved in radical practice. Nevertheless, part of the long-term objectives of the WDS and many organizations seeking ways to democratize the process of designing the built environment has been to try to increase the numbers of women at all levels of the construction industries, reasoning that design professionals more representative of the commmunities in which they are working are more likely to accommodate people's varied lifestyles and needs. It has been argued that merely increasing numbers of women in architecture and related fields does not mean that more egalitarian practices and policies will result.[7] Others maintain that if women's needs in the built environment are going to be addressed and their interests and concerns prioritized, it will not come from professional practice as it is now constituted.[8]

Architects Yvonne Dean and Susan Francis and others associated with the WDS have shown there is a way forward through architectural education which would greatly increase women's access to architectural design and promote equal representation at all levels of the design process.

In the late 1980s and early 1990s, a few British universities, spearheaded by the University of North London, developed a part-time vocational course for women, leading into architecture and other design practices, building technology, and surveying. Called Women Into Architecture and Building (WIAB), the course emphasized the development of basic skills in designing and making buildings. WIAB was organized as four modules: Drawing; Design; History; and Practicals. Each was taught by qualified and experienced women practitioners.

Drawing. Freehand drawing techniques encouraged confidence in mark-making and in developing expressive drawing as a design tool.

Design. Three-dimensional design skills were taught through exercises related to scale, measurement, and proportion, which were further developed via projects on actual sites. Particular emphasis

was placed on manipulation of 3-D form through models and expressive drawings.

History. Seminars explored the cultural and historical background of modern architecture and aimed to develop a critical approach to architectural theory through investigating the social role of women in home and society. Special importance was placed on visits to buildings and exhibitions which highlight current architectural debates.

Practicals. Workshop-based practicals enabled students to produce full-size building elements, using carpentry, plumbing, and bricklaying skills, and to construct structural models for project work as explanatory and design tools. Work with structural models in conjunction with the Low Energy Architectural Research Unit introduced technology through firsthand experience.

Open to women only, twenty-one or older, each course had fifteen students, committed to one day a week for a year. A key aim was to apply students' mature understanding to design problems. The courses produced students who entered schools of architecture in relatively substantial numbers. Our hope is that feminist approaches will help to develop practices which recognize and prioritize the diversity of women's needs, using understanding and imagination to address women's economic and social disadvantages in the built environment.[9]

Most recently, WDS has been developing a method for working with women and community groups to conduct health and safety audits of their local environments. Neighborhood audits have now been carried out successfully with groups of women from immigrant and refugee communities living in inner London. Issues such as access to housing, housing conditions, and health and leisure facilities have been examined from the groups' perspectives, and barriers connected to language and cultural differences identified. The groups have been facilitated by WDS to present their recommendations to service providers to bring about the required changes that will enable them to have an equal opportunity to access public services and amenities. This type of active research has proved to be a valuable method of consulting with social groups, who are often left out of policy and decision-making processes, and to enable more gender and culturally sensitive facilities and services to be planned.[10]

Another current area of Women's Design Service's work has been to coordinate the London Women and Planning Forum network. This initiative aims to support women planners working in London (who are in the minority at 22 percent nationwide), to provide opportunities for an exchange of information about good practice for women-focused policies, and to influence future planning

policies to improve the quality of life for women. Concern has recently been expressed by women planners that the number of women taking up town planning as a career is falling and that gender issues are being dropped from the curriculum of planning schools. This could have serious future implications for the level of awareness of women's requirements in future urban developments.[11] Women's Design Service is proposing to work with the planning schools to develop a method of ensuring that diversity and gender issues within the planning system are brought to the attention of all planning students.

The key to any real future improvements is to work with women in urban planning and design to create and develop the type of communities and places that they want to live in, and to increase the number of women at all levels of policy and decision making. It also means recognizing the limitations of short-term and individual physical design solutions for improving the quality of people's lives, and working toward integrating good-quality design in the environment with long-term strategic planning to equip local communities with sufficient resources to prosper.

Notes

This chapter draws in part on material in Sue Cavanagh, "Women and the Urban Environment," in Clara Greed and Marion Roberts, eds., *Introducing Urban Design: Interventions and Responses* (Harlow, Eng.: Longman, 1998); used by permission.

1. See, for example, Alison Ravetz, *Remaking Cities* (London: Croom Helm, 1980); Rosalind Brunt and Caroline Rowan, eds. *Feminism, Culture, and Politics* (London: Lawrence and Wishart, 1982).

2. Greater London Council, *Changing Places—Positive Action on Women and Planning* (1986) and *Town Centres and Shopping Attitudes Survey: Preliminary Results* (1986).

3. Sue Cavanagh, Jane Debono, and Julie Jaspert, *Thinking of Small Children: Access, Provision, and Play* (London: We Welcome Small Children Campaign, LB Camden, Women's Design Service, 1988).

4. Sue Cavanagh and Vron Ware, *At Women's Convenience: A Handbook on the Design of Women's Toilets* (London: Women's Design Service, 1990).

5. Mary Kelly and Carolyn Clarke, *The Good Practice Manual on Tenant Participation* (London: Women's Design Service, 1997).

6. Architects Registration Council of the United Kingdom, January 1998.

7. Clara Greed, *Women and Planning: Creating Gendered Differences* (London: Routledge, 1994) and *Surveying Sisters: Women in a Traditional Male Profession* (London: Routledge, 1991).

8. Matrix, *Making Space: Women and the Man-Made Environment* (London: Pluto, 1984).

9. Susan Francis, "Prospectus of Women Into Architecture and Building Course," University of North London, 1993. South Bank University currently runs a similar course.

10. Kathy Almack and Pauline Grainger, *STRIDE'S Safety Check: A Practical Handbook on Women's Safety* (Nottingham: STRIDE, 1995); METRAC (Metro Action Committee on Public Violence Against Women), *Women's Safety Audit Pack* (Toronto: Metro Toronto Council, 1994). Safety packs and audits are available from: Women's Design Service; STRIDE (Safe Travel for Women), Nottingham; Hammersmith and Fulham Crime and Safety Unit; METRAC, Toronto.

11. WDS Broadsheet 28, "Gender Issues within Planning Education," 1998.

Historically, issues of social justice and environmental responsibility have been marginal to the teaching and practice of architecture. The many books and articles published recently about the current identity crisis in architectural education and practice are cause, I think, for optimism among those who are committed to architecture as a vehicle for progressive social change. This instability can, I hope, cause the margins and the center to change place, shifting the traditional pursuit of architecture as a formal language that serves and reifies the ruling power in society to an architecture that is responsive to the human condition of society as a whole. If not, the profession of architecture could become anachronistic and irrelevant to the public, whose trust is at the very core of professional practice.

Challenging and questioning the meaning of architecture and the nature of architectural practice today, both in schools and in architectural offices, is both propitious and necessary. In nineteenth- and twentieth-century industrialized society, almost all design and technology reflects a disassembling of organic wholes into fragmented parts. Cities and suburbs, workplaces and dwellings, architecture and nature are juxtaposed as detached spatial realms, segregating and supporting differential status and power to women and men, rich and poor, black and white, young and old, gay and straight, able-bodied and disabled. As we approach a new century, these old dichotomous paradigms are no longer workable. The problems of global homelessness, poverty, and environmental degradation, the escalation of social chaos, violence, and disharmony worldwide, and the bleak and hostile environments of so many cities require healing and the restoration of wholeness within the art of living. Architecture, too often regarded merely as a matter of style, is now a matter of survival. After eleven thousand years of building to protect ourselves from the environment, we are discovering that what and how we design often diminishes our health and the viability of the planet.

Solutions to these complex social problems will increasingly need the expertise of an architectural profession committed to civic engagement and service to the nation. A critical place to start is

Re-designing Architectural Education:
New Models for a New Century

Leslie Kanes Weisman

in architectural education. What is needed is a new educational model that challenges conventional professional boundaries and that questions and transforms what we teach and how we teach.

To effectively seek solutions to society's most vexing problems, architecture needs to become a more research-oriented profession. Within our schools we need to create a climate of participatory learning in which civic activism is regarded by students and faculty alike as an essential part of scholarship and practice. Architects must learn how better to solve problems in collaboration with other specialists in environmental design such as planners, landscape architects, and interior designers and on multidisciplinary teams with experts in natural resource conservation, economics, politics, art, medicine, behavioral and social sciences, law, and engineering. They must be taught how to use design as a tool to create rather than respond to public policy, legal regulations, and building codes. And they must learn not only to design and plan buildings and public spaces but also to evaluate them for their healthfulness, energy efficiency, and accessibility.

The What and How: Learning from Feminism

Feminist pedagogy can be especially useful in constructing a new model of architectural education. Its attention to collective processes, to redefining power relationships, to deconstructing false dichotomies (theory/practice, client/professional), and to eliminating inequities of gender, race, class, disability status, and sexual orientation produces teaching and learning approaches that can help to build in students the skills and capacities they will need to be effective practitioners, problem solvers, and leaders. Four feminist educational principles deserve our attention.

1. Employ collaborative learning methods in which interdependent, team problem solving and cocreativity are practiced and rewarded over competitive, solitary problem solving and individual creativity.

2. Share authority and knowledge so that students are empowered to direct their own learning and so that people in other disciplines and with different life experiences can join in the discourse. In the future, the boundaries of the problem to be solved—not the boundaries of a single academic discipline—will determine what knowledge is needed and where it can best be found.

3. Emphasize ethical values, a respect for human diversity, and interconnectedness among all of humanity, the natural world, and the products of human design.

4. Eliminate false dichotomies by creating learning situations that connect academic theory with "hands-on" practice and by estab-

lishing collaborative relationships among designers, clients, and user groups.

Incorporating Service Learning

I use these four educational principles in tandem with service learning to structure the form and content of the architecture courses that I teach at New Jersey Institute of Technology (NJIT). Students enrolled in these courses have historically received modest honoraria as participants in a New Jersey state grant earmarked to support innovative teaching that integrates community service into the state's colleges and universities. Service learning encourages students to become socially responsible professionals by working as volunteers on real projects for nonprofit organizations addressing contemporary social problems. These nonprofits and the constituencies they serve become, in effect, pro bono clients who generally use the work we produce for them to attract the financial, political, and community support needed to actually build the projects they envision.

Community service is wonderful, but the university is not a welfare agency. Doing good must always serve education first: you can't exploit students in the service of social justice! Neither can you ethically unleash a group of inexperienced students upon a client in real need of services. The responsibilities of clients to educate and students to serve clients' needs must be carefully clarified. Realistic expectations have to be established up front. Finding the right client and project is time-consuming and difficult. But it has to be a "win-win" situation or it won't work.

The Sustainable Cohousing Studio

I organized and taught this fourth- and fifth-year service learning design studio (at NJIT) in the spring term of 1994.

The studio "client" was the Grail community at Cornwall-on-Hudson, New York, located on forty-five scenic acres of woodland within the Hudson Highlands, fifty miles north of New York City and of Newark, New Jersey, where NJIT is located. The Grail is an international, intergenerational movement of women whose roots are in Christian tradition. Grail members are committed to empowering women worldwide, to peace and social justice, and to preserving the environment by promoting ecological consciousness and practice.

It's about a two-hour drive between Newark and Cornwall-on-Hudson, and we often met weekly with the Grail staff. You can imagine the commitment of our client, six very busy women, the students, who, in addition to being in school full time, usually held part-time jobs, and me, who gave up even trying to maintain a schedule. So that says a lot. Especially since it was the winter of seventeen blizzards! We were out doing site documentation on cross-country skis with plastic bags on our heads. "Site, what site? Where's the site?" It was unbelievable! But that's part of working in the world beyond the academy where events are often unpredictable, from the weather to the client's politics. You have to be very flexible and to think on your feet to cope.

The Grail members at Cornwall, many of whom are approaching retirement, wanted to develop new, transgenerational housing on their Cornwall property that supports their spiritual and communal lifestyle and their desire to live simply and sustainably upon the earth. In addition, our studio took on the tasks of retrofitting three existing Grail buildings to minimize energy wastefulness and provide barrier-free access.

Applying the Educational Principles through Teaching Strategies

1. Employ collaborative learning and foster interdependence.

Designing the studio setting: On the first day I asked the students—fourteen in all—to form teams to measure our new studio space, inventory existing furniture, and analyze the ventilation and natural and artificial light in the room, this information to be circulated to all class members. After a group discussion of the studio's educational goals, methods, and philosophy, which was designated a "design research collaborative," I asked the students to return the next day, each with a scaled plan layout for our space. What plan would best support the activities to take place there throughout the semester and would also create a healthy work setting congruent with the ecological values of our client?

Reviewing the proposals, the group evaluated the individual schemes for repetitive spatial ideas which were, by virtue of their repetition, assumed to be important by the majority. They also evaluated for other suggestions deemed good refinements. These concepts were incorporated into a series of composite plan layouts

until we reached consensus that all the proposed desk locations and collective spaces worked well.

Next, voluntary student teams partitioned, painted, and refurbished the studio according to our plan. It provided for a reference and video library, recycling area, model making space, conference/study/pinup area, lounge, and drafting tables and stools organized into team "pods."

Private desks and collective spaces were used by students according to the changing assignments, tasks, and teams they worked on. Everyone claimed ownership of and responsibility for the entire classroom. This contrasted with the usual competitive practice, students vying for the best desk and location for themselves.

> Putting into practice my own strong commitment, we recycled everything in the studio. We refurbished our surroundings with nontoxic paint, which I simply paid for. "There are fifteen of us," I said. "If everybody brings in a plant, we're going to have some oxygen in here, and something beautiful to look at."

Team assignments based on students' self-assessment of skills: At the beginning of the studio, using forms I provided, students assessed their own individual skills in drawing, model making, photography, computer-aided design and analysis, public speaking, writing, research, time management, and organizational abilities. This information was used to develop different task-oriented teams whose members rotated so that students could offer their greatest strengths to our collective work, while at the same time tutoring others who were admittedly weaker.

In an environment fostering honesty and cooperation, each student was both a teacher and a learner, respected both for strengths and for admitting to and working on improving weaknesses. The client also benefited from receiving the best of each student's expertise.

> During the documentation phase of the studio, various teams photographed, measured, and surveyed the Grail building site and each of the three existing Grail buildings. Other teams used these photographs and measurements to produce a site plan and sets of as-built drawings and models for each building. The Phoenix (fig. 12.1), built in 1887, serves as a conference and retreat center; the Gray House (fig. 12.2), is used as a residence for Grail interns and staff; and the Cottage (fig. 12.3), built in the mid-1800s, was to be converted from its present use as a staff

Fig. 12.1. Students' model of the Phoenix Conference Center shows proposed wheelchair ramp to front and dining porch entries. Other alterations to the ground floor include a living room addition to accommodate large group gatherings, the inclusion of a wheelchair lift to access the kitchen, and the conversion of an existing library into an accessible bedroom and bathroom. (Leslie Weisman)

house into an environmental education center and Grail office. Another team used these measurements and drawings to build a four-foot by eight-foot site model at ¹⁄₁₆″ scale, which is now on permanent display at the Grail (fig. 12.4). Still another two-person team researched the rich history of the local region and village and of the Grail buildings and property.

Collective authorship of the architectural program: In most design studios, students are given a brief or problem statement by their instructor that includes a list of spaces and square footages that are to be incorporated in their design solutions. In our studio we began by collectively developing a series of questions for our client about their existing buildings and grounds and their needs and concerns for new transgenerational housing. Based upon the responses, it became clear that the six Grail staff members with whom we were working disagreed about the amounts of privacy and community they wished to support in their new cohousing and about the effects on the current and future use of their existing buildings and property. The class decided that our most important task was helping our client to find both clarity and consensus about the group's housing and long-range planning goals.

Seven teams, each consisting of one Grail staff member and two students, worked on developing five interdependent programmatic components consisting of sustainable site development, modifying each of the three existing buildings, and designing new housing.

Leslie Kanes Weisman

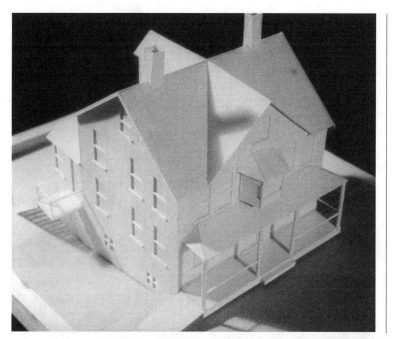

Fig. 12.2. Students' model of the Gray House shows proposed ramps and paths at existing front door and new rear entry to a wheelchair-accessible "basement" apartment with flexible work space. The new exterior staircase leads to an addition to the existing kitchen. (Leslie Weisman)

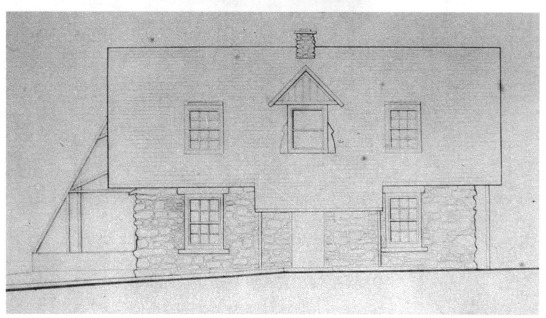

Fig. 12.3. Students' drawing of the front elevation of the Cottage shows a proposed greenhouse addition (left) over an existing root cellar and new bath/shower room for Grail gardeners. (Leslie Weisman)

Frequent feedback sessions with the client group took place both in our studio and at the Grail property (fig. 12.5). In the process, the students developed skills in interviewing, group dynamics, conflict resolution, negotiation and compromise, verbal presentations, assertiveness, and articulating qualitative as well as quantitative programming and design criteria.

Fig. 12.4. Three Grail staff (right) in the library of the Phoenix listen to student model makers (left) discussing the Grail site model they built with their classmates. (Leslie Weisman)

Fig. 12.5. Toward the middle of the semester the class invited the Grail staff (seated, foreground) to our studio for lunch and a formal presentation of their design proposals for development of the Grail's site, existing buildings, and new cohousing. The partition wall on the left was built to display the class mural we created and to enclose the studio's model-making area. (Leslie Weisman)

When all the documentation and programming was done, I said, "Here are the parts. Sign up for whether you want to do the site development, or retrofitting one of the three buildings, or designing new housing." Six people chose the last. We agreed to form three teams. "Each of you should bring in a parti diagram," I said. "You know, a kind of conceptual strategy for how you're going to approach this new housing." We pinned them up, and the entire group together decided which schemes had similar strategies, which seemed to have a kind of compatible sensibility. We grouped them based on the conceptual clarity of each person's own goals, and therefore people didn't argue whether or not they liked their design partners—a risky

Leslie Kanes Weisman

Although I had thought it likely that students would ultimately opt to work on designing their own schemes for new housing for the Grail, the entire class was so enthusiastic about the results of this programming method that they unanimously chose to continue to work in teams on all five program components during the design phase of the studio.

The clients ultimately received a comprehensive master plan for the phased improvement of all their buildings and grounds, as well as a series of design prototypes for sustainably designed collective housing based on three typologies—the private apartment, the boarding house, and the cohousing development. These models proved invaluable to our client group in members' ability to visualize and therefore reach consensus on a final architectural program for their new housing that they could all imagine living with.

2. Share authority and knowledge with students, clients, and others.

Decision making by consensus: To enable students to take initiative and to direct their own learning, teachers must give up a measure of their authority to determine the course requirements and schedule. In our studio, we held weekly group meetings to decide how to proceed with our client, what tasks needed to be done and by what date, and who in the group would best be suited to accept these responsibilities. Rather than voting, we chose instead to discuss each issue until we reached consensus. When students disagreed or were uncertain, as teacher my role was to point out options, trade-offs, and consequences and so guide them through the decision-making process (fig. 12.6).

The word about our unorthodox studio soon spread. One day we were delighted to read about our growing reputation in *The Vector,* NJIT's weekly student newspaper. The architecture columnist wrote:

It is truly rare that studio professors stop to examine the format of their courses as a means for driving content and learning. But one studio this semester is doing just that. Focusing on sustainably designed housing for a real client, the Grail community, the students and their professor have

Re-designing
Architectural Education

Fig. 12.6. Seemingly endless lists and notes filled the walls and covered the tables in our studio as we collectively worked out tight schedules and due dates and coordinated tasks and assignments. (Leslie Weisman)

chosen to confront and accept the difficult labor of thinking before they design. From my studio next door, I see them gather 'round a table every Monday, Wednesday, and Thursday to collectively take account of their progress and plan the next steps. Research, exchange of information, and organization is vital, sometimes all consuming, but always, in the long run, efficient. Their studio is a library—filled with research topic boards, case study updates, skads [sic] of checklists on yellow trace, and a cabinet of research texts on loan from the professor's private library and borrowed from her colleagues that you can take to your desk at any time. There are no hypocrites here—recyclables, greenery, wildlife and community are in residence in their eco-sensitive studio. Except for some runaway speeches, the students of the Grail seem pleased with their quest. What about yours?[1]

The visiting desk critics and consultants: To help solve our client's problem(s) more effectively and to involve people from other disciplines whose participation and expertise would enhance a successful outcome for the project, I invited a variety of "visiting desk

critics" and consultants to meet by appointment in our studio with different student teams and collaborate in problem solving.

"Desk critics" included an engineer, landscape architect, environmental scientist, a "green building products" distributor, and an architect who specializes in sustainable design. Invited consultants on the project, who provided us with feedback and suggestions during several of our design presentations at the Grail, included the Cornwall-on-Hudson town historian, a member of the local planning board, several Grail neighbors, and Grail members living in other locations who were potential residents of the new housing we were proposing for the Cornwall site.

Grading Partnerships: Grading partnerships further shared authority. Using forms that I provided, students determined the focus of their research on sustainable design and developed group criteria for evaluating and grading their own and each others' contributions to our collective learning. The two most important of these criteria were (1) the degree to which the research presented was useful in "solving" our client's design problem and (2) the potential it held for educating others beyond our studio. I completed an evaluation form for each student's research work as well. These evaluations—mine and the students'—were averaged together to determine each student's grade for research and design. Students also regularly formed their own juries for peer reviews of team design work.

At the end of the semester, each student received a lengthy self-evaluation form. Students were to fill them out as thoughtfully, objectively, and thoroughly as possible so they could be "partners" with me in determining their final studio grade. While the quality of each student's design work was an important criterion, I felt that other measures for evaluating "success" were even more important since the studio was based upon an educational model of empowerment and interdependent collaboration. Such measures, for example, included determining how well students met the personal goals they set for themselves in the self-assessment forms from the beginning of the studio, rating the quality of their educational development, and assessing the level of their participation in various activities and tasks throughout the semester relative to their classmates' contributions. I filled out the same form for each student. The two were averaged, along with the evaluations of their work made by other students throughout the semester, to arrive at the final studio grade.

While this process was very time-consuming, it was ultimately far more meaningful for the student than usual grading methods. The process helps establish an environment of mutual respect, trust, and accountability, radically redefining and transforming the

Fig. 12.7. Members of the design studio, Grail staff, friends and neighbors, and the studio professor (front row, third from left) gather behind the Phoenix after the students' final presentation in May 1994. (Leslie Weisman)

traditionally hierarchical power relationship between student and teacher, as well as the typically competitive relationships among students.

3. Emphasize ethical values, human diversity and interconnectedness.

Experiencing human diversity: If students are to become effective professionals in an increasingly multicultural society, their educations must challenge the stereotypes and prejudices still fostered in a predominantly white, male, heterosexist culture. Service learning situations provide teachers with the opportunity to select clients that allow students to build personal connections with those different from themselves and with those who can serve as positive role models. The Grail staff members with whom the students interacted are older women with vitality, strength, humor, intellect, meaningful work, and strong religious and political views, who live with each other in a "family of choice." The experience of collaborating with these clients helped students to deal with negative assumptions they may have held about older people, the disabled, women, and nontraditional families (fig. 12.7).

Design Rituals That Create Community
To acknowledge and celebrate the individual differences that each studio participant brought to the development of our group identity, I divided a partition wall in our studio space into a grid of sixteen equal rectangles—one for each student, one for the client, and one for the instructor—assigned in alpha-

Leslie Kanes Weisman

betical order. I then asked each to design and install within the rectangle a personal statement about architecture, nature, and ecology. Together, these separate pieces formed a large wall mural that beautified and enlivened our studio space while expressing the uniqueness of the individual within the collective (see fig. 12.5).

Our client commissioned an artist to create fifteen "earth medallions" made of fired clay and embossed with a goddess figure in one of nine phases of birth, pain, and transformation over the degradation of the environment. Each medallion, hanging from a silk cord, was individually gift-wrapped and presented by the women to the students and the instructor at a dinner celebration at the Grail that concluded our final design presentation. These medallions remain with each of us, beyond the duration of our semester's collective work, as enduring symbols of our client's appreciation and of our shared experiences, humanity, and commitment to ecological values.

4. Eliminate false dichotomies.

Applying research to design practice: Research in architecture school is still largely confined to looking for building precedents. Seldom are contributions of behavioral, social, and environmental sciences research integrated into design decision making, and they are often not successful when tried in the studio. So that the work of these disciplines can be incorporated and help further to integrate theory and practice, teachers can encourage students to engage in research activities that generate information directly needed in order to solve the assigned design problem.

In the Grail studio, to build on students' knowledge and interests about sustainable design, each student was asked to develop a three-dimensional model to explain a specific ecological principle such as on-site waste management, water conservation, solar and wind energy, low-impact building methods like rammed earth and straw bale construction, and recycled and nontoxic building products and materials. Each student's model could then instruct other students about concepts immediately applicable to the design work in which they were engaged for our client. Installed as a permanent exhibit at the Grail, the models are also educating the general public.

Re-designing
Architectural Education

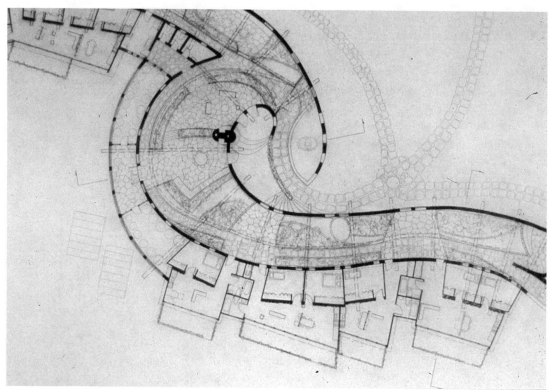

Fig. 12.8. One two-person student team developed a fully wheelchair-accessible cohousing design scheme built from local stone and inspired by the equiangular spiral of the chambered nautilus. Visible in the core of this plan detail are meditation chapel, reflection pool, and water garden, from which radiate individual apartment units. (Leslie Weisman)

Team proposals for new transgenerational housing capture passive solar energy and thermal warmth from site orientation, earth bermed roofs covered with natural grasses and wildflowers, and stone retaining walls, ramps, and mass walls that also eliminate stairs. Rain collection pools and water walls and gardens are used to humidify and cleanse the environment, conserve water, and create places for meditation (fig. 12.8).

Concluding Thoughts

The design studio experience I have described that combines feminist pedagogy with service learning can provide personal, professional, and social dividends for the soon-to-be architect. With raised confidence in their abilities to work with others in developing professional skills, students are better equipped to function in the "real world" in which they will practice. On a larger canvas, they are introduced to the idea that being an architect—with all the technical and formal demands the role involves—and working for social justice and a sustainable future are not necessarily at odds.

As form-givers in our society, architects have both a professional opportunity and a civic responsibility to contribute their expertise toward replacing a politics of human and environmental exploita-

Leslie Kanes Weisman

tion with an ethic of interdependence that values human difference, fosters relationships of human equity, and acknowledges humanity's debt to the earth. Working to creatively transform traditional architectural education and practice is a necessary route to that end.

This essay is dedicated with appreciation to the Grail staff at Cornwall-on-Hudson: Ann Burke, Cay Charles, Ruth Chisholm, Caresse Cranwell, Alice Gallagher, and Peg Linnehan; and to the talented NJIT architecture alumni who produced the work described and illustrated: Michael Bieri, Andrew Binosa, Nicole Barota, Joseph Buda, Robert Donahue, Jason Kliwinski, Christopher Ling, Thomas Muller, Laurent Pierre-Philippe, Sibylle Ruefenacht, Michael Scotti, Eric Trepkau, and Linda Wilson.

Notes

The opening and closing portions of this essay appeared in a different and longer version in Leslie Kanes Weisman, "Diversity by Design: Feminist Reflections on the Future of Architectural Education and Practice," in Diana Agrest, Patricia Conway, and Leslie Kanes Weisman, eds., *The Sex of Architecture* (New York: Harry N. Abrams, 1996), pp. 273–86.

1. R. A. Svetz, "Tech Styles: Quest for the Grail," *The Vector* (March 1, 1994): 10.

In a Masai village in Kenya, women are the home builders. Using stalks and branches from young acacia trees lashed together to construct the rectangular frame, they then layer on a combination of mud, leaves, and straw for the inside and for the flat roof. The end-product is a sturdy, weatherproof dwelling for themselves and their families (figs. A.1–3). Among nomads in Africa and Asia, women construct and are in charge of the tents and often of other related activities, women in Mongolia, for example, sweeping the streets, even herding camels, and transporting milk.[1] In rural and village communities in many parts of the third world, these patterns are repeated. Women are their communities' architects and construction engineers, as part of what we would call their domestic duties.[2]

In some cases, these roles and activities reflect a relatively high degree of control by women—at least within their prescribed sphere. It is another question as to whether whatever degree of control women may exercise as home builders and maintainers translates into any power beyond this sphere. For Masai women in the village we visited the answer was no, not any. When in the summer of 1985 our delegation of Western women—who had come from the Third UN Conference and NGO Forum on Women in Nairobi—met at our hotel with the provincial council, whose members were all male, the village women with whom we had been speaking earlier declined to join us in the adjacent meeting room. Clearly, the women knew even their presence was not welcome, much less anything they might have to say and contribute to the discussion. Home building, and activities stemming from it, were a woman's domain, her power over that domain not extending into spheres beyond it. Gendering of spaces and activities associated with those spaces reflects the allocations of power in these societies. And when the move is made from rural village to the city, women's powers over home and shelter are often eroded, as men take over both construction and plot ownership.

Given the extensive role of women in building and maintaining shelters in many traditional societies, it is perhaps surprising that the built environment did not receive specific focus at the UN international conferences on women in China in 1995 and in Kenya ten years earlier: "surprising" because of these conferences' twin

Afterword

Joan Rothschild

A.1

focus on women's activities and on their empowerment, the goal
to improve women's lives, especially in the so-called third world.
Here is a women's activity—shelter building—that is central to
sustaining their communities and their own lives, and an activity
that confers on women a measure of power, but which is absent
from these international feminist agendas. Both the Nairobi and
Beijing-Hairou meetings did focus prominently on technology.
But technology was viewed mainly in the context of "science and
technology." At the China Forum a delegation from Georgia Tech
featured a sophisticated multimedia presentation to show how
communications technologies could benefit and empower women.[3]
Booths at the forums demonstrated technologies for improving
health, food production, and productive work—especially those
technologies called appropriate and environmentally sound—plus
issues about environmental pollution and degradation. *Design* for
the most part meant traditional crafts; the arts were further cele-
brated through the performing arts. But at both meetings a per-
sistent lacuna remained. Architecture and city and neighborhood
planning, as well as related fields of industrial and graphic design,
were not part of the design and/or technology agendas, whether
applied to the first or third worlds. I argue that they should be.

The essays in this book have explored a number of important
design issues and ideas that feminist perspectives have sought and
developed. These include rethinking and proposing ways cities,
communities, neighborhoods, and dwellings and spaces within
them could be designed to meet people's diverse needs. They in-
clude ways to break down producer-user hierarchies. They include
re-visioning design strategies to deal with the critical and changing

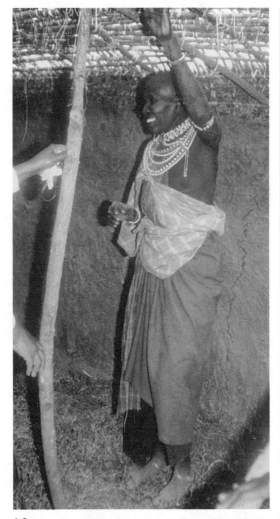

A.2

A.3

relationships between home and work. They include designing that pays attention to ecological and sustainable development. They include freely crossing disciplines to put these ideas and visions into practice.

What are the possible connections between these mainly first world ideas and practices and those in developing societies? It is perhaps a long stretch from a Masai or Mongolian woman home builder to a Pratt Institute graduate practicing architecture and contributing to this volume. But one way they are joined is through the underlying spirit of what they do: both are engaged in productive activities of building that contravene fragmented and disempowering design and technology practices. Prevailing in the industrialized world, fragmenting and disempowering practices come with "development."

The long history of colonial powers imposing their values on the colonized has frequently been carried over to development policies and practices of the postcolonial period. Among these are gendered ideologies and practices that are no more liberating than the ones they replace and that at times represent a step backward for women. With their very strong focus on development, the UN conferences on women and proposals they initiate and attempt to set in motion have been especially sensitive to these gendered patterns in number of areas, exposing and seeking to change them. One of the most persistent of these policies being imposed on developing societies is the gendering of technology: teaching men the more highly technical skills, limiting women's technical training to secretarial skills or mechanical weaving. Since the design and technology professions are still overwhelmingly male in the developed world, pursuing their work in ways critiqued in this book, such patterns and practices may well be expected to be transferred to the third world.

Attempts to deal with critical issues around living environments are by no means entirely absent from international concerns. Notable is the United Nations Centre for Human Settlements (UNCHS), which was the major sponsor of Habitat II, a conference in held in Instanbul in June 1996, a follow-up of Habitat I held more than twenty years earlier in Canada in 1975. The Together Foundation and UNCHS have prepared a data base of six hundred "Best Practices" describing projects from all over the world; it is available on the World Wide Web and was presented at Habitat II.[4] At Istanbul, the "Our Practices" exhibit, sponsored by Women, Homes, and Community Super Coalition, displayed "successful examples of housing and sustainable community development from various countries that address women's concerns and needs from women's perspectives."[5] The "case studies" shown re-

Joan Rothschild

178

flected the "key principles of development defined in the [coalition's] vision statement": "Enablement into self-empowerment," "Participation into collaborative problem solving," "Human settlements into communities," and "Shelters into homes." Ghislaine Hermanuz, whose essay appears in this volume, was among those instrumental in organizing this exhibit and continues to work with the coalition. But neither the Together Foundation and its work with UNCHS nor the projects exhibited by the coalition in Istanbul were represented at the Beijing meeting, even though several of the coalition's member groups were.

Clearly feminist in concept and intent, and including examples from both the inner city in the United States (our own third world) and developing societies, the coalition's "Our Practices" projects demonstrate linkages between designing in the first and third worlds. What we learn especially from third world examples is the critical role that *economic development* must play in creating livable environments. This is something we tend to lose sight of in planning changes in our own so-called developed world. The essays in this book by Roberta Feldman, Susana Torre, and Ghislaine Hermanuz, among others, do deal with this economic component, as did our conference discussions. If women and their families do not have adequate livelihood, then the prospects for improving their living conditions are dim indeed—and the very process of participatory planning is not even possible. The focus on economic development trains our gaze on women's activities and the critical linkage of home and work. The Hermanuz essay further demonstrates the necessary interdependence of dwelling, neighborhood, and community in supporting productive activities.

Reviewing the collection *Shelter, Women, and Development: First and Third World Perspectives,* which was published in 1993, Dolores Hayden points out that the "home is, first of all, a workplace for women." As a workplace, the home "can aid or hinder unpaid childcare and housework, as well as income-producing work such as stitching garments or taking in boarders. The location and design of typical dwellings in a country contribute to women's economic conditions and the hours they need to get their work done." Indeed, "shelter defines the material conditions of women's lives," which is clearly the case in our inner cities, as well as for those better off, and for developing societies.[6]

As we witness what is happening as a result of the urban influx from rural areas, developing societies present us with a laboratory to watch, and to influence, the process of professionalization of building and other design and technology activities. The crowded, unhealthful conditions that have proliferated in the wake of rapid urbanization have been well documented, bringing concern and

varied proposals to cope. But how well has the *process* of development as it deals with city dwellings and neighborhoods been charted and evaluated, as people's traditional activities and livelihoods are disrupted and changed? For women, the shift from rural area to the city can remove the measure of power over their lives that accrued as part of their control over dwelling place. In Botswana, for example, women's "well-recognized sphere of control" as head of household and builder of the dwelling was eroded once families moved to the city of Gaborone. "Husbands rather than wives are usually listed as the plot holders," women lose "creativity and confidence in their house-building skills," men do "most of the construction out of manufactured materials," and "married women lose everything in a divorce, since the husband is listed as the property owner." Not only is reform of marriage and property laws recommended, but also "a bigger stake in the design of urban shelter" for women.[7] But a new environment; new materials, technologies, and techniques; and different activities whose needs must be accommodated in living arrangements carry their own momentum. The drive in urban development is toward the occupational specialization and professionalization characteristic of industrialized societies. How can we deal with this process—that takes on a kind of inevitability—and be able to create shelter, neighborhoods, and communities that will meet new and changing human needs? Is it possible for design and technology skills and methods to be developed without instituting the hierarchies and fragmenting practices that divide people and undermine their control?

The role of the professional becomes critical here. One important step for first world feminists in design and technology fields is to seek out architects, planners, engineers, product designers, and information specialists—that is, counterparts in their own fields—in developing societies. We need to know more of what these trained people are doing, what their objectives are, what are the professional and cultural restraints—as well as resource needs—they face. Perhaps an international task force could plan face-to-face meetings to exchange and draw on ideas and projects from both the third and first worlds. That some of this is happening is clear from the coalitions that have been formed, conferences held, and books published in recent years that I have mentioned. We need to encourage more cross-disciplinary activities and approaches to help generate new ideas to challenge the status quo. Large, formal international gatherings sponsored by multinational organizations serve an important purpose in bringing a wide variety of groups, individuals, and nations together, and proposing policies. But it is at the small, working group level that more can get done. Such forums can follow the triple objective of this book to operate

in cross-cultural settings. The first is the critique of professionalization: does it necessarily lead to fragmentation, oppressive divisions of labor, and a controlling, power-over ethos? Rather, and this is the second objective, design and technology need to break down hierarchies and foster participatory practices that meet the needs of real users. Third, the aim becomes to generate and put into practice projects that work, and so not only change that practice but also transform its supporting concepts and rationale.

Notes

1. Martha Avery, *Women of Mongolia* (Seattle: University of Washington Press, 1996).

2. See, for example, Labelle Prussin, *African Nomadic Architecture: Space, Place, and Gender* (Washington and London: Smithsonian Institution Press and National Museum of African Art, 1995).

3. This multimedia presentation, "Women of the World Talk Back," presented by Anne Balsamo from Georgia Tech and Mary Hocks from Spelman College, was a highlight of the CUNY "Re-Visioning Design and Technology" conference (1995). Combining music, photographic images, and video clips of interviews with international leaders, it enabled viewers to click on and participate.

4. Habitat II drew over eighteen thousand persons from governments, organizations, communities, business, and design professions from 171 countries. See Alison Snyder, "Adequate Shelter (for all)," *Metropolis* (January/February 1997): 66–67, 89–90. See also Carolyn Sweetman, ed., *Women and Urban Settlements* (Boston: Oxfam, 1996); available from Women, Ink., 777 United Nations Plaza, New York, NY 10017.

5. Groups belonging to the coalition included: GROOTS [Grass Roots Organizations Operating in Sisterhood] International, HIC Women & Shelter Network, WEDO [Women's Environment Development Organization], and International Council on Women. Quotations are from "Our Practices: Hidden Strengths and Unclaimed Powers," the coalition's descriptive statement accompanying the Istanbul exhibit. Available from City College Architectural Center, City College of the City University of New York, Convent Avenue at 138th Street, New York, NY 10031.

6. Dolores Hayden, review of Hemalata C. Dandekar, ed., *Shelter, Women, and Development: First and Third World Perspectives* (Ann Arbor, Mich.: George Wahr, 1993) in *Women's Review of Books* 11:8 (May 1994): p. 22. The book's essays were from papers presented at an international conference held the previous year at the University of Michigan in Ann Arbor.

7. Ibid., p. 23.

Joan Rothschild is research associate at the Center for Human Environments, Graduate School and University Center of the City University of New York (CUNY), where she organized the conference "Re-Visioning Design and Technology: Feminist Perspectives." She was instrumental in establishing the field now known as "gender and technology," publishing her *Machina ex Dea: Feminist Perspectives on Technology* in 1983 (Pergamon; Teachers College Press, 1992). Other publications include *Teaching Technology from a Feminist Perspective* (Pergamon, 1988; Teachers College Press, 1992), "Technology and Feminism" theme issue of *Research in Philosophy and Technology* (guest editor) (1993), *Women, Technology, and Innovation* (editor) (Pergamon, 1982), and *Engineering Birth* (forthcoming, 2000), and numerous articles. Rothschild's recent work on design and feminism has appeared in *Design Issues,* the international journal *ICON,* and *NWSA Journal.* A graduate of Cornell University, she received her M.A. and Ph.D. from New York University. She taught at the University of Massachusetts Lowell for over 20 years, following an earlier career as a promotion writer at Scholastic Magazines and the *New York Herald Tribune.*

Amelia Amon is an industrial designer who develops solar, water, and energy-efficient systems in simple, fluid forms for a variety of products and site-specific projects. Her work includes a garden fountain with integral photovoltaic cells for the National Design Museum, a solar freeze cart for Ben & Jerry's, a solar waterfall in a community park in the Bronx, and a solar streetlight for northern climes. She is cofounder of the New York Chapter of the O2 International Network for Environmentally Concerned Designers and was chair of the New York Chapter of the Industrial Designers Society of America.

Paola Antonelli is Associate Curator in the Department of Architecture and Design at the Museum of Modern Art (MoMA), New York City. Her exhibition "Mutant Materials in Contemporary Design" (1995) was followed by "Thresholds: Contemporary Design in the Netherlands" (1996) and "Achille Castiglioni: Design!" (1997–1998), the first retrospective of the designer's work. Prior

to joining MoMA in 1994, she organized a number of exhibitions including "Domus through Domus" (Toronto, Chicago, Montreal, Vancouver, 1988), "Mobili Italiani 1961–1991" (Triennale of Milan, 1991), and "Techniques Discrètes" (Musée des Arts Décoratifs, Paris, 1991) and in 1989 was Italy Coordinator of the XXIX International Design Conference in Aspen, Colorado. Among the publications she has contributed to are *Domus* (contributing editor), *Abitare* (design editor), *Print* (guest editor, special issue on Italy), and *Graphis, ID Magazine, Metropolis,* and *Metropolitan Home.* Born in Sassari, Italy, she graduated with a master's degree in architecture from the Polytechnic of Milan. She has taught at the University of California, Los Angeles, and has lectured on design and architecture throughout Europe and the United States.

Wendy E. Brawer is an eco-designer with an artist's background. Since 1990, her company, Modern World Design, has created services, systems, and products that promote ecological stewardship, including the Green Apple Map of New York City's environmentally significant places, which inspired the Green Map System, a global collaboration that Brawer directs. She has created collaborative works since the early 1980s. Brawer was the 1997 designer in residence at the Cooper-Hewitt, National Design Museum, Smithsonian Institution, and is past chair of the Industrial Designers Society of America's enviro-committee (1993–1995) and O2 NYC (1996). She received the 1998 KUDOS award for "Connections" from Communication Arts Eco Critique. Brawer has taught at Parsons School of Design and the Cooper Union and has spoken at numerous design schools and international events.

Cheryl Buckley is Reader in Design History, Department of Historical and Critical Studies, University of Northumbria, Newcastle-upon-Tyne, England. Previous work includes numerous books and journal articles as in Judy Attfield and Pat Kirkham, eds., *A View from the Interior* (Women's Press, 1989), Pat Kirkham, ed., *The Gendered Object* (Manchester University Press, 1996), Victor Margolin, ed., *Design Discourse: History, Theory and Practice* (University of Chicago, 1989), and Jerry Palmer and Mo Dodson, eds., *Design and Aesthetics* (Routledge, 1996). Her doctoral thesis was published as *Potters and Paintresses: Women Designers in the Pottery Industry, 1870–1955* (Women's Press, 1990). New work includes an essay on feminism and ceramics in Claire Pajaczkowsa and Fiona Carson, eds., *Feminist Visual Culture* (Edinburgh University Press, 1999), and "On the Margins: Theorising the History and Significance of Making and Designing Clothes at Home," in *Journal of Design History* 11:2 (1998). Currently she is cowriting

Fashion, Gender, and Representation (forthcoming, I. B. Tauris, 2000), and researching the role of women potters in the USA to contribute to a book/exhibition catalog edited by Pat Kirkham.

Sue Cavanagh is projects manager for the Women's Design Service in London and has contributed prolifically to the WDS research program, producing publications on the design of shoppers' crèches, public conveniences, housing for older women, and neighborhood safety. A former student in the women's architectural access course (WIAB) at the University of North London, she is currently completing a Ph.D. in user participation in health building design at that institution.

Alethea Cheng works for an architectural firm in New York City and is also a publication, Web site, and graphic designer. She has a Bachelor of Architecture degree from Pratt Institute, Brooklyn, New York. Her thesis, "Architecture as Teaching and Learning," proposed that nonarchitects can and should be important collaborators with architects in a process in which both teach and learn from each other. Cheng founded and edited *PASS News,* an architecture student publication. She has taught at the Pratt Saturday Art School and has worked on architecture projects with first- and fifth-grade students at the Ethical Culture School. She has published in *Architectura,* a CD-ROM–based magazine.

Roberta M. Feldman is a professor of architecture and founding co-director of the City Design Center in the College of Architecture and the Arts at the University of Illinois/Chicago. Feldman has lectured and published widely in the United States and abroad on socially responsible housing and neighborhood design. Currently she is under contract with Cambridge University Press to write a book on Chicago public housing women residents' activism to improve their housing developments. Feldman holds a Ph.D. in psychology (Environmental Psychology Program) from the City University of New York (1986) and a Master's of Architecture from the University of Pennsylvania (1976).

Etain Fitzpatrick received her Bachelor of Architecture degree from Syracuse University in 1993. Moving to New York City the following year, she worked for Ethlelind Coblin Architect, P.C., from 1994 to 1996 on projects such as work for the New York City Housing Authority. Since 1996, she has been at Hom+Goldman Architects, P.C., where projects include a new Youth Opportunity Center in Ridgewood, Brooklyn, a Campus Development Study for Purchase College/SUNY, Purchase, New York, and the Bingham-

ton University Student Union, Binghamton, NY. She is currently a registered architect in New York State.

Alice T. Friedman is a professor of art and director of the Architecture Program at Wellesley College in Massachusetts. She is the author of *House and Household in Elizabethan England: Wollaton Hall
and the Willoughby Family* (University of Chicago Press, 1989) and *Women and the Making of the Modern House: A Social and Architectural History* (Harry N. Abrams, 1998). She has published extensively on domestic architecture, social history, and gender relations in both the Renaissance and the modern period.

Dolores Hayden is an urban historian and architect and the author of several award-winning books on urban design and housing. *The Grand Domestic Revolution: A History of Feminist Designs for American Homes, Neighborhoods, and Cities* (1981) raised many issues for feminist architects and planners. *The Power of Place* (1995) is an account of her work in downtown Los Angeles developing collaborative public projects on urban history, gender, ethnicity, and labor. She is Professor of Architecture, Urbanism, and American Studies at Yale University.

Ghislaine Hermanuz holds a Diplome d'Architecte from the Ecole Polytechnique Fédérale de Lausanne and an M.S. in urban planning from Columbia University. She is Professor of Architecture at the City College of the City University of New York, where since 1986 she has been director of the City College Architectural Center (CCAC), a community design center affiliated with City College's School of Architecture. During the 1970s, she was an active member of ARCH (the Architects' Renewal Committee in Harlem), Harlem's first community design center where African American architects began to define development from the perspective of the community itself. In addition to numerous articles and papers, Hermanuz has published *At Home in Harlem: An Architectural Walking Tour* (1992), *Sustainable Development in Industrialized Countries: The Challenge of Decent and Affordable Housing for All* (1990), "Infill: A Remedy to Harlem's Deterioration," in *Reweaving the Urban Fabric* (1989), and "Housing for a Postmodern World," in *The Sex of Architecture* (1996).

Barbara Knecht is an architect and principal of Barbara Knecht, Inc., a New York City consulting firm. The firm was created to expand on her previous experience in government developing housing, and increasing access to services for people living in poverty

and homelessness. Knecht holds a B.A. in architecture from the University of California and a Master of Architecture from Columbia University. She writes and lectures frequently on housing policy and architectural design issues and is the recipient of several grants and awards, including a Loeb Fellowship at Harvard University, a Kinne Fellowship from Columbia University, and a research grant from the Graham Foundation for Advanced Studies in the Fine Arts.

Ellen Lupton is Adjunct Curator of Contemporary Design at Cooper-Hewitt National Design Museum, Smithsonian Institution, in New York City. Her projects there have included "Mechanical Brides: Women and Machines from Home to Office" (1993), "The Avant-Garde Letterhead" (1996), and "Mixing Messages: Graphic Design in Contemporary Culture" (1996). She is chair of the Graphic Design Program at Maryland Institute, College of Art, in Baltimore.

Maggie Mahboubian is a practicing architect in New York City. She has taught at Parsons School of Design and at the University of Kansas. She holds a master's degree in architecture from the Harvard Graduate School of Design and has worked for several New York architects, including Paul Rudolph and Robert A. M. Stern. Currently she is working in the firm of Costas Kondylis & Associates.

Francine Monaco, RA, a graduate of the Architecture School at the University of Cincinnati, has worked on projects in the United States and Europe. In 1992, she established Monaco Architects, which as a young firm has taken on a broad spectrum of work. Recently completed projects include the administrative offices for the Sister Fund and the Astrea Foundation, two nonprofit organizations focused on women's issues.

Nancy Perkins, FIDSA, is an industrial design consultant for consumer products, industrial equipment, and mass transportation vehicles. She has designed for over forty-five product lines in twenty-six categories. Perkins has been profiled in *The Philadelphia Inquirer, Feminine Ingenuity, ID Magazine,* and *Working Woman* and is currently a member of the State of Pennsylvania's Ben Franklin Partnerships' Technical Review Committee. She received her BFA in industrial design from the University of Illinois at Urbana in 1972, has held adjunct teaching positions at Carnegie Mellon University, the University of Illinois/Chicago, and the Illinois Institute of Technology, and is a fellow of the Industrial Designers Society of America.

Victoria Rosner is an assistant professor of twentieth-century literature at Texas A&M University. She recently received her Ph.D. in English from Columbia University; her dissertation, "Housing Modernism," is a study of gender, architecture, and the culture of space in modern British literature. Recent publications include "Home Fires: Doris Lessing, Colonial Architecture, and the Reproduction of Mothering," in *Tulsa Studies in Women's Literature,* and "A Study in Secrets: Architectural Privacy and the Construction of Female Masculinity," in *Mosaic: A Journal for the Interdisciplinary Study of Literature.*

Susana Torre is an architect, urban designer, and educator. She is a principal of TEAM for Environmental Architecture, an interdisciplinary design firm. Torre has taught at Columbia University, the University of Pennsylvania, and the University of Sydney, among others; she was formerly chair of the Architecture Program at Parsons School of Design and director of the Cranbrook Academy of Art. Among her best-known projects are Fire Station Five in Columbus, Indiana, and a master plan for Ellis Island in the New York harbor. Her work is included in such standard reference books as St. James Press's *Contemporary Architects* and *Contemporary Masterpieces,* Udo Kulterman's *Architecture in the Twentieth Century,* Hazan Editions' *Dictionnaire de l'Architecture du XXeme siècle,* and the Whitney Library of Design's *Twentieth Century American Architecture: 200 Key Buildings.* Torre's projects are archived at Virginia Polytechnic's International Archive of Women in Architecture. She was curator of "Women in American Architecture: A Historic and Contemporary Perspective," a traveling exhibition, and edited the book of the same name, which has been translated into Dutch and Spanish.

Lynne Walker is the former chair of the Women's Design Service in London and taught the History of Architecture in the access course Women Into Architecture and Building at the University of North London. Most recently, she helped launch the gender and architecture course at the University of Cambridge and published "Home and Away: The Feminist Remapping of Public and Private Space in Victorian London," in R. Ainley, ed., *New Frontiers of Space, Bodies, and Gender* (Routledge, 1998); and with Vron Ware, "Political Pincushions: Decorating the Abolitionist Interior, 1789–1860," in I. Bryden and J. Floyd, eds., *Domestic Space: Reading the Nineteenth Century Interior* (Manchester University Press, 1998). At the Royal Institute of British Architects, she produced a number of exhibitions and catalogs, including *Women Architects: Their*

Work (Sorella Press, 1984) and *Drawing on Diversity: Women, Architecture, and Practice* (RIBA Heinz Gallery, 1997).

Leslie Kanes Weisman is a professor, founding faculty member (in 1975), and former associate dean of the School of Architecture at New Jersey Institute of Technology. She served as endowed professor at the University of Illinois at Urbana-Champaign (1995–96), and has taught at the Massachusetts Institute of Technology, Brooklyn College, and the University of Detroit, covering architecture, planning, and women's studies. Weisman cofounded the international educational forum Sheltering Ourselves: A Women's Learning Exchange in 1987, and the Women's School of Planning and Architecture (1974–1981), a national summer program for women in the design professions and trades. The author of *Discrimination by Design: A Feminist Critique of the Man-Made Environment* (1992) she is coeditor of and contributor to *The Sex of Architecture* (1996), both award-winning books. The recipient of public service and teaching excellence awards, Weisman has served as keynoter and speaker at numerous conferences in the United States and abroad.

Index

Page numbers in italics refer to illustrations.

Morton, Eleanor, 122–123
Mothers and Daughters of Invention
(Stanley), 24
Mulvey, Laura, 16
Murase, Mike, 46

Nagasawa, Nobuho, 53
National Trust for Historic Preserva-
tion, and ethnic diversity, 55
Naughton, Jack, 141
neighborhoods: and New Urbanism
(*see* New Urbanism); and
NIMBY attitudes, 105; and "spe-
cial needs" housing, 105; safety
of, 151; survival of, 42–43 n.16;
workspaces in residential, 73–
83. *See also* communi-
ties; TNDs
Neutra, Richard, 91–96, 97 n.8
New Feminist Urbanism, 40–41.
See also New Urbanism
*New Frontiers of Space, Bodies, and
Gender* (ed. Ainley), 21
New Households, New Housing (ed.
Ahrentzen and Franck), 12
New Jersey Institute of Technology
(NJIT), 161, 162–173 *passim*;
and *The Vector,* 167
New Space for Women (ed. Wekerle,
Peterson, and Morley), 11
New Urbanism, 4, 36–38, 40–41,
71, 73, 136; feminist critique of,
36–41
New York City: Bradhurst neighbor-
hood, Harlem, plans for, 78–81;
designs for Douglass Boulevard
apartments, Harlem, 74–77
North East Sustainable Energy Asso-
ciation (NESEA), 126

objects, gendered, 23, 24, 110; and
bodies, 32 n.78; and postmodern-
ism, 115–116. *See also* industrial
design: women in; technology:
and women
Ockman, Joan, 13
Olive Hill (Los Angeles), 86
Ormrod, Susan, 24
"Our Practices" (Women, Homes,
and Community Super Coali-
tion), 178–179, 181 n.5. *See also*
Habitat II conference

Parker Hotel, Los Angeles, *103*
participatory design, 135–148, 153,

164–165, *166,* 169; as strategy
for revitalizing public housing,
146
patriarchy: and design history, 22,
109; and discourse of postmod-
ernism, 113; and space
allocation, 10, 85, 86
patron-builders, in Britain, 9, 28 n.11
Paving the Way documentary (Don-
net), vii–viii
Perkins, Constance, 91–96, 97 n.8
Perkins, Nancy J., 5, 119, 187; on
women and industrial design,
120–125, 134 n.3
Perkins house (Pasadena, Calif.),
91–96, 97 n.8
Pesotta, Rose, 52, 53
Peterson, Rebecca, 11
photovoltaics, uses of, 126, *127,*
128, *128;* water projects, 126,
128, *129*
Pizan, Christine de, 20
planning, *see* urban planning
political action, grassroots, 144, 145
Polo Grounds Towers, New York, 80
Popova, Liubov', 24
postmodernism, 8, 14, 30–31 n.58;
and absence of women in, 110,
111; and feminist theory, 20,
111, 112–116; and gender, 4–5,
114; and masculine discourse,
20, 111
poverty, and women, 12, 13, 136,
149–150
power: allocation of, and gendered
spaces, 175; relations of, and
structuring of domestic space,
85–86, 95; sex, class, and race
inequalities of, in urban and sub-
urban landscape, 15, 35, 39;
struggles for, by public housing
residents, 144, 145–146. *See also*
control; empowerment
Power of Place, The, 46, 47; and
the Biddy Mason homestead, 47,
49–51; and the Embassy The-
ater, 51–53; impact of, 54–55;
Los Angeles walking tour, 47, 48,
53–54. *See also* Hayden, Dolores
Power of Place, The (Hayden), 19, 55
preservation, historic: as elite prac-
tice, 45; as social history, 45–46;
as women's and ethnic history,
46–55
Princeton University symposia on